P9-DBL-944

Ready to Wear

AN EXPERT'S GUIDE

TO CHOOSING AND USING

YOUR WARDROBE

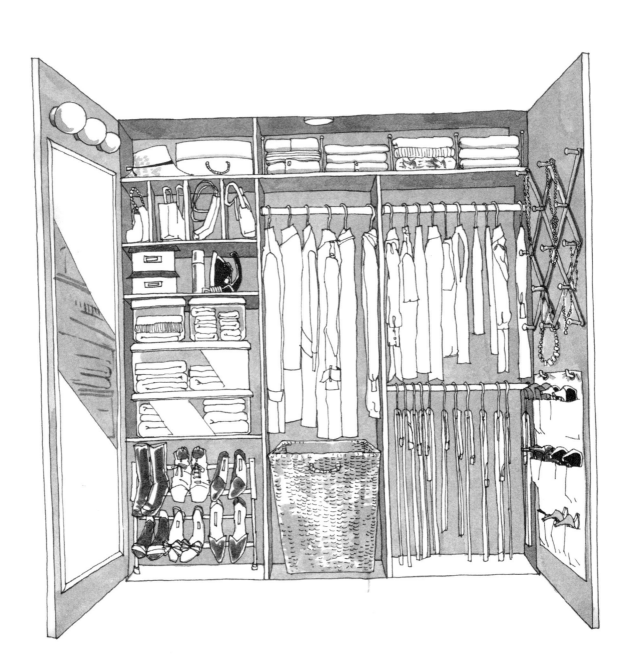

Ready to Wear

AN EXPERT'S GUIDE

TO CHOOSING AND USING

YOUR WARDROBE

Mary Lou Andre

A PERIGEE BOOK

Most Perigee Books are available at special quantity discounts for bulk purchases for sales promotions, premiums, fund-raising, or educational use. Special books, or book excerpts, can also be created to fit specific needs.

For details, write: Special Markets, The Berkley Publishing Group, 375 Hudson Street, New York, New York 10014.

A Perigee Book
Published by The Berkley Publishing Group
A division of Penguin Group (USA) Inc.
375 Hudson Street
New York, New York 10014

Copyright © 2004 by Organization By Design, Inc.
Cover design by Charles Björklund
Cover photos © by David Henderson
Text design by Tiffany Estreicher
Illustrations by Susie Jang

All rights reserved. This book, or parts thereof, may not be reproduced in any form without permission. The scanning, uploading, and distribution of this book via the Internet or via any other means without the permission of the publisher is illegal and punishable by law. Please purchase only authorized electronic editions, and do not participate in or encourage electronic piracy of copyrighted materials. Your support of the author's rights is appreciated.

First Perigee edition: March 2004

Visit our website at www.penguin.com

Library of Congress Cataloging-in-Publication Data

Andre, Mary Lou.
 Ready to wear : an expert's guide to choosing and using your wardrobe / Mary Lou Andre. — 1st ed.
 p. cm.
 ISBN 0-399-52953-5
 1. Clothing and dress. 2. Fashion. 3. Clothing and dress—Purchasing. I. Title.

TT507.A664 2004
646'.34—dc22
 2003063278

Printed in the United States of America

10 9 8 7 6 5

To my husband, T.J., whose unconditional love always brings out the best in me, and to my sons, John Joseph and Timothy, who teach me day in and day out that life is not a dress rehearsal.

ACKNOWLEDGMENTS

None of us exists as an island and this book is a perfect testament to this truth. Although it has been a lifelong dream of mine to write a book, it would have never materialized if it wasn't for the love and support of my family and friends and my colleagues and clients.

Here is a brief, yet heartfelt, thanks to those who have had a significant impact on this personal and professional milestone:

To my mom, the teacher, for showing me through example how to give openly and unconditionally to any student. I think of you often when I share my own message. Thank you for all that you have done and continue to do for me.

To my dad who helped me fall in love with the business side of what I do. I miss you every day.

To my three siblings—Neil, Kathleen, and Tim—for keeping me close to the family values we all share. I cherish our unique history together.

To my aunt Joan who gave me my first style lessons and, in doing so, gave me the confidence to give them to others.

To my childhood friend, Lisa (Waryas) Duncan, for playing dress-up

with me when we were kids and still playing with me now that we are adults. Your friendship means the world to me.

To the Moroney family for introducing me as a child to the magic of the entrepreneurial spirit that was actively alive in their home. I'm hooked!

To my "adoptive" family, the Andres, who never cease to amaze me with their generosity and kindness. It means more than you know.

To Karen Zahn for inviting me over to her home in 1992 and helping me launch my dream job from her closet. I am forever grateful.

To Ellie Anbinder for introducing me to the world of formalized networking. By taking me under your wing, you gave me my own wings. Thank you.

To my SBA mentor, Carol Coutrier, who taught me through her fine example how to be successful in business on my own terms—not anyone else's. You have been a true entrepreneurial and spiritual guide to me over the years. It is a privilege to be your co-mentor.

To my "big sister" Elizabeth Mallory. Thank you for helping me sort through all of the life "stuff" that came up as I was writing this book. Your wisdom and remarkable insights help shape all that I do. I can't imagine this life without you.

To Eleanor Uddo—my attorney, confidant, and friend. There is a saying that when the student is ready, the teacher appears. Seeing the world through your eyes is like getting a master's degree over and over again. Thank you for taking the time to educate and befriend me. I'm a lifelong fan. Your friendship is irreplaceable.

To my good friend Nancy Michaels for saying, "You have to write a book . . . it's selfish not to!" back in 1999. Your words helped me shift my thinking about becoming an author, encouraging me to write this book sooner than I had planned. Your friendship is a gift in and of itself. We are karmically connected.

To Karen Marinella—my first "celebrity" client. Thank you for your faith in me back then and your continued support of all that I do.

To Christine Edmonds—my trusted friend and colleague. Your good

karma fills my office and my life each week and makes even the most difficult days end on a positive note. Thanks, in particular, for helping me master the mechanics of book writing. This book would never have been born without your steadfast encouragement. You are a constantly blooming rose in my bouquet of friends.

To Donna Kent for believing in me even when I didn't believe in myself. Your loyalty and incredible service to me and my company continues to be appreciated year in and year out. Thank you.

To June Tarter—my soulmate in all things fashionable and stylish. Thank you for bringing the principles outlined in this book to life each day with our clients. You not only perform your job with warmth and humor, but you do it with a level of integrity, openness, and honesty that is both rare and unique. I couldn't ask for a better business partner and friend. Thank you for being at the right place at the right time back in 1997.

To Suzanne Bates—my client, friend, and collaborator. Your approach to business and life is inspiring. Thank you for sharing your talents and camaraderie with me over the years. The grace and dignity you bring to all your friendships is exceptional. Our time together is always a gift.

To Jane Pollak for becoming a client one day and the very next day introducing me to your daughter (my book coach) and your sister (my agent). I love the way you operate! Thank you for kicking me (and this book!) into high gear.

To my incredible book coach Lindsey Pollak. You took the idea for this book, polished it, and gave it life. Thanks for teaching me that in addition to your wise publishing acumen, all a writer really needs to get through the often lonely process of authorship is snow, movies, and tapas bars!

To my agent, Meredith Bernstein. Your belief in this book from day one never swayed. I am amazed at your negotiation skills and am grateful to have you on my side. You're simply the best at what you do.

To my editor, Christel Winkler. The first time I met you, I knew I was in good hands. Your sense of humor, kindness, and genuine enthusiasm for this

project shaped it from beginning to end. Thank you for teaching me the ropes and guiding me through this incredible experience. I will be forever grateful for your confidence in me and this book.

To Sharron Kahn—my secret weapon every time writer's block hit. Speaking to you and having you e-mail me back my thoughts perfectly organized and in synch with my message kept me sane during the final weeks of the writing process. Thank you for being there when I needed you.

To my baby-sitter, Rocio Barriera, for taking good care of my boys while I was writing this book. Knowing Tim and John were in your loving care allowed me to focus on this project and get it done in the allotted time frame. You are always welcome in our home.

To makeup artist David Nicholas, the folks at Henderson Photography, and my friend Gina Penna and her staff at Salon Capri for working with me to create the cover of this book. You all are the ultimate professionals in your respective disciplines.

Finally, to my clients. Without you there simply would be no book. Your faith in me over the years has allowed me to wake up every morning and do the work I love. Yes, I always did like to play dress-up, and I'm deeply grateful that my favorite childhood pastime has become my adult profession.

CONTENTS

PART THREE | **Smart Shopping**

How I Sold My Wedding Dress to Start My Fashion Business

When I was a little girl, I would have chosen a trip to the mall over a trip to an amusement park any day. I loved the touch and feel of fabric, whether I was draping it on my Barbie dolls, my friends, or even my mother. Unlike most kids who dreaded the approach of Labor Day, some of my fondest memories are of back-to-school shopping. I would line up my friends in adjoining dressing room stalls, and dash in and out, selecting outfits for each one of them. I never dreamed that my passion would end up being my career.

That piece of my life began to come together when I was in public relations during my 20s, and I took a freelance job promoting the annual charitable holiday display in a Boston department store. I always knew I wanted to start my own business, and this situation was perfect—fashion and public relations combined with community service and the ability to be my own boss with a secure contract. I learned the inner workings of the retail and fashion industries at this job.

I also learned something about myself. While I was at this job I met a woman who forever changed my life. She was the vice president of public affairs and the store's spokesperson, and she took me under her wing.

Through our work together, she and I became fast friends. She was intrigued with the stories I would tell of helping family and friends organize their closets, dress their best, and shop for fashions that fit their unique needs. She asked me to come to her home and demonstrate these skills. My wardrobe management and fashion consulting company, Organization By Design, Inc., was literally born in her closet. She encouraged me to follow my dream and gave me my start by referring her friends to my wardrobe consultation service. Although I was thrilled by her confidence in my abilities, I realized the pressure was on to prove that I had a winning concept.

I had very little capital to establish my fledgling business. So I begged, borrowed, and . . . sold my wedding dress! At the time, I harbored some doubts about parting with my gown. After all, it was quite sentimental. But now, years later, I can appreciate how perfectly that decision reflected my dressing well philosophy. My business is built around the concept of wearing the flattering pieces that you own and getting rid of the items that no longer serve you. I wore my wedding dress on the day for which it was intended. After that, I really didn't need it anymore. After all, I now had my husband and I was in *serious* need of some capital!

Over time, as my business grew, I realized that my wardrobe management and fashion tips and strategies could be taught outside the closet. My consulting with private clients led to seminars and presentations for the general public, as well as extensive corporate image consulting for such organizations as Estée Lauder, Fidelity, Harvard Business School, John Hancock, Nordstrom, Sara Lee, and Sonesta Hotels and Resorts. I ventured into print, publishing the *Dressing Well* newsletter. Now I share my dressing well message free of charge to thousands of Internet readers around the world who subscribe to "Mary Lou Andre's *Dressing Well* Tip of the Week." You can sign yourself up by visiting www.dressingwell.com.

The enthusiastic response to my consulting, seminars, national and international media appearances, newsletter, and "Tip of the Week" e-mails have led to the creation of this book. ***Ready to Wear: An Expert's***

Guide to Choosing and Using Your Wardrobe is a collection of my favorite fashion tips and strategies.

Yet this book is not just about fashion. It's about helping you feel good about yourself every day by organizing a wardrobe and dressing strategy to match your budget, lifestyle, personality, and figure. Helping women feel better about themselves in their personal and professional lives is the foundation on which the entire concept of my wardrobe consulting business and this book are based. And it is my firm belief that anyone can be well dressed with a little organization and a few simple fashion strategies.

For nearly my whole life, I have practiced the concepts detailed in this book, and I am now grateful to be able to share them with you. It's definitely all been well worth a wedding dress!

Mary Lou Andre

Ready to Wear

AN EXPERT'S GUIDE

TO CHOOSING AND USING

YOUR WARDROBE

I started my company, Organization By Design, Inc., in 1992 based on a philosophy I call *Dressing Well*. The premise for this philosophy is that absolutely anyone can be well dressed with a little organization and some simple fashion and shopping strategies.

The related *Dressing Well* systems that will unfold on these pages have been developed through years of working with private clients with dramatically different needs. These are women who have hired me or an Organization By Design, Inc., trained consultant to come to their homes, organize their wardrobes, coach them about what looks best on them, and then shop with them to complete their wardrobes. These women include executives, doctors, lawyers, teachers, entrepreneurs, stay-at-home moms, artists, bankers, retirees, and young women just starting their careers. I share many of my clients' stories throughout the text as a way to further illustrate the *Dressing Well* philosophy.

This book is organized in the same order we follow when consulting with private clients and presenting group seminars. In Part One, *The Organized Wardrobe,* you will learn the five essential steps to gaining control over your existing wardrobe. Part Two, *Fashion Finesse,* helps you develop your

personal style. Finally, Part Three, *Smart Shopping*, teaches you to become a better, more efficient shopper.

These three sections are built from the following five strategies—mentioned throughout the chapters of this book—that are essential to learning and maintaining the *Dressing Well* system:

Step #1 Correctly assess your lifestyle, and be sure your wardrobe accurately reflects how you live.

Step #2 Organize your closet in a way that makes dressing easy and effortless.

Step #3 Train your eye to recognize the styles that flatter your figure.

Step #4 Learn to shop in your own closet before ever spending another dime on clothes.

Step #5 Develop a shopping strategy—make it focused, organized, and efficient no matter what your budget.

When we first meet them, some of our private clients despair because they have spent thousands of dollars on clothes, yet never feel pulled together when they leave their homes. Others tell us that if they only had more closet space, they would be able to master the art of dressing well. Still others claim they have hardly any clothes at all, yet, when we get to their home for a consultation, every closet they have is filled to the brim!

Although their fashion issues might seem very different, most boil down to the same cause: the wrong clothing choices and a lack of knowledge about basic fashion principles.

The wardrobe management systems detailed in this book are adaptable and designed to be followed at any pace. Using the wardrobe management tools at the back of the book, you can whip through all the steps of this system in a day, or take a more leisurely approach and stretch out the process over a weekend, a week, or a month.

The same flexibility is built into this book. If you are committed to a total wardrobe makeover that includes tackling your closets, dressing better, and learning to shop for the right pieces at the right places, then read this book cover to cover before putting your plans into action. If you can't live another day with the clutter in your closet, then by all means, plunge into Part One of the book, where you will learn how to regain complete control of your wardrobe. After you've brought your closet into shape, dip into the other parts of the book.

As you get ready to read this book, you might also want to start a fashion journal—a notebook where you can capture ideas that resonate with you, keep shopping lists, and itemize clothing donations you plan to give to charity. Many of my firm's private clients also appreciate having a two-pocket "fashion folder" where they can store coupons, magazine articles, catalogs, and copies of the wardrobe management forms we personalize on their behalf.

Although the *Dressing Well* system does require maintenance from season to season and throughout the seasons of your life, I guarantee that investing a little time to develop an organized approach to style will pay you back dividends if your goal is to have a closet full of clothes that are "ready to wear" every day and for every occasion!

The Organized Wardrobe

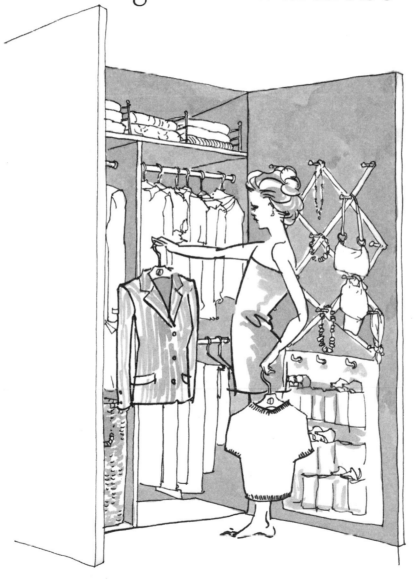

THIS FIRST PART OF THE BOOK DETAILS MY FIRM'S FIVE-STEP APPROACH TO TAKING APART AND THEN RE-ORGANIZING YOUR ENTIRE WARDROBE. THESE STEPS ARE THE HEART AND SOUL OF the *Dressing Well* system and for well over a decade have been successfully implemented in the homes of private clients of my wardrobe management and fashion consulting firm as well as the homes of participants who have attended one of my company's group seminars.

These steps involve going through your wardrobe closet by closet and drawer by drawer so you get a thorough and accurate read on your clothing inventory. Whether you have a small clothing inventory in your home or you have closet after closet crammed with everything you have ever bought, chances are you are only wearing 20 percent of what you own.

While we're putting your wardrobe back together again, I'll give you some fresh new ideas about how to add new life and energy to the wardrobe storage areas in your home so that dressing day in and

Identifying the 80 percent of the clothing you don't wear and then making choices about what to do with it is essential to effectively managing your wardrobe and feeling more confident with your overall personal style.

day out is more enjoyable and less of a hassle. Because ongoing maintenance from season to season is important to maintaining the *Dressing Well* system, this part of the book will conclude with a seasonal wardrobe organizational summary.

Although fashion styles do come and go, an organized approach to dressing lasts a lifetime and never goes out of style. Taking the time now to learn the wardrobe organization aspect of the *Dressing Well* system and adapting it to your own needs is time well spent if you want to master the art of dressing well. Remember to use the Personal Action Plan in Appendix A and/or a fashion journal to capture any wardrobe organization tips and ideas you would like to put to use in your own home.

Let's get started!

1

An Organized Approach to Style in Five Easy Steps

Step One: A Place for Everything, and Everything in Its Place

Whether you are living in a tiny loft apartment with makeshift closet space or have a sprawling mansion with multiple walk-ins, the first step toward effectively managing your wardrobe is to accurately assess all the storage space available to you.

First, decide which storage areas will be used for your in-season and out-of-season day-to-day clothing as well as your outerwear, special occasion wardrobe, shoes, and accessories. Everything in your day-to-day wardrobe should fit your lifestyle, figure, and personality—you'll be hearing a lot about this concept as this book unfolds.

Next, analyze what space, if any, you and/or other members of your household are wasting storing clothes that are never worn or household items that could be given away or stored more effectively. If you live in a small apartment or home with limited storage space, are there any untraditional storage spaces that could be transformed into a closet or other wardrobe storage area with the help of carpentry, store-bought hooks and

rods, or other widely available storage accessories such as crates, drawers, or armoires? Look to the resource guide at the back of this book for a guide to retailers, websites, and manufacturers that specialize in home storage solutions.

Understanding your storage options and then developing a plan so your clothing is easy to locate when you need it is worth your time spent if you are serious about getting an accurate inventory of all the clothing currently in your wardrobe.

Step Two: Know Thy Lifestyle

If you are someone who is having a hard time with too many clothes that don't work, chances are that you have had a lifestyle change and haven't made the time to bring your closet up to speed to reflect this change.

For instance, if you used to leave the house five days a week in a suit or dress but are now working from home, raising children, or in retirement, don't waste prime closet space on suits you never wear. On the other hand, if you work outside the home full-time and just got promoted (or would like to be!) and need to step up your wardrobe a notch to help you project a stronger on-the-job presence, you probably can let go of many of your overly casual items that are cluttering your closet and won't help you project an air of authority on your job.

More often than not, the person who calls our office in dire straights about having too many clothes but not enough "outfits" is the same person who has a closet full of clothes that no longer suit her lifestyle. How do you assess your lifestyle? Begin by getting a basic understanding of the five categories of dress commonly worn in today's society.

- **Traditional business attire:** The easiest way to picture this category of dress is to visualize the lawyers and news anchors you see on tele-

| Behind Closed Doors |

Colonial Closets

I celebrated the 225th anniversary of the beginning of the American Revolution in the year 2000 by visiting various historical sites in Lexington and Concord, Massachusetts, with my husband— a true history buff.

As I toured some of the historic homes, I remember noticing how small closets were in Colonial times. Most people back then had their "Sunday best" and a few work outfits. An armoire or a small closet with a board-and-hook arrangement was often sufficient to store the wardrobe of an entire family.

Today, we have entire categories of clothes for members of our families and ourselves. Professional, casual, business casual, sportswear, resort, social, maternity . . . you get the gist. And for each outfit, we have shoes and other accessories to match. For those of you who live in older homes, trying to squeeze all this stuff into closets that were designed for other generations often leads to frustration.

If you have already pared down your wardrobe and gotten rid of the things that don't compliment your lifestyle, personality, and figure and are still pressed for space, it might be time to completely reconfigure your closet design. Professional closet companies such as California Closets as well as home superstores such as The Home Depot are great resources.

Regardless of the size of your closet, you can most likely bring order to your wardrobe through a carefully planned and strategically designed system of rods, shelves, racks, and drawers. Adding proper lighting and installing mirrors on closet walls and doors are two additional ways to make a small closet appear bigger.

vision shows and reporting the nightly news. Dark suits with power ties are the norm for men practicing this style of dress; equally conservative skirted and pant-style suits best depict this level of dress for women.

- **Business casual:** One step down from traditional professional attire yet never sloppy or overly provocative. Pant suits with knit T-shirts and loafers as opposed to the same pant suit with a formal

blouse and heels is a conservative way to practice this trend. Cardigan twin sets, shirt jackets, khakis, and polo shirts are also common articles of clothing that allow women to relax the dress code without giving up their visual power on the job—or any other place, for that matter.

Dressed-up casual (a.k.a. smart casual): What you wear to afternoon and evening office and social functions that don't require a suit, cocktail dress, or other formal business or social attire. A pair of dressy black slacks or a black skirt are great base pieces that can help you present many different looks appropriate for this category of dress. To add your personal signature, consider topping off the slacks and skirts with embellished twin sets, vintage jackets, and/or ethnic-inspired tunics.

All-out casual (a.k.a. "grubbies"): What you throw on in the privacy of your own home or to be comfortable with family and friends. Sweatpants, T-shirts, shorts, jeans, sneakers, and stretch pants are good examples. Everything in this category of dress is unacceptable for most business situations.

Special occasion: We all have them—weddings, bar mitzvahs, formal dinner parties. These are clothes you would never wear to work or standard social events but you need when the invitation reads "black tie" or "formal attire" requested.

Once you have a clear understanding of the definitions of the various levels of dress, edit your wardrobe to reflect your unique dressing needs.

| Closet Focus |

Organizing to the Fives

How much of your life is spent in sweat suits versus business attire versus clothing for a night out on the town? Mark the percentages here:

◯ Traditional business
◯ Business casual
60 ◯ Dressed-up casual
38 All-out casual
2 Special occasion

= 100% of your time

Remember, the percentages written above should match the amount of clothes you own in each category.

For example, if you wear business casual attire 50 percent of the time, 50 percent of your wardrobe should be business casual clothing.

Step Three: Ready, Set, Organize!

Now that you have a handle on your storage options and are clear about your lifestyle, take a deep breath and get ready to tackle your wardrobe closet by closet and drawer by drawer. To begin, start with your main closet. Pick a time of day when you are most alert, dress in comfortable clothes, and give yourself a few hours to get started with this project.

Grab several large trash bags and/or large boxes to help you sort your castaways. We also recommend having pad and pen handy to accurately document what you are giving away to charity. The fashion journal mentioned at the beginning of the book is a great place to store this information so you

| Behind Closed Doors |

The Professional Painter

I once had a client who was completely frustrated with the state of her professional wardrobe. When I went through her closet, she had countless pairs of sweats, jeans, and T-shirts. Every time I asked her how often she wore various parts of her nonworking wardrobe she replied, "Oh, those are my painting clothes." Because I knew she worked more than 60 hours a week as a real estate broker, we both had a big laugh when I asked her if she was a professional painter! Obviously she wasn't, and the joke allowed her to part with half of these clothes and replace them with more professional pieces. We took the other half of her casual wardrobe and stored these clothes in a closet on the first floor of her home where the gardening and household maintenance items were located.

For one reason or another, we all form habits with our clothes that allow them to take on a life of their own. Be gentle on yourself. If you approach this process with a sense of humor, you're sure to get the best results.

can easily access it at tax time. See the following Insider Tip (page 15) for some insights about the kind of money you can save on your tax bill by properly deducting your charitable contributions.

While you are in the process of organizing your closet, it's a great idea to have a clothing rack available as well as some makeshift lighting if your closet is dark and hard to see into. The rack we use is available through our website. If you don't have a rack, clear off your bed and consider bringing a few over-size chairs into the room to serve as clothing catch-alls. You will be emptying your closets and will need these spaces to help organize and sort both the keepers and castaways.

If you only have one closet where you store clothes, the process will obviously take less time than if you have to go closet to closet and drawer to drawer. If you have clothes in every corner of your house, starting with one closet will help you stay focused and less overwhelmed.

Step Four: Separate and Categorize

It's now time to get down and dirty! Reach into your closet and put your hand on every item. As you are handling each individual piece, ask yourself: *Do I love it, and am I currently wearing it on a regular basis?* If you answer yes, the item stays in the closet.

If you like a certain item but you're not wearing it either because it is the wrong season, it doesn't fit, or you don't have anything you think matches it, take this item out of the closet. As you go through this process, start making piles outside the closet of things that you plan to fix or match or that you are ready to part with. Here are some ideas to help organize your piles:

- Tailor/seamstress

- Dry cleaner

Cash for Your Used Clothes

It's a typical scene: You've cleaned out your closet and have dozens of items you no longer want. You'd rather give the items in good repair to charity than toss them or have a time-consuming yard sale.

You know you can deduct the value of the items on your tax return when you itemize, but how on Earth do you determine their worth? If you overstate the value, you risk an audit, penalties, and interest. If you underestimate, you pay more taxes than you should.

Valuing donations is difficult because the law does not allow the charities to set values. Donors hold this responsibility. Unfortunately, most people have no idea what their donations are worth.

The handy reference booklet "It's Deductible" answers many valuation questions for the uncertain taxpayer. Written by a certified public accountant, it estimates that the average consumer can save at least $500 on their tax bill.

Here are some examples of what donated clothes in good condition are worth:

Cardigan sweater	$15
Dress slacks	$18
Woman's suit	$52
Wool coat	$50
Formal dress	$68

The 137-page booklet also gives market valuations for men's, children's, infants', and toddlers' clothing along with a guide about how to accurately assess the value of many household items. It's a great incentive to free up valuable closet space. For information about how you can purchase it, visit www.dressingwell.com.

- Charity

- Consignment (See Part Three for some great consignment shopping tips.)

- Sell on eBay or other online auction website

- Try on later (Part Two will help you look at your clothes with new eyes.)

- Children's dress-up trunk

- Out-of-season storage

- Bring to the store for matching

- Garbage—when it needs to go, it needs to go!

Next, categorize the items that are remaining in your closet. For instance, hang all suits, pants, skirts, and tops in their own areas of the closet. Hanging dressy T-shirts in your closet, as opposed to folding them in drawers where they are often an after-thought, is also a good wardrobe organization strategy that will help you put outfits together with more ease. It's best to hang suits together as opposed to breaking them up and hanging them as separates. Not only will you save room hanging suits together, you'll also get a more accurate read on how many "outfits" as opposed to "separates" you have. Sure, you can mix and match them later. It's just been my experience that hanging them together keeps your closet more organized.

If your special occasion clothing is mixed in with all your other clothing, separate it out and hang it together, too. See Chapter Four for some handy tips on organizing special occasion and holiday clothes.

Do all of this initial sorting as quickly as you can—it does not have to be perfectly neat right now. Don't stop to try anything on at the moment, either. There will be plenty of time for all of this later.

Once you have gone through the hanging items, sort through anything stored on shelves and the floor of the closet such as sweaters, tops, pants, and shoes. Next, tackle your drawers and any other storage areas you are using for your clothing. Remember, only things that are currently being worn should stay in your main dressing areas.

Step Five: Play Tough Love

If you have trouble deciding the fate of a particular item, here are some guidelines to help you along:

- You haven't worn it in more than a season (exceptions are classic evening wear, sentimental favorites, and high-quality classics).

- It is permanently stained.

- It is torn beyond repair.

- It was bought only because it was on sale.

- It no longer reflects your lifestyle.

- You simply don't like the way it looks or feels when you put it on.

Clothing that no longer fits but you are not ready to part with should also have its own

| Behind Closed Doors |

The Bride

One of my most memorable clients over the years is a woman who I fondly refer to as "The Bride." "The Bride" was stressed out every morning, trying to get out the door quickly, efficiently, and looking her personal best for her job as an administrative assistant at a law firm.

When I opened her closet door the first time we met at her home, I was faced with a big white cloud. Her wedding dress was front and center, taking up primary real estate in her closet. She had to reach behind the dress to get her everyday clothes. The story got funnier when she told me she had been married twenty-five years earlier and she was now divorced! Because the dress had been there for so many years, it had become a permanent fixture that was creating anxiety and stress. Removing the dress and giving it a new home was the first step to allowing her to see her clothes, inventory them correctly, and redesign the space to work for her current lifestyle.

Think about what big white clouds might be standing in your way, and be sure to remove them as you continue this process.

Casting Away with Respect

Early in my career as a wardrobe consultant, I volunteered to help set up the clothing donation center at a new shelter for homeless women that was opening in a town near where I live. I secured a custom closet design company to donate the design and installation of a brand-new closet for the facility. I then recruited several local Girl Scout troops to help me sort, hang, and fold all the clothes that were pouring into the shelter each day.

When the shelter opened, the "boutique"—as it was affectionately dubbed—looked great, and I continued to volunteer my time helping the organization manage their clothing donations. Instead of the Girl Scouts, I was now working with the women who lived in the facility to help keep the boutique under control and in good working order.

When clothing would arrive that was pressed, cleaned, and still in dry-cleaning bags, the eyes of the women being served by the shelter would light up and they would instantly try things on and easily chat about a job interview or visit with one of their children. When dirty, wrinkled, and stained clothes came in, the entire atmosphere changed. Not only did they not try it on, but also the conversation hardly shifted to anything other than the tough time they were going through in their lives.

As you go through your closet and ponder whether or not to give certain items to charity, ask yourself if you would feel comfortable wearing the items to a job interview or to court to attend a hearing about the fate of your children. I must admit that before I had this up-close-and-personal experience, I was often guilty of giving clothes to charity that were better off going directly to the dump. I simply wasn't aware of the potentially damaging impact my actions could have on the self-esteem of others.

home—preferably away from your main dressing area. Think about it. One of the first decisions you make each day is about what you are going to wear. Looking at clothes that used to fit typically makes you feel bad about yourself. When you are presented with dressing choices each morning that make you feel your personal best at your current weight and for your current lifestyle, you set yourself up to succeed no matter what your day entails.

Sentimental clothing and accessories that are meaningful to you but are no longer wearable should also be given a special home. It's amazing how much more special they become when they are no longer tangled up with business suits, jeans, and bathrobes.

Putting It All Back Together

Now that you've separated, categorized, assessed, and played tough love with your wardrobe, it's time to be sure that your "keepers" are being stored in the best possible fashion.

This chapter will help you access each area of your wardrobe individually while helping you understand how each impacts the other in terms of organization, function, and your ability to dress your best each and every day. In other words, this chapter will help you control clutter one small step at a time.

The Multiple Personality Closet

Have you ever considered how many personalities you have hanging in your closet? Many women today juggle motherhood, careers, community service, and social calendars like seasoned circus performers!

If you find that you have many different styles of dress in your closet that you need to change in and out of on a daily basis, you should arrange

your closet in a way that easily supports the many roles you play both inside and outside your home. This will help you get dressed more quickly and with less stress throughout the day.

For instance, I have two modestly sized closets in my bedroom that I personally use. In one I store my professional and special occasion wardrobes, and in the other I store my more casual things. Because I work at home and am the mother of twin boys, I am in and out of my casual closet more than the other.

In the fall and winter, I have four to five polar fleece tops hanging in my casual closet at all times. A collection of black and gray Lycra leggings and body suits and an assortment of cotton Ts and turtlenecks that I wear very casually are conveniently stored in separate crates respectively under my hanging things. They are typically all I need to get dressed quickly on the days when I'm hanging out with my boys, going to the gym, or running a quick errand. In the warmer weather, I put the polar fleeces in my off-season closet located in a spare bedroom in my home and store more seasonally appropriate layering pieces in their place. I also have a few tote bags stored in this closet in case I need to pack a quick bag of these items.

A woman in a fashion seminar I once conducted told me the number of hours she spent changing her clothes every week was wearing her out. At least three days a week she needed to transition from a nonprofit executive wearing a suit to a soccer mom wearing sweats to a hostess at fund-raising cocktail parties wearing black tie and dressy casual separates. A quick conversation with her revealed that all her clothes were mixed up together, causing her extra stress.

She later e-mailed me to say by taking the time to categorize and separate her clothes, she can now sit down and have a meal with her family in between her various commitments—a true gift to her in her rushed and unpredictable world.

Picture what your life could be like without spending so much time star-

ing into your closet trying to figure out what to wear and where to find items. Use that picture to motivate you to find the time to organize your closet in a way that will support your lifestyle while putting you in more control of your time.

The "Right" Closet Design

Marketing experts have long known that our eyes are naturally drawn to the right. Merchandisers take advantage of this by placing items they want to sell quickly to the right of a store entrance. And you've probably noticed that newspaper editors always place their lead story on the right-hand side of the front page.

So how does this translate into an organized closet? Knowing your tendency to gravitate toward the right, assess your lifestyle and consider keeping the types of garments you wear most often on the right side of your closet. Take this concept a step further and hang your favorites within each category on the right end of each group.

Beyond right and left, think top and bottom as well. If you have a closet with double hanging rods, hang your tops (shirts, blouses, knit Ts) on the top rod and your bottoms (pants, skirts, shorts) on the bottom. This is another great strategy to train your eye to see outfits as opposed to separates.

Organizing your clothes by color within categories in your closet also makes sense. Light to dark has a nice flow and keeps things extra organized. Color categorizing also makes it easier to get dressed each day while helping confirm your suspicions about the use of color in your wardrobe. For instance, you might instantly see that you really do have too many khaki pants and gray suits, or that you're missing certain colors completely.

We've all had the experience of frantically rooting through our closets in search of our favorite blouse in our rush to get dressed in the morning. By

designing your closet the "right" way, you'll save yourself time and frustration. Remember, when you see your clothes, you wear them.

> *The way you hang your clothes in your closet is the single most important tool in training your eye to see outfits as opposed to separates.*

No More Wire Hangers!

Although I don't advise anyone to adapt the parenting style of Joan Crawford in the film *Mommy Dearest*, I advise all of you to adapt her way of organizing her closets! She is heard in the movie repeatedly saying "No more wire hangers," and I must admit, as disturbing as it is to hear her say these words, I do hear myself repeating them (in a much nicer tone, of course!) to clients all the time.

Here are some handy guidelines to help you develop a consistent hanging system that will allow you to effectively organize your clothes while saving valuable room:

- Use hangers that won't end up in a tangled mess in your closet. Opt for sturdy, clear plastic department-store-style swivel-top hangers, not traditional wire (i.e., from the dry cleaner) or decorative padded ones. The two styles of "swivel-top" hangers we bring to every private consultation are simply labeled "dress" and "suit" by hanger retailers everywhere.

| Insider Tip |

A Closet of One's Own

Although my marriage is a good example of how opposites attract and make pretty good mates, I am not fool enough to think that my husband and I could actually share a closet and stay married!

I often find it amusing when I go into homes where spouses, partners, and roommates are sharing one closet. Nine out of ten times, one side is neat and the other is messy. Many times it's the guys who are the neat freaks and the gals who are, well, a little more organizationally challenged.

Although it's often not realistic to be able to have your own closet, if it can be arranged, I highly recommend it.

- When you buy new clothes, ask to keep the store hangers to build your collection.

- Keep wire hangers under control by setting up a recycling bin in or near your closet. When the bin is full, bring the hangers back to your dry cleaner or give them to a local charity for clothing donations.

- Assemble complete outfits, including accessories, on one suit-style hanger—a great tip for busy professionals. Out of suit hangers? Make your own by hanging the swivel top of a "skirt" hanger inside the dress hanger. Most dress hangers have a place at their base to accommodate this type of arrangement.

- If you have closet space that doesn't accommodate hanging your pants full-length, look for hangers specifically designed for folded pants. Be sure the ones you select have rubber pads (or are covered in cardboard from the dry cleaner) where the pants rest to avoid having pants slip off. These pads will also eliminate obvious crease marks made when pants are folded over plain wire hangers.

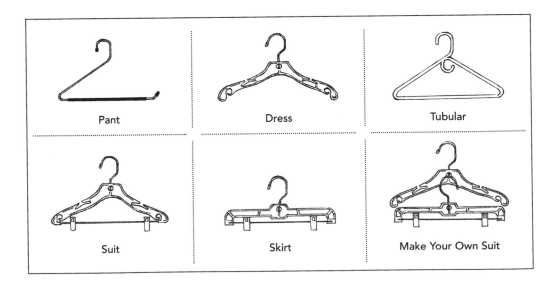

| Pant | Dress | Tubular |
| Suit | Skirt | Make Your Own Suit |

- Although decorative "padded" hangers can look nice, they often get lost in a closet and contribute to its disorganization. Consider placing them in a guest room closet where they can be more appreciated.

- Finally, be aware that big, bulky suit and jacket hangers (typically handed out with purchases at upscale men's and some women's stores) can eat away at your storage space because of their half-moon shape. Consider moving them to your coat closet.

The Hanging of the Coat Closet

Because closet organization and how clothes are visually presented are so near and dear to my heart, in a burst of organizational energy one day, I went out and bought some sturdy plastic, tubular hangers in white and black to use in the two coat closets in our home.

I hung the black hangers in our front entrance closet. Because black is more dressy, they connect nicely to the formal coats hanging in this storage spot. Besides using these hangers for coats, I also use them for my winter scarves.

I hung the white hangers in the closet near our back entrance where we stow snow parkas, rain gear, and miscellaneous walking, running, and other outdoor activity coats and jackets in their respective seasons. The white hangers work well in this space because they look nice with the soft green paint in this closet. Color coordination goes a long way in keeping any closet looking nice and, of course, organized.

Like socks in the dryer, these hangers disappear out of the closet from time to time. When they do surface at least it's easy to return them to their proper home.

An added benefit of this hanging system is

| Insider Tip |

Winter Scarf Access

It's best to keep winter and coat scarves separate from other fashion scarves and hang them directly next to your coats for easy access. Hang each scarf folded once over the hanger to keep them neat and wrinkle-free.

that when I store many of these items in my basement for the winter, it's easy to transport them up and down the stairs using these hangers. They also help keep our out-of-season storage areas more organized.

I also use these plastic, tubular style hangers in our laundry room to drip-dry items I don't want to put in the dryer. Wire hangers tend to rust when exposed to moisture.

Organizing Dresser Drawers

Like closets, drawers can become catch-alls for items in your wardrobe that you never wear and would never miss if the fashion police came into your house one night while you were sleeping and raided your wardrobe!

Before you fill drawers back up after dumping them out and purging their contents as part of Step Four of the *Dressing Well* system detailed in Chapter One, think about how best to use this storage space.

Underwear, pajamas, hosiery, and a variety of tops, pants, and shorts populate many of my private clients' drawers. Some clients use drawers for their jewelry, scarves, and wardrobe maintenance items such as lint brushes, pins, and shoe polish, while other use drawers for specialty items such as workout gear and bathing suits. Some people have drawers in their bedrooms that are used for household items such as sheets and towels. I even have a client who uses the drawers in her bedroom to store her children's artwork.

For the purpose of this book, I am going to assume that your dresser drawers are being used for clothes and accessories. Having said that, here are some strategies for putting your drawers back together in good working order:

- If you choose to store small items such as jewelry, underwear, and hosiery together in your drawers, consider purchasing drawer

dividers that are widely available through online merchants, catalogs, and traditional brick-and-mortar retailers to help keep these small items highly organized. See our resource guide at the back of this book for a list of these retailers. See the following tips for specific organizational ideas for hosiery and underwear. Because they can easily snag and tear on bra hooks and jewelry, scarves are best assigned to their own drawer if you choose to store them this way.

- Pajamas are a natural item to store in drawers. They can look messy and out of place in your closet, and because most people utilize them on a daily basis, having them located in a specific drawer makes them easy to access. Storing lightweight slippers and slipper socks alongside pajamas makes good organizational sense as well.

- Another good option for PJ control is to leave them (and bathrobes, for that matter) on a hook in your bathroom or bedroom, depending on where you change at the beginning and end of your day. It's often less of a hassle than going in and out of drawers.

- Other than undergarments, hosiery, and pajamas, the only other clothing I store in my own dresser are very casual tops and pants. I use one drawer for each category. My system for keeping the drawer I use for casual tops under control is fairly simple. In the winter, I store cotton turtlenecks and long-sleeve T-shirts that I wear year-round in here. Summer cotton tops are stored in a plastic tub under my bed. When I change my wardrobe over for warm weather, the turtlenecks come out of the drawers and get stored in the tub. The T-shirts come out of the tub and are put into my drawers. If it becomes unseason-

| Insider Tip |

PJ Control

Be sure to cut down on the number of PJs taking up valuable drawer space. You really don't need that many pairs, and updating this area of your wardrobe each season can give you a real lift, especially if you are in a "personal-time-casual" rut, as so many women find themselves from time to time.

ably warm or cool, I don't have to venture far to find a T-shirt or turtleneck.

- The "one-tub-storage" system for my casual tops helps me limit the amount of T-shirts coming and going from my wardrobe. When the drawer starts getting full, I know it's time to purge. As I add new tops to this category, I make a point of moving older tops in my top drawer that are not as fresh and store them in the crates in my closet that hold my exercise clothes or I simply get rid of them.

- I often hang some of my casual T-shirts (rather than keeping them in a drawer) on the same hanger with the other casual separates that complete an outfit. I do this for clients as well so they can easily remember combinations. All my dressier T-shirts are hanging in the closet either with an outfit they were specifically bought to go with or in their own area of my closet for mixing and matching.

- The only pants I store in drawers are blue jeans. I hang all my dress shorts (I use skirt hangers for these) and other casual pants in my closet. In the summer, very casual shorts are placed in a crate next to my workout gear. Because denim is a year-round fabric, my jeans never leave my drawers. Once again, the key is to get rid of older styles as you update and add new jeans to your wardrobe.

Intimates: Organizing from the Inside Out

About a year after the birth of my sons, I completely upgraded and reorganized my underwear drawers. With my maternity bras mixed in with day-to-day bras and some sexier undergarments, I was having a serious identity crisis! Here is what I did to get this area of my wardrobe under control:

- First, I decided it was time to have two separate underwear drawers—one for undergarments I wore on a day-to-day basis, the other for lingerie as well as undergarments purchased for specific outfits that I didn't need to access as frequently.

- I then completely removed all my pregnancy and postpartum underwear from this drawer. Because my body was on its way back to somewhat of a normal size and shape, it was psychologically beneficial for me to do this.

- Next, I decided to have only two colors of underwear, black and beige, in my day-to-day drawers and went out and bought a whole new collection of appropriate styles in these two colors to complement my lifestyle and wardrobe. See Chapter Nine for more of my insights on why beige and black are your best color choices for underwear.

- To get my "special occasion" lingerie in better working order, I separated the camisoles and short robes out and hung them on hooks on the inside wall of my closet. I organized what was left in the drawers by color and style. I also put a few scented sachet pillows I had received as gifts in these drawers to give them an extra-special quality.

| Insider Tip |

The Black and Beige of Undergarment Control

Black and beige really are the only two colors needed in most undergarment wardrobes. Limiting the amount of color in your underwear drawers can help keep them under control. It also cuts down on the amount of time you spend in the morning pondering which underwear you should wear.

Hosiery Control

I remember attending a baby shower one winter that motivated me to go home and completely re-organize my sock drawers.

| Insider Tip |

*Getting More
Mileage from Runs*

Keep pantyhose with modest runs to wear under slacks. Cut a slit in their labels so you can easily identify them.

When I arrived at this particular party, the hostess asked me and the group I had arrived at the door with to remove our shoes before entering. The woman behind me started to laugh in a nervous kind of way. She reluctantly removed her shoes and started apologizing about the condition of her socks. The rest of us looked down just in time to see two unmatched socks with numerous holes in them coming out of a stylish pair of ankle boots! Because she was otherwise well dressed and had a tremendous sense of humor about the situation, I revealed my profession and we all had a good laugh.

If you live in a cool climate, you most likely have a love-hate relationship with pantyhose, tights, socks, and knee-highs. Here are some tips for gaining control over this area of the wardrobe that is often neglected:

- Toss all hosiery that is torn beyond repair and/or are missing their mate. Make a list of all the hosiery you need to replace, and make it a priority to stock up, especially if you can find a sale.

- Like the rest of your wardrobe, categorize and separate. If you have the space, devote separate drawers, crates, and/or cubbies for each category of hosiery. Storing socks, hose, tights, and knee-highs together often contributes to hosiery mayhem.

- If your space is limited, consider separating hosiery by color and category and storing each side by side in its own plastic Ziploc bag.

- Chances are your favorite hose, socks, and tights are made with a percentage of Lycra or Spandex. The addition of these modern fabrics makes them more comfortable and durable. Over-the-calf socks with a small percentage of Lycra are my personal favorites.

- When you find a pair of hose you love, save the packaging. When you need to buy a new pair, you'll have all the information you need— brand, size, percentage of Lycra, and color.

- Whether you are at home or on the road, always have a few brand- new pairs of hosiery at your disposal. Few things are more frustrat- ing than getting a run in your stockings when you're getting ready for an important business or social occasion and you don't have a back-up pair.

Organizing Shoes

A client once told me that her wardrobe organizational low point occurred when she looked down at her feet at an important business meeting and noticed she was wearing two different shoes! When I opened her closet, I found dozens of shoes thrown all over the floor. She didn't know what she owned, let alone what matched or was in fashion.

Here are my most popular tips for organizing shoes, boots, and sneakers so you start your day off on the right foot:

- Take a Polaroid or digital snapshot of your shoes and attach the picture to the outside of the shoebox. I have to admit that when I first saw this done by a client, I thought she was a little compulsive. Over the years, I have come to respect this practice, especially for those who have lifestyles that justify extensive shoe collec- tions.

Oftentimes, freshening your shoe collection is the "first step" to a more well-dressed you. Taking the time to retire shoes that are uncomfortable, worn out, or out of style and then organizing the ones you want to keep will do wonders for the or- ganizational state of your closet as well as your self-confidence.

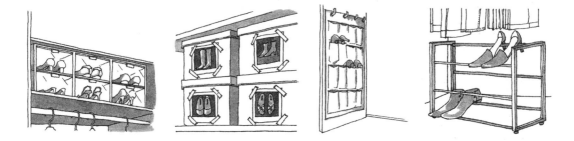

- Invest in clear shoeboxes. This is my personal favorite shoe storage strategy. Not only do I love how my closet looks when I stack two or three of these together, but I also love how easy it is to access my shoes through the pull-front compartment. I get mine from the Hold Everything catalog.

- If you like to store shoes in the bottom of your closet, place a three- or four-level shoe shelf under the short hanging items in your closet so you can better see (and organize) them. Getting them off the floor and hanging them in over-the-door shoe pouches is also a good idea if you have limited space and want to see your shoe options more clearly in the morning.

- Make it a habit to wipe your leathers regularly with a soft cloth. Dust particles can dry out leather and eventually cause cracking. Suede and exotic leather shoes often require different care. Never buy a pair without getting instructions on how to keep them looking nice. I swear by the instant shoe wipe kits, widely available at mall shoe stores for around five dollars.

| Insider Tips |

Stand Tall

Keep your knee-high boots in upstanding condition by purchasing plastic boot shapers specifically designed to support boots. You can also use rolled-up magazines to get the job done.

- My friend Lindsey confided in me that she places clothes dryer sheets in the toe of each shoe in her closet to keep them all smelling fresh and clean, especially in the summer months. I tried it, and it really works!

- If it's the middle of winter and you keep tripping over your beach sandals, purchase a large, clear tub with a cover and throw all your strictly summer shoes inside. Store it somewhere where it is easy to access should a winter vacation to a warm climate present itself. Use the same strategy for sneakers, boots, and other seasonal footwear you use for various sports at different times of the year. Most people we consult with only need one or two pairs of "everyday" sneakers in their main closet.

- If you have limited shoe space in your main closet, consider keeping the shoes you wear each day in a coat closet or other space by your main entrance. If your shoe collection is not extensive, you can probably leave all your shoes together in your main closet.

- Finally, here's a simple but effective tip I learned from a client: "Store all your professional shoes at the office and commit to having one pair of shoes you commute to and from the office in!"

A Notch on Your Belts

I once worked with a woman who, quite literally, had never parted with a single item of clothing she had ever purchased. The most significant lesson I learned from her was how many retailers in the 1970s and 1980s sold dresses with matching belts!

When belts are not properly organized in your closet, these accessories have a way of becoming tangled up with all your clothes and adding to closet disorganization. Because you most likely only wear a few belts with your fashions today, it's fairly easy to bring them under control in your closet.

Here are a few simple belt storage tips:

- First, go through your closets and drawers and remove and review all the belts you come across. Get rid of those that go with items that

have long been retired. Do the same with belts that don't fit or you simply don't like.

- If you come across a belt that you only wear with a specific outfit, consider hanging it on the hook of the hanger you are using to hang the garment it matches. Don't leave belts in the belt loops of pants, skirts, and dresses. The weight of the belt in the loops of hanging items can cause unnecessary wear and tear on your garments. The belt can also become distorted and permanently disfigured.

- I'm a big fan of belt rings (i.e., circular hanger with an opening for easy access and storage of belts) and have two in my closet. One belt ring is for belts I wear frequently, and the other is for belts I don't regularly wear but that I'm not ready to part with. Because belt widths and shapes do come in and out of style from season to season, I tend to hold on to a variety of good-quality belts that might help me update an outfit in the future.

 - Hanging belts in your closet alongside your clothes helps you see them better and can help you incorporate them into an outfit. I hang my belt rings to the far left side of my closet so I always know where to look when I'm in a rush and need the finishing detail a belt can often provide. Hooks on closet doors or elsewhere inside and outside the closet door work well as belt storage systems, too.

- If you have a custom closet company design your closets, be sure to have them incorporate belt hooks into the design. Many such belt systems are on rollers and can easily be pulled out for viewing and then pushed back into the design of the closet when you are through.

Finally, find a special home for belts that can't be hung in the closet. For instance, I have a few belts that don't have a traditional belt buckle and,

therefore, can't be hung on a belt ring or other hanging belt organizer in my closet. I have neatly rolled them up, secured them with an elastic band, and stored them in a compartment in my jewelry cabinet. Shoeboxes and baskets are other handy places to store specialty belts.

Get a *Real* Handle on Your Totes!

If the thought of organizing your closets seems too overwhelming, why not start gaining control over your wardrobe in a smaller space, say your pocket book and/or briefcase? By tackling more manageable projects first, you can actually get motivated to take on the bigger projects later.

The first step in gaining control over your totes is to figure out what you need to carry around on a daily basis. Eliminate those items you don't need, and consolidate any duplicates. Your shoulder and back will thank you for it.

Next, choose bags that coordinate well with each other as well as with your personal style and your professional image. For instance, a soft leather briefcase or roomy tote will hold larger items, like important papers, a daily planner, an umbrella, perhaps a brush, and your cosmetics case. Select a smaller purse or wallet (with or without an attached shoulder strap) to carry essentials like cash and credit cards. Keep this purse inside the bigger tote, where you can grab it for quick errands.

Remember, like shoes and belts, it's important to take good care of your pocketbooks and totes so they don't detract from your overall image. Someone who walks into a meeting toting a scuffed, bulging briefcase, for instance, is going to appear harried and disorganized, now matter how well dressed.

| Insider Tip |

Divide and Conquer

Are you always digging for loose change from the bottom of your pocketbook? Do you have trouble locating your lipstick? Do you frequently switch handbags? If you answered yes to two or more of these questions, consider buying small, zippered pouches that will contain these small items, making it a snap to locate them or move them from purse to purse.

Many of my clients are able to tackle their closets with renewed vigor and energy once they've gotten these smaller spaces under control.

Out-of-Season Storage

Now that you've organized the clothes that suit your current lifestyle, figure, and seasonal climate, it's time to organize the items you've placed in your "out-of-season" pile. In my home I have a closet in a spare bedroom devoted to off-season storage. Remember, it's critical to have only clothes that are seasonally appropriate in your main closet if you want to work the *Dressing Well* system most efficiently.

Here are some other tips for storing the out-of-season items:

- Choose a date each spring to put away your winter clothes and bring out your warm-weather wardrobe. Do the same in reverse in the fall.

- When switching your wardrobe, inventory your clothes. Make notes on what you want to replace or update. You can sometimes find these items on sale before all the new seasonal merchandise hits the stores.

- Consider storing out-of-season clothing at your dry cleaner. Most dry cleaners will do this free of charge for the cost of dry cleaning. It's a great way to free up some closet space.

- If you choose to store out-of-season clothes at home, put them in a cedar closet, hanging garment bags, storage chests, or in clear bins that fit under a bed or in other out-of-the-way places.

- Storing winter clothes in the attic is not the best idea. Attics tend to get too warm in the summer and some breed insects. Furthermore, your clothes can't breathe properly in such heat. I have actually seen clothing get imprinted with dry-cleaning logos that melt off the bags and onto the clothes. Basements, on the other hand, can be a

| Behind Closed Doors |
Working the System

I don't know many people who would elect to spend a week of summer vacation in their closets, but I'm sure glad to have met one.

When we met at her home nearly a decade ago, this particular client had clothes in every corner of her home. With a wonderful sense of humor about herself and her shopping habits, she led me through an enjoyable (and I have to admit hilarious) quarter-century of her life using her clothes as a tour guide.

We spent the better half of the week sorting, organizing, and playing dress-up in her closet. At the end of our work together, all her clothing storage areas were functioning efficiently, she had more than twenty bags ready to go to charity, and her wardrobe "keepers" were beautifully coordinated. She reported back that she got dressed for work for the rest of the summer without ever repeating an outfit or visiting a store!

I still visit her closet from time to time and am amazed at how well she has adopted and maintained the *Dressing Well* system over the years.

Here she shares some of the *Dressing Well* strategies that, she says, "resonate in my head every time I go into my closet":

- Put whole outfits on one hanger. I hang everything together—top, bottom, jacket, scarves, and even necklaces. Dressing is a snap!

- One doesn't need a lot of shoes. Have your basic black and a few other pairs for specific outfits. Keep them in good shape, and don't be afraid to wear them out. You won't feel guilty about discarding them after a season or two when they are no longer fashionable.

- Buy a clothing rack and pull everything out of the closet so you can really see your clothes. If you haven't worn a basic item in more than a year, get rid of it. I have never missed a thing.

- Hang your holiday and party items separately— this keeps them out of the way and you also know exactly where to find them.

good storage area as long as you don't have a flooding problem or they aren't too damp and/or moldy.

- Make sure the clothes you are storing have been laundered or dry cleaned before you store them. Even if clothes appear clean, invisible stains can cause permanent spots and attract pests.

- Cedar products are handy moth repellents because they last a life-time and don't produce the odor of old-fashioned mothballs. If your cedar loses its scent, simply sand it for quick revival.

- If you have a lot of shoes for special occasions and seasonal outfits, switching them to an out-of-season storage area is a good rule of thumb.

Make Your Closet Your Masterpiece

Creating a plan to make your closets cheerful, warm, and bright will allow you not only to see your clothes more clearly, but also help you feel good each morning when you open the closet door. Here are some of my favorite closet decorating ideas for you to consider.

Decorating Your Closet

Did you ever notice that otherwise common spaces are often transformed into cheerful and highly welcoming places during the holidays just by hanging festive lights, adding bright colors, and placing special decorations and fixtures in key areas?

Why not visit your closets with the goal of creating a plan to make them more welcoming and cheerful all year long? By decorating your closets with the same creativity you might decorate a tree or front entrance during the holidays, you can give yourself a present every time you open the closet door.

Whether you have large walk-ins or small reach-ins, it's amazing how

▌▌▌▌▌▌▌▌▌▌▌▌▌▌▌▌▌▌▌▌▌▌▌▌▌▌▌▌▌▌

| Inside Tip |

Pole Power

Many older homes have wooden poles to hang clothes on in the closet. After time, the weight of clothes on these poles causes them to bend and sometimes break. You can visit a hardware store with the exact measurements of your wooden pole, and they can cut you a metal pole that will look more modern while holding your clothes more securely.

▌▌▌▌▌▌▌▌▌▌▌▌▌▌▌▌▌▌▌▌▌▌▌▌▌▌▌▌▌▌

you can give your closets (and your clothes!) a dramatic lift just by adding a fresh coat of paint to the closet walls. When selecting a paint color for your closets, don't limit yourself just to white. Visit a local paint store, and consider all your options.

If you do choose to stick with white closet walls, why not stencil or paint a mural on them to create visual interest? Obvious design choices include fashion accessories such as shoes, belts, and bags. Wallpaper books can give you some excellent options as well.

Not feeling creative in this area? Hire a professional painter or interior decorator to help with the project.

Light It Up

The lighting in your closet also has a significant impact on how you feel when you open the closet door and how well you are able to see your clothing choices. Many people suffer needlessly with closets that are poorly lit.

Battery-operated lights are available at many hardware stores and are easy to install in closets that are not equipped with an electrical outlet. It might be worth consulting with an electrician to have the problem solved once and for all. When you can see your clothes effectively, you will most likely pair them together with more confidence and style.

If you still have trouble seeing colors clearly in your closet or bedroom, try taking your clothes outside into the sunlight or near a large window. Natural light can do wonders for your vision.

Accessorize the Accessories

By using accessories as decorations, you give closets even more character and personality. Here are some ideas:

- Antique and special occasion handbags become pieces of art when hung on a pegboard or mug rack inside your closet or on the back of your closet door. Funky necklaces and belts that have outlived their usefulness around your neck and torso might bring you new joy when they're hung on hooks strategically placed at eye level in or around your closet.

- Decorative hatboxes, pretty baskets, and colorful crates are not only great places to store sentimental favorites, nylons, gloves, hats, bags, scarves, and other items that often take over your closet floor, but they also can easily add color and creativity to your closet décor. In my closet, for instance, I have my wedding accessories stored in one of these pretty boxes.

- Don't want to keep your favorite hats hidden in hatboxes? One of my clients displays her collection of hats on flower bud vases of various heights. Her closet and dressing area look like a beautiful millinery shop.

- Small chests of drawers placed under short hanging items such as shirts and jackets make interesting visual additions to your closet. You might have enough room on top of these bureaus to place picture frames, scented sachets, and/or wardrobe maintenance items such as sewing kits, lint brushes, and shoe polish.

- Fashion-inspired pulls on the drawers also add a whimsical touch.

- Consider buying a faux or real antique compartmentalized jewelry box or cabinet for both fine and costume jewelry. You'll have no more tangled necklace chains, and it will be a joy to open it each time you use it. In addition to jewelry compartments, the one I use has two drawers on the bottom that are ideal for storing clutch evening bags, shawls, and other odd-shape accessories that need a home.

- Antique china closets also offer a unique wardrobe storage solution. My friend Christine bought an attractive 1960s china closet with deep shelves to store her shoes. It works with the interior design of her home and prevents dust accumulation.

- If you have some sentimental scarves that you aren't wearing but would like to display, consider having them professionally framed to add to your décor. Another great idea for scarves that might have been collected on a special trip or passed down from a favorite relative is to display them under a piece of glass that has been custom measured to fit a bureau, night table, or other unique surface in your "boudoir."

Feng Shui Your Closet

The ancient art of feng shui—which is pronounced *fung shway* and means "wind/water"—implies that the proper placement of every object in your living space can increase positive energy flow, bringing health, wealth, and prosperity to those who practice its principles.

Although at first glance, feng shui might sound like pure superstition, you have to admit that when you eliminate clutter in any area of your life, you just feel better. That goes for your wardrobe as well. Over the years, we have worked with hundreds of people who have benefited spiritually, emotionally, and, yes, financially from having an organized approach to dress.

In preparing this book, I asked a certified feng shui practitioner, Evana Maggiore, to share her insights about how you can begin to reap the benefits of feng shui with your wardrobe. Here are three of the tips Evana shared with me:

- The old cliché "out of sight, out of mind" takes on new meaning when viewed from a feng shui perspective. For instance, when you throw excess clutter from your closet under your bed, instead of getting rid of it once and for all, the stagnant energy of these items can negatively affect the quality of your sleep.

- Likewise, clutter that accumulates on top of closets can manifest as "problems hanging over your head" that can potentially be the root of chronic headaches.

- Even though something might be out of your day-to-day vision, it still can have an effect on your subconscious until you have completely released ownership of it. It's amazing how liberating it is to just let go!

Another concept that relates well to Evana's feng shui insights is what several of my clients refer to as "closet karma." These clients hold on to the suits they landed their first job in or the dresses they wore to land their husband. They hang these items in the back of their closet and swear they bring them good luck. Believe me, I don't tell these women I sold my wedding dress to start my business—I guess good karma can work both in and out of the closet!

Mirror, Mirror on the Wall

I remember well the day a reporter from *Marie Claire* magazine called on a tight deadline. She was contacting fashion experts from across the country

for a top ten list of secrets for organizing your closets and making the most of your clothes. There was no guarantee that we would make her final list, but she asked me to e-mail my best tips for consideration.

When I was contacted by the fact-checking department of

The first step in developing a strong personal and/or professional presence is to train your eye to recognize the style elements most flattering to your particular figure and lifestyle. A full-length mirror hung in or near your closet is a great strategy.

Marie Claire a few months later, I was thrilled to be informed that one of my tips had made the list. The tip they selected—"Hang a full-length mirror inside your closet door. You'll learn to understand your wardrobe and really see what works best"—continues to be one of my favorite tips I share with private clients and participants who attend public and corporate seminars.

If you already have a full-length mirror, make a commitment to use it to help you part with clothes that don't make you feel or look your personal best. It's also a great tool for getting out the door in a hurry without overlooking elements in your outfits that should be attended to before showing up for work, an important meeting, or a social occasion.

If you don't have a full-length mirror, make it a priority to pick one up. You can buy one at a store or have a glass company come to your house, measure the space where you want to hang a mirror, then come back and install one to your exact measurements. Neither of these two options has to be an expensive proposition.

4

Organizing Through the Seasons

The key to an organized wardrobe is ongoing maintenance. Many of my firm's private clients use our services twice a year to help transition their closets for the warmer and colder months. This chapter shares my strategies for tweaking your own closets a few times a year to make sure you stay organized with the influx of items that inevitably arrive each season.

Winter: Cold-Weather Accessories

My mantra of "a place for everything, and everything in its place" took on new meaning when one of my sons, who was eighteen months old at the time, picked up a glove from the kitchen floor, walked over to a set of drawers in our kitchen where we store gloves, mittens, and hats during the winter months, and dropped it in. He started clapping and cheering for himself like he had conquered an amazing feat!

Whether you have children or not, developing systems in your home so you can easily locate items when you need them is a great time management tool. When everyone in the family knows where to find and store necessities,

life gets a little easier. Like my son has discovered, it also makes you feel good when things are put away in an orderly fashion.

During the winter months, we all have extra outerwear needs that can take up valuable storage space if we let them get out of control. If you find yourself in desperate need of a mid-winter organizational fix, getting the area of your home where you store these items under control is a great first step.

- To start, gather all your outerwear in one place and take a critical look at your storage space. Sort everything into piles, getting rid of items that are beyond repair, don't fit, are missing a mate, or that you simply don't like.

- Purchase organizational products that can help keep things neat and accessible. I'm a big fan of clear storage bins of various sizes that can be stacked one on top of the other. Another great idea for storing sunglasses, gloves, mittens, and even keys is to hang a multi-pocket organizer on the back of a door.

- Whenever possible, install hooks on the inside of closet doors and other convenient places near your entryways to help control the closet overflow in the winter months.

- Boot trays are an inexpensive way to create a tidy space for boots and shoes during the snowy and rainy months. You can find high-quality mats ideal for this type of storage in the automotive department of department stores for less than ten dollars.

Spring: Transitioning Your Closets
from Winter to Spring

Early spring is a great time to review and make adjustments to your outer-wear collection. Here are some simple steps to get you started:

- Visit your coat closet first and start packing your heaviest winter coats away. Be sure you check the pockets and, if necessary, remove pins from any lapels before putting them away. I once had a client who reclaimed more than $100 by cleaning out her coat pockets!

- Consider storing your heaviest coats at the dry cleaner or moving them to the cedar closet now to free up room and get you in the mood for spring, or consider another place in your home where they will be protected.

- If you are not quite ready to part with all your wool coats this early, consider adding a lightweight wool scarf in a vibrant color to brighten your look.

- Pile all the shoes you wear in both winter and spring that have been soiled by the wear and tear of winter into a handy tote, and make it a point to drop it off at the cobbler. In a month or two, when you put on your spring fashions, you'll be glad you took the time to clean up your shoes. You don't want salt and snow stains all over your shoes in April and May!

- Review your spring coat collection. Trench coats are great when transitioning from winter to spring. Trench coats with a lining can be particularly handy to help you chase away any remaining chill in the days ahead. Many of my clients have long parted with some of their heavy wool coats, preferring to wear a lined trench on most winter as well as spring days.

- Silk and rayon scarves generally look the best with trench coats. Use the colors in these scarves strategically to connect your coat to the outfit you are wearing underneath.

Summer: Summer Strategies

Without a well-thought-out storage plan, summer shorts, T-shirts, shoes, bathing suits, and accessories can clutter your closet in no time. With pen and paper in hand at the beginning of every summer (or with a fashion notebook if you have adopted that idea), pay a visit to your closet and make a list of the following items you might like to add to get your closet properly organized for summer:

| Insider Tip |

The Summer "Getaway Bag"

For maximum efficiency, store all your beach gear in your getaway bag—bathing suit, towel, sunglasses, various cover-ups, flip-flops, beach hat, and sunning supplies—so you're out the door in no time when you want to head to the beach or a pool. In between outings and trips, leave this bag in the laundry room. Wash frequently worn items, and put them back in the bag so they are always easy to locate.

- **Expandable wooden mug racks:** In addition to using these handy items to hang your jewelry and accessories, consider purchasing them to hang bathing suits and cover-ups. The sturdy wooden pegs are ideal for summer items, especially hats and caps.

- **Plastic crates:** These are the perfect container for beach items, gardening gear, and athletic shoes that often end up in a mess on the closet floor. Also consider crates another way to organize workout gear such as T-shirts, bike shorts, and leotards.

- **Hanger recycling system:** You're apt to visit your dry cleaner in the summer months because summer linens and silks often need more pampering in hot weather. If you haven't developed a hanger-recycling system yet, this is the season to do it.

Fall: Closet Check-Up for Cooler Weather

If you live in an area with a seasonal temperature change, fall is the time to prepare your wardrobe for the even cooler weather that is just around the corner.

Here are some helpful strategies for transitioning your closet for an organized autumn:

- Take some time early in the season to pack summer away and make room for sweaters, long pants, boots, fall suits, and blazers. Make sure the items you do decide to store have been laundered or dry cleaned. Remember, even if clothes appear clean, invisible stains (especially on light-colored linen and cotton) can turn into permanent spots by the time you take them out next summer.

- As you begin to bring out your sweaters for the cooler weather, avoid tumbling sweaters by only stacking them two or three high on a shelf. Consider using shelf dividers in between the stacks to keep them extra neat.

- Opt to store knits folded on a closet shelf or in a drawer rather than on hangers. You can hang flat, slim knits both with and without shoulder pads as long as you use the proper hangers (i.e., department store–neck styles) as opposed to wire dry-cleaning ones. Generally, the weight of more bulky knits tends to make them stretch when hung.

- If you store your winter coats at the dry cleaner during the warmer months, now is the time to call and schedule a time to

| Insider Tip |

Pant Hangers for Sweaters

Remember the pant hangers from the previous chapter? You can also easily hang medium- to lightweight sweaters over these in your closet without the risk of stretching them out. Knit dresses can also be hung on these hangers as well as plastic "tubular" hangers.

pick them up. It typically takes a week or two to get them out of storage once you have placed the call. When they are returned to you, give all your items a once over and make necessary repairs to such things as broken buttons and misshaped shoulder pads.

- Gather all your boots and other fall/winter footwear, and give them a good once over. A visit to the cobbler might be in order to get last year's cool-weather footwear in better shape. When you buy new footwear, don't wait for bad weather to waterproof it—it might be too late. Applying mink oil or silicone sprays early in the season will save you time and money later.

Evening and Holiday Attire

We've all heard the golden rule, "if you haven't worn a piece of clothing in a year, it's time for it to go." Nine times out of ten, this holds true.

Yet the one category of clothing it makes sense to be more flexible with is holiday and other special occasion attire. Because these clothes are not worn as often, they tend to have a longer closet life and you don't get bored with them as quickly.

Invest in quality pieces, and you'll be sure to get years of holiday, wedding, and other special occasion wear from them. Silks, chiffons, beaded, and many vintage pieces can be worn in many seasons and can be mixed and matched for optimum use.

Here are some great tips for storing and making the best use of all your special occasion clothes so they (and you!) will look great—one, three, and maybe even five to ten years from now:

- If you have the room, devote a separate closet for your special occasion clothes or hang them in a zippered garment bag in the back of

your main closet. Not only will they be out of your way, making day-to-day dressing easier, but also they will be easier to locate and review when an invitation comes your way.

- Consider storing dressy shoes, evening bags, fancy hose, evening shawls, holiday scarves, and special jewelry together so they, too, are protected and easy to locate when you need them. We recommend using stackable storage chests in plastic, cardboard, or cedar for maximum protection and organization.

- Make it a pre-holiday ritual to review and try on all your special occasion clothing, making a note of what you wore to last year's parties and what pieces, if any, you need to add, replace, or alter. Adding festive buttons to a favorite suit or sweater, for instance, may be all it takes to get the perfect holiday flair.

> | Behind Closed Doors |
>
> ## *Letting Go*
>
> Are you afraid to get rid of any clothes for fear of having nothing left to wear? Many of my private clients have faced this same fear. As I stated in the beginning of this chapter, letting go of clothing that no longer serves you is the essential first step to the *Dressing Well* system.

Here are a few testimonials I have collected over the years that illustrate that this system really does work. I hope these quotes will further confirm the value of letting go:

"I'm embarrassed to say it, but when you removed clothes from my wardrobe I hid them in bags in my basement just in case I changed my mind and wanted them back! I didn't feel right giving up so many pieces. But you were right. By streamlining my closet and focusing on the clothes that make me look great, I never missed these other pieces. After a few months, I went back down to the basement and got rid of all those bags, and I've never looked back."

—April, retiree

"For the first time in my life, I can wake up, go to my closet, and know that I have so many options to choose from when deciding what to wear every day. It's not because I have so many clothes, but because with this system, the clothes I do have are perfectly interchangeable."

—Laura, entrepreneur

"As a saver and a bargain buyer, I have found myself with crowded closets and dressers, yet always searching for something to wear. By eliminating those 'Well, maybe I'll wear these someday' items, I've been able to give new life to the clothes I enjoyed by creating new combinations. Getting ready for work in the morning used to be a dreaded event as I stood in front of my closet waiting for something to jump out at me. I am now able to spot a great outfit in a minute!"

—Lisa, working mother

Last Word: Coming Out of the Closet

If you have adopted some of the steps outlined in this chapter, your newly organized closet should also be starting to resemble a department store (or tony boutique!) right about now. Remember to use the Personal Action Plan in Appendix A and/or a journal to write down some of the closet organization ideas you plan on implementing.

The goal of the wardrobe management system I have been outlining for you at the beginning of this part is to continuously focus on the 80 percent of your wardrobe you don't wear or you are not satisfied with when you do wear it, while organizing the definite "keepers" (the 20 percent) in a way that you can easily see and access everything on a day-to-day basis.

You still have a little work to do before you know exactly how many wearable clothes you actually have, but you are off to a great start. As you continue reading the fashion and shopping parts of this book and implementing more of the wardrobe management and image enhancement

strategies they each contain, the "80/20" paradigm I described at the beginning of this book will start to shift in a more positive direction—I promise!

Don't panic yet about getting rid of too many clothes at once. Client after client who goes through this process with us reports that they are thrilled to have fewer clothes, yet many more outfits, than before they started this process.

In fact, many of the same women who originally called my office in a panic about "having nothing to wear" can often get dressed for weeks without repeating an outfit or going to the store to add a thing. By eliminating the "maybe someday" pieces taking up valuable real estate in their closet, they are able to see new clothing combinations they simply couldn't see when their closet was cluttered and not organized properly.

I refer to this magical process as "shopping in your own closet," and you, too, can do it when your closets resemble stores with separate departments for suits, dresses, tops, pants, coats, out-of-season items, and accessories. Of course, being the proprietor of your new "boutique" will take some more training. The next part of this book, *Fashion Finesse,* will help you develop the innate fashion skills you were born with while teaching you how to shop in your own closet before you ever spend another dime on clothes. Read on!

Fashion Finesse

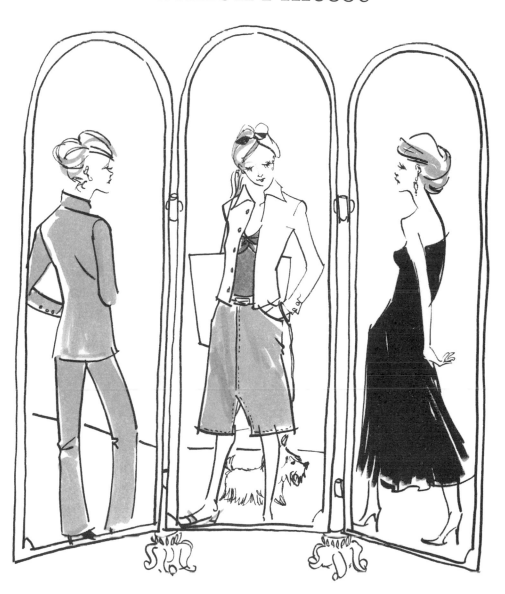

KNOWING HOW TO DRESS APPROPRIATELY THESE DAYS TAKES THOUGHT. YOUR WARDROBE SHOULD REFLECT YOUR LIFESTYLE, YOUR BODY TYPE, AND, IF YOU WORK OUTSIDE THE HOME, THE rules of your profession.

But the rewards of learning how to dress well are many and varied. When you wear a stylish, well-tailored outfit that is tastefully accessorized and in a flattering color, you project confidence and energy.

This section of the book is all about developing your personal style. It opens with a personal story about the true power of dressing well. Next, you'll learn to train your eye to recognize the styles that enhance your natural beauty. In the following chapter, you'll take your newfound knowledge on the most exciting and adventurous shopping trip you'll ever experience. Where? Your own closet, of course!

Once we are back in the closet (and I have outlined for you exactly how to shop there), I will show you how to build and update every category of clothing in your wardrobe. From suits to dresses, to jeans and swimsuits, we'll get you covered. You will learn how to stock your

The adage "when you look good, you feel good" never goes out of style.

wardrobe with the staples, add color to your wardrobe strategically, and dress up and down base pieces in your closet with the proper accessories to complement varied dressing situations.

By the end of this section, you will clearly see the gaps in your wardrobe and have a plan for filling them with the most efficient use of your time, resources, and energy. Before you spend another dime on clothing, read on.

The True Power of Dressing Well

As a wardrobe consultant, my antennae are always up for stories that underscore my philosophy of dressing well. When I have a firsthand experience, the lesson really sticks. Such was the case one Saturday morning a few years ago.

I jumped out of bed, dashed into the shower, and threw on my sweats before heading out the door to get to a massage appointment I had been anticipating all week. I carried all my makeup, hair products, and the outfit I would be wearing after the appointment in a tote and garment bag, respectively.

I entered the upscale salon where the appointment was scheduled and sat in the waiting room for about fifteen minutes before being called in for my appointment. Other than a brief "check-in" conversation with the receptionist, no one seemed to notice I was there. It was actually nice to put my nose in the newspaper and have a quiet respite—quite different than my typical Saturday morning at home with my twins who were toddlers at the time.

Once I had my massage, I then used the salon's changing area to get dressed, do my makeup and hair, and get ready for the rest of my day, which

included stopping by a client's home for a consultation and then having lunch with a friend. I took my time getting ready and was pleased with how relaxed and pulled together I felt upon getting ready to leave the salon. Even though I knew I would be overdressed for lunch with my friend, I was dressed appropriately for my client meeting and I knew my friend would understand that I had been coming from a work appointment.

When I came back into the reception area to settle my account, several women (two who had been there when I entered) instantly noticed my presence. I was wearing a black pantsuit, red turtleneck sweater, stiletto ankle boots, and a three-quarter-length red and black mohair coat that always gets noticed. I had a pretty black and red flower pin on the lapel of the coat and carried a black leather tote under my arm. With makeup and hair done, I'm sure I looked like a completely different person than I did when I arrived.

One woman told me how nice I looked, and the other asked where I got the jacket. She started a conversation with me about her whole life and even gave me an unsolicited referral to her chiropractor—"a must," I was told— if I wanted to take my massage therapy to another level! She added that I could tell the chiropractor that she sent me if I had trouble getting an appointment. It was pretty comical. I had never met this woman before, but it was like I was now her new best friend.

Even the receptionist, who had barely given me the time of day an hour earlier, was falling all over herself to be sure that my "salon experience" had met my expectations. She offered me a bottle of water to take on the road, which I was quite grateful to receive. I wasn't even offered a cup of coffee when I was in my sweats!

I cracked up all the way out of the parking lot. I had gone from invisible to the most popular girl in the place just by changing my clothes. When I met my friend, who was dressed in jeans, I told her the story. It was interesting to both of us that the hostess at the restaurant seemed to ignore her while directing all her questions to me. The hostess wasn't rude by any means, it was just clear that a suit got more respect than jeans in this particular establishment.

None of what I am sharing is meant to make you get dressed in anything other than jeans on a Saturday (or any other day, for that matter) if that is not your preference. My point is to illustrate the power of revving up your image in certain situations.

The next several chapters will guide you in the process of complete ownership of your personal style.

Fashion 101: Five Steps to Owning Your Own Style

Step One: Train Your Eye

Whether you are dressing for work, play, or a night out on the town, **the interplay of line, proportion, and balance** is the key to dressing well. Young or old, tall or short, training your eye to recognize how these three style elements impact your overall image is the first step toward developing a strong sense of personal style.

To help clients understand the importance of these elements, I ask them to think of their eyes as a camera that automatically seeks out a break in line, proportion, and/or balance. When you are interacting with someone, regardless of their degree of fashion savvy, their eyes are automatically drawn to those places in your outfit where there is an obvious break in the overall flow. Often and without knowing why, women feel less than 100 percent confident in their clothes because they are needlessly attracting attention to areas of their body they are self-conscious about.

We'll begin our fashion lesson with my definitions of line, proportion, and balance, as well as a few examples of how to make these essential elements work for you.

Line: To understand the importance of line in dressing, consider how your eye naturally seeks out and follows lines. The goal is to use lines strategically in your outfits to complement both your appearance and communication style. For example, an outfit that presents a vertical line tends to be more slimming and naturally draws the eye up to your face—a very handy strategy when you want people to instantly focus on what you are saying instead of what you are wearing. You can easily incorporate this effect into your wardrobe by dressing monochromatically (all one color from shoulder to hem) or by selecting clothing with vertical details such as pinstripes, a long row of buttons up the center of the outfit, or inherently vertical elements like corduroy or ribbed knits. Want to draw the eye to a pair of well-toned legs? Be sure the hem of your skirt hits the most flattering part of your legs. No matter where your hem falls, wearing a skirt that is tapered (i.e., following the natural line of the leg) can make your bottom half look slimmer as well.

Proportion: Proportion is how everything fits. Whether you are a tiny size 2 or a very tall size 24, there is no substitute for a good fit. If you are wearing a suit and the length of the jacket is too long for your height, your overall appearance will be out of proportion. You might look top-heavy without even realizing it. If you are very tall and wearing pants that are too short, you will look out of proportion for your height. Sleeve and hem lengths as well as pocket, zipper, and collar sizes and shoulder pad placement on an outfit need to be scrutinized and, if necessary (or even possible), properly adjusted before you can be confident they are in proportion (and, therefore, flattering) to your figure. My "Sizing Yourself Up" tips, which are outlined next in this chapter, will give you some more ideas about the importance of proportion in building a wardrobe.

Balance: Balance is how every part of an outfit fits together. It's the trickiest of the three style elements to master. The best way to get a handle on balance is to think of your wardrobe as a puzzle. Be aware of how fabrics, styles

of clothes, and the weight of shoes and accessories work with one another as you piece together your outfits. For instance, if you are wearing a heavy turtleneck sweater with a wool skirt and tights, a boot or a suede loafer will connect to the outfit and balance it better than if you wear nylons and patent leather pumps. If your pants have a heavy cuff, a jacket with a flap-over pocket might help balance the weight of the cuff. If you decide to take advantage of a casual dress policy at your office, wearing a pair of khaki trousers with a loafer and polo shirt will look more balanced than wearing the same pants with a dress pump. When all the elements of your outfit are well balanced, the outfit is more flattering.

Step Two: Size Yourself Up

With a basic understanding of line, proportion, and balance, you're ready for the next step toward owning your personal style: figuring out your size. Proper fit is the single most important factor in wearing your clothes well.

Fortunately, we live in a time when clothing manufacturers—having finally recognized that not all women are built to the same specifications—produce different cuts for the range of body types. To take advantage of this breakthrough in women's sizing, however, you need to match your body proportions to a size category.

Women's clothing is sold in petite, missy, tall, and plus-size categories. Plus-size fashions are also commonly referred to as women's sizes. Below are some basic rules of thumb for each category. This information will help you identify the labels on clothing that are most suitable for you.

By strategically incorporating line, proportion, and balance into your outfits, you will be wearing your clothes instead of having your clothes wear you.

Petite: A petite is any woman 5'4" or under, *regardless of body shape or weight.* Height isn't the only mea-

surement that separates the petite woman from her taller counterpart. Petites tend to have narrower shoulders, shorter arms and legs, and less distance between their neck and waist. Petite fashion reflects these differences with shorter sleeves, higher armholes, a higher rise in the pants, more narrow collars and lapels, and smaller pockets and buttons. You can be a size 2 petite or plus-size 22 petite.

Missy: Missy sizing typically starts at a size 2 (although more and more store brands list size 0 as their start point) and goes up to a size 16. A missy-size woman is 5'4" and taller and has longer limbs, wider shoulders, and a longer torso than her petite counterpart.

Tall: Many women who are 5'8" and taller need to shop at stores that cater to the taller woman. Look for labels with a "T" next to the numerical size in the missy department if you need pants and jackets with extra-long length. If you have a hard time finding clothing for your particular sizing requirements, select clothing in the missy department that has generous sleeve and pant hems that can be let down to complement your particular needs.

Plus size: A plus-size woman wears a size 14 or above and can be any height. According to the book *Plus Style* by Susan Nanfeldt, at least 35 million women in the United States wear a size 14 or over. She suspects that there are as many, if not more, size 18s as size 8s in the world. Based on the size ranging of my private clients, I agree. A plus-size woman can be very short or very tall. The fashion industry is waking up to the fact that this demographic represents a significant number of American women and is providing more fashion-forward items that fit and flatter the plus-size figure. If you border between a missy and a plus-size fit, look for a "W" next to the numerical size. For instance, if a regular 14 is too snug and a regular 16 is too big, a 14W could provide the best fit.

It's not unusual for a woman's figure to be a mixture of sizes. Don't be afraid to wear an outfit that combines petite with missy and plus-size fash-

| Insider Tip |

When in Doubt, Try It Out

Still not sure of your size? On a slow shopping day, visit a store that has separate departments for petite, missy, and plus-size customers. Ask a salesperson to pull the same jacket from two different departments for you to try on. You can also make an appointment with the store's personal shopper if it has one.

With the sales associate's assistance (and others who happen to be in the dressing room!), determine which jacket flatters your figure best. I have done this exercise over and over with private clients with excellent results. Although not foolproof (as I stated, different designers cut fabrics quite differently even though they all use the same numerical sizing), it can help open your eyes. Two nationally known brands we typically use in this exercise are Jones New York and Ralph Lauren. They tend to be cut well and have generous seams for altering.

ions to perfect your fit. I don't know a woman alive whose wardrobe doesn't contain several different sizes—all of which fit perfectly at the same time! Designers and manufacturers cut and size clothes differently, so be aware of the range of sizes that fit you best. Become loyal to the designers and brands of clothes that consistently fit you well, and head for them first when you need to add something to your wardrobe.

Step Three: Know Your Seams

Somewhere in the last half-century or so, Americans fell out of the habit of altering their clothes for a good fit. In a cost-conscious society, what you see is often what you wear. The problem with this, of course, is that sometimes what you wear should see a tailor.

Unless you opt to have your clothing custom designed (a wonderful luxury that is simply out of reach financially for most women), you should expect that some of the items in your wardrobe need to be altered. If you do want to have some clothing custom-made, see Part Three of this book for some tips on utilizing custom clothiers.

If you don't sew for yourself, develop a relationship with a skilled seamstress or tailor. Interacting with someone who knows garments inside and out (literally) will provide a priceless education and further your fashion savvy.

With the range of quality ready-to-wear clothing available today at var-

Perfectly Petite

I once worked with a client who ran her own company and was just starting to be aggressively pursued to serve on boards in her male-dominated industry. She confided in me that although she had the credentials and the desire to increase her visibility, she was less than confident with her appearance and often felt that she wasn't as powerful as she could be when delivering her input at these types of meetings.

When she told me she was wearing a regular size 12 in suits and dresses, I immediately did a double take. Barely 5'2", she was definitely more suited for petite clothing. Being quite slim through her mid-section and hips with a generous bust line for her size, I suspected that she was actually a 12 petite on top and a 10 petite on the bottom.

When we visited her closet, the first thing I did was have her slip into a black turtleneck and pair of black pants and try on all her suit jackets for me. A black, flat knit top and black bottoms serve as a wonderful backdrop when you want to clearly see how jackets fit.

Sure enough, the shoulder pads were too big, the sleeves and the lengths of the jackets were too long, and the overall silhouette was unflattering to her petite frame. She was literally drowning in her clothes, and when she wore these oversize suits to meetings, her message was going down with the ship.

Because the skirts that came with her suits were too big, she was rolling them at the waist. She felt that she was saving time and money by not having them properly fitted at the waist and shortened. She was actually creating unnecessary bulk at her waist—an otherwise very slim and flattering part of her body. The lack of professional tailoring of her suits also made her appear disheveled and, therefore, harried. She did need some extra room in the jacket to accommodate her bust line, but the jackets she was wearing day in and day out were so big in other areas that she looked bigger all over.

When we got to the store and determined her correct size (yes, she was a 12 petite on top and a 10 petite on the bottom), shopping was a breeze. She lit up like a Christmas tree when suit after suit fit her nicely with minimum alterations.

Although we bought a lot of suiting that was sold as separates to get the best fit, she was able to buy some skirted suits that were sold as an outfit by making sure the skirts didn't have pockets and could be taken in at the waist easily and, therefore, inexpensively. With her full bust line, we stayed away from jackets with breast pockets and looked for clean lines that would keep her looking uncluttered and polished.

She reported back to me the week after our outing with the zeal of a convert! She was speaking out more confidently in board meetings, and she noticed that her input was becoming more actively sought by others.

She was particularly proud of the number of compliments she received on her recent weight loss, even though she hadn't dropped a pound!

ious price points, buying off the rack and then having items adjusted by a tailor is often the best strategy. For instance, I often buy clothing off the rack that fits me well and then head directly to my tailor to have items "tweaked" for an even better fit.

It's important to remember that not every garment can be altered. Some clothes simply aren't worth refitting. They might be inexpensively made with poorly sewn seams or a low-quality fabric or constructed in a way that cannot be altered. In this case, alterations will either be impossible or more costly than the item's original price.

Case in point.

I once fell in love with a fashion-forward couture (which means it was individually created as opposed to mass marketed) jacket I found at an upscale consignment store. It appeared to be the deal of the century. It was under $100, and shortening the sleeves was the only alteration it needed. Sounds easy, right? Well, not exactly.

When I brought it in for alterations, my tailor pointed out that the unique design element at the cuff—which included three buttonholes for the buttons on the sleeve to be secured into—actually made the sleeves impossible to shorten at the cuff without first doing some expensive invisible weaving (the process of reweaving threads to repair holes in fabric) to close the buttonholes.

He showed me that if he tried to hem it at the cuff without first reweaving the holes shut, the sleeve would look like it was ripped because the hem needed to be made exactly where one of the buttonholes was placed. In addition, even if he were to do the very best possible reweaving work, it would look like the jacket had been torn and then repaired. I might have been able to live with this if the jacket were a dark color. Because it was tan, we agreed it would look sloppy.

When it was determined that, if I did want it to be properly altered, the only way to save the jacket was to take the shoulders off and shorten the sleeve from the top instead of the cuff, I surrendered. Fixing the problem would have cost me more than I had paid for the jacket.

Had I been aware of all this when I bought the jacket, I would have left

it on the rack, because I couldn't return it. Luckily for my sons' baby-sitter, the jacket fits her perfectly. She just loves my fashion mistakes!

On most mass-produced jackets, the buttons sewn at the cuff are for decorative purposes only. Most times, they can be removed entirely, or removed and sewn back on once the sleeve has been properly adjusted.

Before you buy that gorgeous blazer that is just a bit too long in the sleeves or the pants that fit too loosely around your waist, check it over to make sure it can be altered for the perfect fit.

Garments that can be altered well tend to be of a high quality with good seams that can be re-sewn for a neater fit. The placement of seams is important, too. For instance, a jacket with one or two vertical seams down the back can be pulled in for a more snug fit or let out to give you more room. Even if a salesperson is telling you a jacket that you love can be altered to fit you better through the body, be sure to assess it for yourself. If there are no back seams, it simply cannot be altered in this way.

Using the information you now have about proper fit, go to your closet and cast one more critical eye on your clothes. Is there an item that you love but that never felt quite right on you? Slip it on. Are the sleeves a tad too long or short? Do the shoulders conjure memories of last January's Super Bowl? If so, it's time to determine if it can be altered and/or is worth the cost. The guide below will help you figure out which of your clothes can be salvaged and which should be tossed. These fashion guidelines will help you make smarter purchases, as well.

Step Four: Accentuate Your Assets; Camouflage Your Flaws

You can further edit your wardrobe by eliminating the items that don't complement your figure. Learning ways to play up your physical assets while hiding less-than-perfect parts of your figure will help you find the clothing that you'll want to wear over and over again.

Quick Guide to a Perfect Garment

Jackets: Shoulders should line up with your hips. The length of a jacket typically should not extend more than an inch past where the bottom of your fingers meets the palm of your hand unless an extended-length jacket is part of a fashion look. Shoulders can be slimmed as long as the sleeves are long enough to support this (they will come up as the shoulder comes in). Most single-breasted jackets can be shortened, too. It is difficult to get a double-breasted jacket to hang properly once it is shortened.

Arms and sleeves: High armholes allow for the best drape, but they shouldn't bind. Your sleeves should hit just below your wrist bone. Some women prefer their sleeves to be a little shorter than this standard size to show off bracelets and watches.

Buttons: Tug at all the buttons before buying anything. They should be well sewn on. Button holes in a garment should also be neatly trimmed with stitching so they don't easily fray and look messy. If you are in a department store, ask for extra buttons when you buy a garment.

Pants: While trying on a pair of pants, bend your knees and squat. The crotch shouldn't be tight or short. The fuller the cut of the pant, the longer the hem can be. A pair of pants is correctly hemmed when the hem clears the shoe heel but rests on the front part of the shoe, creating a slight break.

Skirts: Whether you choose to wear a pencil-slim or an A-line cut skirt, be sure the hem ends at the most flattering point of your leg. A slim-cut skirt can be tapered (i.e., following the natural line of the leg) for a more slim and flattering look. A-line skirts, which flare out below the knee, can often be taken in at the waist to perfect the way they sit through the hip.

Knits: Many people don't believe that knits can be altered, but they can. For example, if you need to buy a turtleneck one size big to get it to fit though the bodice, the sleeves can easily be adjusted.

No matter what your approach to getting a perfect fit, training your own eye to know what fits properly is always better than relying on someone else's expert (or not so expert!) opinion.

General Tips for Various Sizes

- **Heavy:** Fit is critical. Wear flattering colors close to your face. Avoid wearing too many different textures at once. The bulk of textured fabrics can give the appearance of extra pounds.

- **Overly slim:** Bulky and highly textured fabrics like sweaters, tweeds, and corduroys can be worn easily. Use multiple layers to create body fullness. Don't wear clothes that are too tight—this will overexpose your thinness.

- **Short:** Clean, simple lines work best. Stay away from overpowering jewelry, ruffles, and puffy sleeves. If you are under 5'4", remember to start your search for clothes in the petite department.

- **Tall:** The name of the game is proportion. Opt for a small- to mid-size heel instead of flats for a balanced look. Double-breasted jackets work well if you are not heavy through the middle. Jewelry pieces can be bigger. Break up a monochromatic look with a printed scarf or blouse.

Specific Suggestions

- **Large bust:** Open collars and V-necks make a bust appear smaller. Avoid heavy knits that cling. Short necklaces with coordinating earrings will bring the eye up to your face, away from your bust. Avoid long necklaces, wide belts, bunched up scarves, and breast pockets.

- **Small bust:** Layer, layer, layer! Also, seek out tops with ruffles, pockets, and other interesting embellishments.

- **Short neck:** Avoid turtlenecks. V-necks, mock, and crew style necklines are best. The lower your neckline is cut, the more flesh you will show and, therefore, you will lengthen your neck.

- **Long neck:** Turtlenecks, choker-style necklaces, and other accessories that fill in this area work well. Don't wear anything too low cut

without filling in the area from bust to chin. There is a reason models have long necks—they truly are a fashion asset.

- **Big arms:** Obviously, long sleeves work best. T-shirts with three-quarter-length sleeves work well, too. Like a bootleg trouser on a heavy thigh, a fluted sleeve (i.e., one that flares away from the arm) can balance out a thick upper arm.

- **Wide hips or heavy thighs:** Don't underestimate the power of shoulder pads. Although oversize pads can make you look like a football player, appropriately sized pads create balance in an outfit and can actually make your hips look smaller. Make sure the hem of your jacket ends below your hip line. Dark-colored skirts and trousers will look slimming on hips and thighs. Boot-cut pants can help balance you out as well.

- **Thick or short waist:** Avoid belted looks whenever possible. Belts can work when they are thin—about one inch wide—and are similar in tone to your outfit's base color. Keep the buckle simple. Don't wear a jacket that stops at your waist. A longer line will elongate your midsection. Avoid pants with a tapered bottom, especially when you are tucking in a blouse. Long scarves draped inside blazers and/or worn loosely over tops can hide a bulging midsection.

- **Heavy calves or ankles:** Pants can be your best friend. Avoid shoes with ankle straps, which will draw the eye to your leg. Make sure your skirt hems don't stop at the widest part of your leg. Opt for dark hose and shoes instead of light-colored ones.

Dressing Ten Pounds Thinner

Although it might be a little more challenging to feel your personal best when you have extra weight on your frame, anybody can be well dressed by learning a few slimming techniques. Here are some strategies to flatter a less-than-perfect figure:

- Start with a monochromatic base. As I mentioned earlier in this section, this easily creates a vertical—as opposed to horizontal—silhouette, which is typically more slimming than an outfit with several contrasting colors.

- Make sure all your clothes fit properly. Clothes that are too big or too small can add weight to your frame.

- Pay particular attention to your sleeve length. When sleeves haven't been properly shortened, they can cause a distraction at your hip line. Many women would rather not call attention to this particular area.

- Dark colors such as black, chocolate brown, navy, and dark gray are "minimizers." Wear these shades to camouflage the areas of your body where you are least confident. See page 118 for a more in-depth look at my "light with dark, dark with light" philosophy.

- Light and bright colors are "maximizers." Many women who are self-conscious about their weight like to wear dark base pieces (pants, skirts, and jackets) and wear light colors near their face to draw the eye up and away from the rest of their body.

- Select pants with a bootleg cut to balance hips, thighs, and mid-sections. Pants that fit closer at the ankle can cause your midsection to balloon out more than it needs to.

Step Five: Bring Yourself into the Twenty-First Century

If you are young with a fabulous figure, you can pull off an endless range of styles. As you advance in age, your fashion options will drop off, even if you maintain the figure of your youth.

I am well aware that there are genetic miracles who look decades younger than they actually are. The most savvy among them would never wear short skirts, sleeveless tops, or other youthful fashions. They know that if they try to look too young, they'll end up looking older.

Before we head back to the closet, here are a few more tips for the over-50 crowd that will take years off your age. These additional tips will help you focus on new ways to wear the clothing left in your wardrobe while giving you permission to get rid of any remaining items that will hamper you from dressing your personal best.

- **Even if they still fit, retire the styles that date you.** I have seen very few suits, pants, and skirts that are not dated after five to seven years. Some sweaters, simple tops, blazers, classic skirts, coats, purses, and belts (especially if they are designer or couture level) can last a lifetime. Yes, it is true that some styles come back after several years. After 50 (or 40 for that matter!), you're typically too "mature" to make them work again. Although your daughter or niece might look adorable wearing your shoes from the 1960s, you most likely will not. Adapt the "been there done that" attitude and select pieces that flatter your figure and personality while complementing your age.

- **At the very minimum, update your shoes and tops each season.** A few fresh blouses in flattering colors can make you feel younger and stylish. Likewise, replacing shoes that might be comfortable but are shouting "old lady!" with a pair that are more fashion-forward will

do wonders for your psyche. See the resource guide for some comfortable yet stylish shoe sources.

- **Make the most of sensible shoes.** If you must wear "sensible" shoes due to arthritis or other ailments that often result from years of wear and tear on the feet, long skirts and pants are nice style choices. These fashions conceal footwear the best. In other words, your shoes won't be the focal point of your outfit. And, yes, coordinating shoe and hose color is always a safe bet.

- **Stand tall.** As we age, we begin to shrink. Creating support systems in our outfits that help balance our figure while drawing the eye to our face is an excellent dressing strategy. In addition to balancing out your hips, a modest shoulder pad (i.e., sized appropriately to your frame) will make you appear less frail. If you are wearing a blouse or sweater without pads, try wrapping a cardigan sweater around your shoulders. It can give you the same kind of lift as shoulder pads.

- **Give yourself a face-lift without ever seeing a surgeon!** A collared blouse or shirt can do wonders for an aging face and neck because of the coverage they provide. The trick to wearing this type of top well is to be quite deliberate with how you position the collar around your face. Start by lifting up the collar in the back and then gently folding it down around your face. The goal is to have the collar create a sloping effect instead of wearing it flat around your neck. Practice does make perfect! Play with your collars in the mirror and you'll get the idea.

- **Limit the black.** Although black clothes can be a young girl's best friend, too much black in a more mature wardrobe can literally suck

the life out of your face. I'm not suggesting that you abandon all your black clothing—see my insights in Chapter Eight for a list of why I love black base pieces. I am, however, suggesting that you become more aware of the colors you wear next to your face. If you need to select a dress for a special occasion, for instance, you might want to use the opportunity to lighten your wardrobe. Silver gray, teal green, and periwinkle blue are my favorite colors on a variety of my senior clients, especially those who choose to wear their hair gray or white.

- **Consider your sleeves.** Many 50+ women ask me if they can wear sleeveless tops. I think of this as a very personal decision. If you are pleased with your bare arms, keep showing them—particularly in casual situations. In more formal settings, such as weddings or work, opt for short- and long-sleeve styles. Layering is another option. A sleeveless T under a linen shirt, for instance, in the summer (especially in air conditioning) often works. You can always remove the top layer when you feel warm. Along with necks and hands, arms can start to show your age first.

- **Defy gravity.** Many aging women are still tucking their blouses and sweaters into their pants and skirts. As we age, we often put on weight in our midsection. Although tucking and belting makes sense with some outfits, tucking in all your tops is probably unnecessary and can create visual interest where many of us don't need it. Start untucking, and you'll be amazed at the pounds that appear to come off. The trick to untucking with style is to be sure the tops you choose to wear untucked are not too long and that they hit you at a flattering point on your thigh. See Chapter Eight for more tips on whether to tuck or untuck.

Ode to My Grandmother

Attending a family wedding a few years ago with my 93-year-old grandmother reminded me once again about the power of having clothes that make you feel your personal best.

When my mom and I arrived at the assisted-living facility where my grandmother lived to get her ready for the wedding, her dress, shoes, and bag were laid out waiting for her. The light blue and rose chiffon dress she and my Aunt Pam selected for her was perfect. Not only did it bring out the blue in her eyes, but it was also lightweight enough for her to move around easily and, therefore, enjoy herself more at the wedding. A touch of makeup and a matching cane were all she needed to look and feel great.

Right up until the time she passed away, my grandmother was a savvy woman who prided herself on her appearance. Her nails were always flawlessly manicured and her hair perfectly coiffed. She seemed to always be prepared to take the world by storm—which she did on a daily basis!

When she was a widowed mother of three small children in the 1950s, I believe the extra attention to her appearance was one of her survival tactics. Over the years, I heard story after story about her ability to negotiate car deals, buy a new house for her growing family, and get all her children into college—no small feat for a woman who was barely five feet tall.

No matter her age, details mattered to my grandmother and spoke volumes for her good taste in so many things. I am grateful to have had her as one of my earliest style mentors.

Shopping in Your Own Closet

The first four chapters of this book helped you conquer closet chaos. You categorized your clothing and accessories and pared down your wardrobe to its most essential elements while organizing it in a way so you can find and see everything quickly and effortlessly.

In Fashion 101 (Chapter Six), you learned about style and design and how to apply these basic principles to your own wardrobe. I hope these steps also gave you permission to let go of even more items in your wardrobe that are holding you back from looking (and feeling!) your personal best.

It's now time to put those wardrobe management skills and fashion education together. Get ready to dive into your closet and put together new outfits from your own clothes. Finally, we are ready to play dress-up!

Because the goal of shopping in your own closet is to instantly see what you have and, from there, imagine all the possible combinations, be sure you can view your entire wardrobe easily. By now, all your clothes should be separated into categories. All the suits are hanging together, as are separate pants, jackets, skirts, dresses, shirts, and blouses. If you live in a place with a seasonal temperature change, remember to remove out-of-season clothes from your closet.

If your closet is hopelessly dark and/or hard to see into all at once, try to

get your hands on a clothing rack you can set up outside the closet, which will allow you to see all your clothing at once.

Take any sweaters and tops you have decided to store in drawers and other storage areas, and pile them on the floor near your closet. You want everything you own at your fingertips to create as many outfits as possible.

The following are some additional ideas to help you get ready for your closet adventure.

Recruit a Second Pair of Eyes

Consider inviting a girlfriend (or a professional image consultant, if you can afford one) to help you shop in your closet. Your mirror can also serve as a surrogate best friend. Look in the Yellow Pages under "Image Consulting" for a list of wardrobe consultants in your area who are available for in-home consultations.

Remember, the eyes are like a camera. Whether you are interacting with someone with a lot of fashion savvy or someone with very little, their eyes are automatically drawn to places in your outfit that reveal an obvious break in line, proportion, or balance. That second set of eyes will help you discover new fashion combinations and eliminate those items that hinder rather than help your image.

As you try on new combinations during your closet shopping spree, you will most likely find yourself equipped for another trip to your favorite charity, so have a few boxes and bags on hand for your extra discards.

Put Together a Personal Image Toolkit

Before you start this process, it's handy to put together some tools for building your wardrobe. Here's what I use (to varying degrees) when I work with my private clientele in their closets:

- **A Polaroid or digital camera.** Taking pictures of each outfit reminds you of the many and varied possibilities you've discovered when shopping in your own closet. Some of my clients store the photos in decorative shoeboxes, while others keep them tucked in a drawer. A regular film camera works well, too. I prefer a Polaroid or digital camera because of the instant feedback it provides (i.e., if the photo is too dark, it can be re-shot).

- **Notebook/Fashion Journal.** In this catchall, list the items that you discover to be missing from your wardrobe—like a pair of black loafers that will update your casual clothes, or a white T-shirt that will go with just about everything you own. You can also use a notebook/journal in place of the camera. Write down all the combinations you own, and refer to these when looking for an outfit to wear.

- **Extra Hangers.** Use the extra suit and dress hangers to hold the outfits you piece together from separates. As you create new outfits, place the combinations together on the same hanger. Preassembling your outfits takes the guesswork out of dressing in the morning. At the end of your closet shopping spree, you can go hanger to hanger to see if you forgot to write down any missing items that might further complete the look you are after.

- **Hang-Tags.** Write down the various pieces of an outfit on these small cardboard tags and tie them to the neck of the hanger for easy reference and packing. You can purchase these at most drug stores.

- **Wardrobe Grid & Summary.** You'll find the grid I designed many years ago (and still use with my private clientele) in Appendix B. This exercise will help you maximize your separates and keep an accurate clothing inventory. The grid is especially handy if you travel and want to preplan outfits for each day of your trip, or if you have a demanding job where your image is especially important. *Extra tip:* I fondly nicknamed the grid "The Claudia," which is the

name of a dear client who has placed every grid I ever drafted for her during the last decade in clear plastic page protector sheets. She hangs these from a belt ring in her closet for easy reference. This system can work for you, too.

- **Personal Action Plan.** If you haven't referred to this form yet in Appendix A, now is the time to do so. As discussed in the first section of the book, I use these same personal action forms with new clients as I walk them through the *Dressing Well* system. Combined with the wardrobe grid, this form will help you capture what is missing in your closet while helping you prioritize your shopping.

- **Catalogs.** Clothing catalogs contain endless ideas for achieving a variety of looks. Although I love fashion magazines and devour them each season, catalogs often better translate the trends for real life. When I am helping a client create new looks, we tear out pages that contain outfits she would like to emulate in her own wardrobe. This puts focus into shopping trips in and out of your closet. If you want to use catalogs for more than just looking, see Part Three for catalog shopping tips.

- **A Two-Pocket Folder.** Use this to store any magazine and catalog pictures and articles you would like to use as a future reference. If you utilize department store coupons, this is a handy place to keep them, too. Names and numbers of various clothing maintenance vendors you use and/or hear about and might need in the future can be collected here as well. Some of my clients store credit card receipts related to clothes in their two-pocket folder. Stow your folder in a handy place. I keep mine in a drawer under my blue jeans.

| Behind Closed Doors |

Fashion Inspiration from Mrs. Claus

For me, fashion inspiration comes from many sources. I study catalogs and read fashion magazines. I do "live" research at the mall, at the corporate and not-so-corporate offices I visit, and even while I'm waiting in line at the bank! I love style, color, and fabrics, and my eye is naturally drawn to unique combinations of each.

A few Christmases ago, I got one gem of a fashion idea while watching *Santa Claus II* with my kids. Toward the end of the movie, Tim Allen's character's love interest was wearing a red turtleneck sweater with a camel coat. The combination was stunning and complemented not only the holiday season depicted in the movie but also the leading lady's warm coloring.

At the end of the previous winter, I had bought a brick red cashmere turtleneck sweater from Burberry on Newbury Street in Boston at a considerable discount. I loved the way it fit and knew its classic styling would work nicely with my winter/holiday wardrobe for years to come.

When I got home from the movie, I slipped this sweater on under my three-quarter-length camel coat, and it looked smashing. A pair of gray flannel wool pants I had recently purchased further complemented the outfit. My black wool trousers worked well also, but the charcoal gray looked much softer.

The wools in all three pieces blend nicely together, and it will be a simple choice for dressy casual occasions during the holiday season. My black ankle boots and some gold jewelry are all I need to feel completely put together when I wear this outfit.

Whether at the movies, waiting in line at the bank, or having a cup of coffee with a friend, open your eyes to what others are wearing. It's often easiest to incorporate a fresh new look into your own wardrobe when you see how simply someone else has made it work!

Revisit Your Lifestyle Needs

Most of us have three major areas of our wardrobes that need time and attention—professional, casual, and special occasion. Although there are subcategories to each (such as business casual, resort casual, black tie, and maternity), these are what I call "the big three."

Remember, as you did in Chapter One's "Organizing to the Fives" activ-

ity, to continue to balance your wardrobe based on the percentage of time you spend involved in each area of your life. As your life changes, be sure to continually adjust your wardrobe to reflect these changes.

As you prepare to mix and match the clothes in your closet, revisit in your mind the part of your wardrobe you need to focus your energy on the most. Asking yourself a series of questions about your own lifestyle before opening your closet door will help you get the best results from your in-home shopping trip.

Here are some questions I frequently ask clients to help us focus on "the big picture" (i.e., their day-to-day personal style) before we start mixing and matching:

- Do you work an office job five days per week with the same group of people? Do you find yourself changing outfits two or three times each morning because you have "nothing to wear"? If so, you'll need to devote a significant share of your closet shopping trip to making "new" outfits for work.

- Are you a stay-at-home mom who volunteers frequently at the school but whose closet is stuffed with suits from the days before children? If this is the case, you should concentrate on breaking up some of your suits and then dressing them down to reflect a more casual lifestyle.

- Are you always stressed out before a date, trying on outfit after outfit without ever feeling really put together and appropriate? If this thought resonates with you, you might want to try on an outfit that you felt really good in on a date and use it to build other appropriate dating outfits from what you already own in your wardrobe.

A well-focused shopping spree in your closet will result in a clear picture of precisely what you need to purchase and how to prioritize your shopping dollars at the stores.

Try It On Baby, Try It All On

As you probably guessed, the next step in this process is to try on everything in your closet.

As I advised in Part One when we were planning to organize your closets and drawers, I suggest playing dress-up in your closet when you are well rested. Give yourself a few hours to complete this project. It is a lot of work to try on outfit after outfit. You want to be mentally alert when you give each outfit the once over and then strategize about what new additions will make each one "sing."

In addition, you will be messing up your wardrobe management system quite a bit and will need some energy at the end of your shopping spree to put the closet back together again. I hope you are enthusiastically nodding your head on this one instead of rolling your eyes! Maintaining the system is crucial if you want long-term mastery of your personal style.

The next chapter will help you identify what pieces are missing from your wardrobe. I'll give you checklists and fashion tips for every item in each category of your wardrobe—more than you might imagine. For the moment, however, let's stay focused on the clothes you already have in your closet and how you can effectively mix and match them for optimal results.

Here are some ideas to get you started.

- If you own some suits, they are an obvious starting point in the mix-and-match game because they can be broken up easily and also can look quite different just by switching shoes, tops, and accessories.

- Borrow the jacket from a conservatively cut navy or black wool gabardine or lighter-weight wool suit and pair it with a pair of light-wool or cotton khaki-colored trousers for a business casual look. The smooth finish of the wool gabardine will instantly connect with the smooth finish of the pant.

- A cotton shirt (white or French blue are safe bets) or a cotton-knit shell in cream, white, or red can complete the look.

- Do you own a scarf that captures the color of the pant, jacket, and top? Tie it on, and you will further polish your look.

- Further accessorize the outfit by taking some cues from the buttons on the jacket. If the jacket is navy with buttons that have a brown or beige cast to them, wear a brown loafer and brown socks to further complement the outfit. If the jacket is black with black buttons, a black loafer and black socks will be a good choice. If the buttons are gold, consider gold earrings and a belt and shoe with gold hardware. Yes, it's best to match your socks to your shoes (rather than to your pant) if you are wearing dark footwear.

- Next, pair slacks from suits with smart sweaters for a less structured look. A good pair of dark pants, whether they are part of a suit or not, can serve as the anchor for many outfits.

- Dress up a pantsuit with a silk blouse and dress pumps. Dress it down with a silk T-shirt and loafers.

- When you have finished matching your solid-colored suits and pants with different tops and shoes, move on to other items in the wardrobe. Do you have a skirt you love but that doesn't seem to get along with anything in your wardrobe? Hold it up to every top you own. Perhaps your pink sweater brings out the trace of pink in the skirt. Maybe your black blazer picks up the black in the skirt. If so, you have two new outfits!

To really see how versatile one good pantsuit can be, set aside all the tops that go with it, and do the same with your shoes. If you don't have a black pantsuit, put it on your list as a possible item to add at the store.

When you try on different combinations, remember to stand in front of

| Insider Tip |

Knowing When Not to Break Up

Keep in mind that there are some suits you shouldn't break up, especially those that are made of high-maintenance fabrics such as silk or linen and/or are made in a light-colored fabric. Wear the top and jacket together, and dry clean them together for the most longevity.

a full-length mirror and compare what you're wearing with what you now know about line, proportion, and balance. If one of your combinations is off, see if it can be corrected with a different shoe or a top in a different style or made of a different fabric.

Even if your eye catches a new combination that appears obvious, still try it on. Get in the habit of previewing all your outfits before wearing them for the first time. This means trying them on with accessories you plan to wear and checking to see that the shades and textures match and the sleeves and hems are the right length.

Keep working at it—I guarantee you will come up with some great new combinations.

Identify What's Missing

By creating outfits with your existing wardrobe, you will also begin to notice the gaps. Perhaps you need a good pair of dress pumps to help "step up" your suits. Maybe you are discovering that although your suits are certainly wearable, none are making you truly happy and you'd like to update that part of your wardrobe completely. Or maybe your favorite cream silk shell is starting to look too worn with your newer suits. If so, make a note on your shopping list to replace it.

Your primary goal when shopping in your closet is to make the most out of what you own; your secondary goal is to recognize what items to purchase to complete your wardrobe.

Maybe a cotton cardigan sweater you typically wear with a white T-shirt and jeans in the spring and summer can be winterized for the cooler months by wearing it with a red cotton turtleneck and some casual corduroy pants.

The Buddy System

When one of my girlfriends calls in a panic and says she is headed to the mall because she has nothing to wear, I tend to panic more than she does! I typically open my date book and tell her to hold tight until I can get over to help her shop in her own closet.

One Sunday afternoon in early April, I received such a call. This time, my friend Nancy had already been to the mall and was heading out again because her new purchases weren't working out in her closet. I jumped off my couch and raced over to her house for a little fashion therapy.

Here's how I helped Nancy (who is quite fashion savvy, by the way!) mix and match her new purchases with her existing wardrobe to develop some fresh new looks to complement a busy spring/summer calendar:

- We paired a new black matte jersey top with ruffles on the sleeves and neckline with a pair of chocolate brown Ann Taylor matte jersey pants from the previous season. To tie the look together, I suggested Nancy slip on a pair of black, brown, and cream leopard print sandals already in her wardrobe. They were perfect. We decided that adding a coordinating leopard print oversize bag would update the look for day—she added this item to her future shopping list. A small animal print bag she had was perfect to wear with the outfit at night.

- She had several spring suits in various shades of gray in her wardrobe. They all looked great with a sleeveless coral silk turtleneck. She picked up the turtleneck for $11.99 at a discount retailer, proving once again that fashion truly is where you find it.

- A classic black linen skirt she had worn for years looked more fashion-forward this particular season with a white safari linen jacket in her wardrobe and a new black and white sandal she had just bought. I suggested that she change the tan buttons on the jacket to black to coordinate better with the skirt and sandals. Because she is a curvy petite, the belted jacket complemented her figure.

- A long floral blue and cream skirt she has had for a few years looked great with a cream silk wrap shirt she had recently purchased. I suggested wearing the blouse over a camisole in the same color to guard against embarrassment should the top pop open. I also suggested she visit a seamstress to attach a button on the inside of the blouse to further secure it.

| Insider Tip |

Free Shopping

Shopping in your own closet first before ever heading to the store is one of the best strategies in the *Dressing Well* system. The best part is that there's no credit card bill when you're finished. Ask a sympathetic friend who has a good sense of fashion to be your designated shop-in-your-closet buddy when you think you have nothing to wear. It could save you a small fortune!

As you assemble new outfits, note the missing pieces. Once again, the Wardrobe Grid and Personal Action Plan are handy tools during this process, especially if you are doing this for the first time.

At a very minimum, record this information in a notebook or on a piece of paper that you are not likely to lose. I actually have a small notebook given to me by my good friend Jane tucked into my underwear drawer that I whip out every time I'm in my closet and something isn't working. I make a note of what I should look for at the store to make the outfit better. The pages are small enough to tuck into my wallet. Whether I am shopping for a client or for myself, I always have some sort of list with me to help me stay focused at the stores.

Closet Check-Out Time

There is nothing like being in the privacy of your own home to test out new fashion concepts and see for yourself where your gaps are. I play closet dress-up in my closet on a regular basis and often prefer it to shopping, especially when I'd like to shift wardrobe dollars to another area of my life.

When you are done shopping in your closet, you should have some new outfits to wear and a list of items to purchase. When you look over this list, keep your budget in mind, and set priorities if you don't have a lot to spend. This will allow you to clearly prioritize your shopping dollars later.

At the end of your closet shopping spree, put your closet back together. If you have broken up suits to make new combinations, hang the suit back up with its original mate. It's best to have outfits hanging together in their most obvious manner to keep things organized and worn most effectively.

Ten Excellent Rules for Effectively Shopping in Your Closet

Fashions change with the wind and trends come and go, but these essential guidelines will never fail you when you are trying to make the most of what you own:

1. Practice the "Rule of Three"—accessorizing in three places with the same color, fabrication, size, or shape accessories instantly ties a look together. For example, if your blouse has pearl buttons, wear pearl earrings and a pearl necklace.

2. Match your shoes with your belt for an instant, pulled-together look.

3. Don't mix your metals. Buttons, zippers, belt buckles, and shoe ornaments are part of the accessorizing game. Select your jewelry to coordinate with these details, and the compliments will be sure to follow.

4. Remember to balance the various textures in your outfit. Wear tights with sweaters and turtlenecks. Wear nylon pantyhose with a blouse.

5. Nine times out of ten, you can wear black shoes with almost any color clothing in your wardrobe, even navy. Today's modern fabrics hold color extremely well, and most have a significant amount of black in them. If you still need convincing, take one of these colors into the sunlight and hold up a black shoe to it. You will see that it often connects nicely to the fabric.

6. Yes, you can wear prints and geometrics together. Look for patterns that have color themes in common. For instance, if you have a black and white plaid skirt, coordinate it with a floral scarf at your neck that repeats the black and white while bringing more color to the outfit and giving you an interesting flair.

7. Avoid wearing too many different textures at once. The bulk of textured fabrics can give the appearance of extra pounds.

8. Denim can be dressed up or down with the proper accessories. Wear skirts, shirts, and pants in this versatile fabric. Silver jewelry looks especially nice with denim in the summer months. *Be advised that denim can be risky in many professional situations.*

9. Borrow dressy turtlenecks and knit Ts that you wear with suits to help you dress up more casual items in your wardrobe.

10. It takes a pretty well-trained eye to pull off wearing different shades of black together. Instead of pairing black separates that don't exactly match, try matching them to something printed. If you don't like prints, you can pair black separates with something made of the same fabric in a lighter color.

Of course, you need to have the right base pieces, colors, and accessories in your closet to be able to play the mix-and-match game well. The next four chapters will help you fine-tune your shopping list while giving you some new ideas about how to continue to build a truly "ready-to-wear" wardrobe.

Building a Base Wardrobe

At this stage, it helps to think like a professional contractor. Before you start building on your wardrobe, make sure you have a solid foundation. In this case, that means suits, jackets, pants, skirts, and dresses. As you learned in the last chapter, these basics will support the pieces that come next—your accessories.

This chapter will detail the components of your base wardrobe and offer suggestions for dressing up and down these pieces. Some of these ideas will work for you; others might not. Use the information with a solid dose of your own common sense about what looks good and feels right. My goal is to help you sift through your dressing options without overwhelming you with too much information. I promise you that at the end of this chapter, you will have some wonderful new ideas for your wardrobe.

A Vote for Black Basics

Over and over again when I survey the audiences at my public and corporate seminars about their individual fashion challenges, I hear "having too much

black in my wardrobe." It seems that almost everyone (save those who work in the fashion industry) thinks that having too much black in their wardrobe is the biggest of all fashion sins. I couldn't agree less.

Black basics are a natural place to start if you are interested in building a cost-effective wardrobe that is easy to mix and match. Here are some of the reasons I love to build a wardrobe with black basics:

- **Black is less memorable than brighter colors.** You can often wear the same black basics over and over again without a trace of repetitiveness. Even if your favorite canary yellow capri pants make you feel happy and energetic when you put them on, you (and others!) can tire of them pretty quickly if you wear them over and over again with the same crowd. Black pants, on the other hand, can easily take on many identities. They are an easy choice to wear day in and day out, especially when they fit well and are comfortable.

- **Black doesn't show wear and tear as much as its lighter counterparts.** If you are a busy professional who works with pens and drinks coffee at your desk, you probably love your black jackets and sweaters. If you are a stay-at-home mom, you probably couldn't live without the black polar fleece running jacket or sweat suit that you throw on whenever you need to take the kids someplace.

- **Black has day and evening appeal.** It's also appropriate for many of life's happy and somber occasions. A black dress, for instance, is very handy. Keep it simple and demure, and it can be appropriate for the office as well as for weddings, funerals, and many other circumstances just by switching the accessories.

- **Black can be price-neutral.** When you don't have much money but you want to look as sophisticated as possible, black can be your best friend. Black items don't get dated as easily. And wardrobe basics made in black can look much richer even if the garment is inexpen-

sively made. Cheap black shoes, for instance, are barely detectable. Cheap white shoes . . . well, they look like cheap white shoes!

If you are trying to improve your performance in the game of fashion, you're apt to score more points experimenting with black. I repeatedly say to clients, "When in doubt, wear black." It's a rule of thumb that often rings true.

Capsule Dressing: One Suit, Ten Outfits

Whether you work inside or outside the home, love black or are really opposed to it, building a wardrobe around "capsules" (i.e., a group of separates that easily mix and match with each other) is another effective wardrobe-building strategy.

Here is an example of a simple capsule dressing formula I have put together over the years for many clients of all different ages and lifestyles. It is easy to implement on your own:

- Start with a great three-piece suit (jacket, skirt, pant) in a dark, neutral color. In addition to black, good base wardrobe colors include navy, chocolate brown, charcoal gray, and olive green. A long skirt, as opposed to a shorter style, will give you more versatility because it can be both casual and/or dressy in its presentation, depending on the top and shoe you wear with it.

- If the maker of the suit has a dress in the same fabrication and dye-lot, grab that, too—you will get even more looks if you can find one that fits. My favorite style dress to wear with a jacket is a classic sheath—a figure-hugging dress that is typically short-sleeved or sleeveless. See page 118 for an illustration of a classic sheath.

- Capsules built with lightweight wools, silks, and polyester blends can be multi-seasonal and easy to pack. Knits, such as those designed by

| Behind Closed Doors |

Dress Code Enlightenment

Every year, on a Saturday in November, our church holds a family holiday bazaar in the afternoon followed by an auction and dinner for adults in the evening.

While I was participating in the family part of the festivities one year, my minister pulled me aside. Having shared many enlightening and soul-searching conversations with her, I was expecting another profound conversation to start up. You can imagine my surprise (and I must admit delight!) when she wanted to discuss the dress code for the event later that evening. She was sincerely perplexed about what to wear to an evening event that wasn't technically in the holiday season yet was billed as a holiday celebration of sorts.

Yes, even my minister—someone I admire greatly for helping me wrestle with some of life's biggest questions—was searching for direction about something as relatively simple as what to wear to an event. Sensing her embarrassment that perhaps she had asked a foolish question, I assured her she wasn't alone in her questioning and that it is often difficult for anyone to know exactly what to wear to evening events that fall somewhere between dressy and casual. After all, I have carved out a living giving out this type of advice!

When I suggested she wear a dressy black pant and festive top, I remember her saying, "That's so obvious, why didn't I think of that?" Later that day, as I was putting my own black pants on in preparation for the event, I laughed to myself at how many times somebody had said the same thing to her (myself included!) after asking her a question about a topic that appeared troublesome and complex when they were playing it out alone in their own minds.

Whether it's a church auction or an off-site business meeting, pulling aside someone you trust to help you figure out the dress code is a good strategy to helping you feel your personal best.

Eileen Fisher, are also handy for building capsule wardrobes. Knits are not just for winter. There are a variety of lightweight knits that are great for the summer or year-round warm climates.

- Stock up on different styles of tops in a variety of colors, including a crisp white shirt, silk blouse, a variety of knit tops, and a beaded camisole, to give suited combinations versatility.

- Pick up a twin set—cardigan sweater with matching shell—to wear with the pants and/or skirt. A tailored vest can often be worn instead of the blouse with many suits for a more creative and fashion-forward flair.

- Stick with black shoes—loafers and dress pumps are good starters. Ankle boots look great with pants and will keep you warm in cool weather. A black dress sandal can help you dress things up for special occasions and evening events.

- A dark-colored trench coat with a zip-out lining is a good choice for business. It often works with casual and dressy outfits as well.

Suits versus Separates

Of course, your base wardrobe doesn't have to include suits at all. Some of my clients tell me that their vision of being well dressed is to look "less suited" and to be more creative and daring with their clothes. If this same client has relatively few accessories or is missing the perfect pant or skirt that can become the foundation of countless stylish and creative looks, we automatically place these items on the top of her shopping list.

If you don't consider yourself a "suit person," I urge you to give it some more thought before you write them off altogether. A suit can be a lifesaver for those occasions when nothing else will do. And even if you rarely have cause to wear one, the separate pieces of a suit will lend versatility to the rest of your wardrobe.

Brilliant Flashes of the Obvious

One day I was sitting in my office when a reporter called looking for a list of what every woman should have in her wardrobe. I started my typical spiel about how no two wardrobes are alike—how each is a reflection of the unique individual who put it together.

As I was talking to her, my eye caught some of the clothes hanging on the wall in my office. (We hang outfits on a metal grid system on the wall when we are working on accessorizing and altering outfits on behalf of a client.)

When I shared with her that I was staring at five black pantsuits and that each was bought for different-age clients with a variety of budgets, figures, and lifestyles, a new angle to her story began to emerge.

As I described each suit, its owner, and its primary purpose, it became apparent that a good black pantsuit was a staple almost any woman could wear with confidence. Here are three of the "black pantsuit" scenarios I described:

- One pantsuit—a dressy Armani taken from the closet of one of our wealthiest clients—was hanging on the grid waiting to have its buttons changed and a beaded top added. Its owner, a prominent philanthropist, planned to wear the suit to a variety of evening fund-raising events she was hosting in New York and Boston. The price tag on this suit, bought the previous season in New York City, was just less than $3,000.

- Another black pantsuit was one I had purchased for my mother. After organizing her closet when she retired from teaching, it was apparent she needed a new suit. I bought her a jacket, pants, and dress in the same grouping on sale for less than $300. She has worn these three pieces in various combinations over and over to weddings, holiday parties, and other social events, both at home and on the road. She originally thought she didn't need any more suits after she stopped working but quickly realized how handy this ensemble is.

- Perhaps the most memorable of the five black pantsuits hanging on the wall that day was one that had been purchased for a 26-year-old receptionist. Her employer had given her a $250 clothing allowance and hired us to take her shopping. Upon learning that she was a size 18 petite with very little personal money to add to our outing, I took her to an off-price retailer. After trying on suit after suit, we selected a black pantsuit for $59. It was composed of an unlined tunic-style jacket (i.e., less structured than a tailored jacket, with vents on each side for a more relaxed fit) with matching elastic-waist pants. In addition to being a plus-size petite (the most challenging of all figures to correctly assess and fit), the bottom half of this client's figure was disproportionately larger than her top half. Selecting separates that were unlined cut down on extra bulk while keeping alterations to a reasonable cost. Zeroing in on this wonderful suit for such a reasonable price allowed us to get some more mileage out of her tight budget.

The new angle to the reporter's story was cinched when I reminded her that Hillary Clinton had gone public with her support of black pantsuits—sharing her victory in the 2001 New York Senate race with the half-dozen she wore on the campaign trail—a fact she announced in her victory speech!

Jackets and Blazers: The Command Center of Many an Outfit

Whether part of a suit or worn on its own, the right jacket can make you feel like you can conquer the world. Here are a few reasons why I love them:

- They camouflage a variety of figure challenges.

- They create boundaries between you and others when you need them to.

- They instantly set a business tone.

- They can give you extra credibility.

I consider my professional and casual jackets and blazers to be my coats of armor. I remember throwing on a navy blue blazer over a pair of jeans one day when I had to run into the bank to dispute an extra fee on my statement. Whether it was the jacket, my attitude, or the teller's good mood, I got the charge cleared without any discussion. Whatever the reason, I'm glad I had my jacket with me!

Here is a guide for wearing your jackets with extra confidence:

- If you are wearing a top with shoulder pads under your jacket, make sure they are small enough so they don't make your jacket look too bulky or ill-fitting.

- Whether the jacket is fitted or unstructured, look for one that is long enough to cover your seat and that hits a flattering part of your thigh. Yes, shorter styles can work, but I find that a longer length is most flattering on most women.

- A three-quarter-length jacket that ends at or just above your knee is a nice option for fashion-forward women. Petite women can easily

carry off this longer length. Just be sure to select elongated styles in the petite department, where they have been properly scaled to fit your proportions.

- Peplum jackets, which hit at the hipbone, are more difficult to pull off than ones that are cut longer. If you do want to wear this shorter jacket, be sure to pair it with a full-cut skirt or a pant. You will achieve balance if you combine a short jacket with a longer skirt (the opposite holds true as well). Also, beware of wearing your peplum jacket with pleated pants or skirts. I have seen many women unnecessarily call attention to their midsections by wearing peplum-style jackets over a pleated bottom that puckers out instead of laying flat.

- Double-breasted jackets can be more formal than their single-breasted cousins. If you choose this style, make sure you find one that fits well and has six to eight closely spaced buttons. If the jacket is poorly fitting or the buttons are placed at the midsection, the effect will often

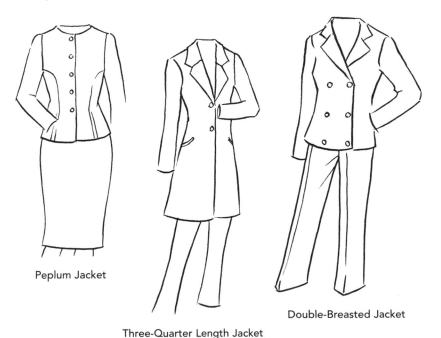

Peplum Jacket

Three-Quarter Length Jacket

Double-Breasted Jacket

create a strong horizontal line where you least need it. A vertical row of buttons that rise from top to bottom will create a slimming effect. Another caution about double breasted jackets: Always keep them buttoned. Most don't fall correctly if left hanging open.

- A single-breasted blazer is typically much easier to fit and, therefore, more flattering to your figure. Left open, this type of blazer will lend a casual air to your image. Buttoned up, it will bring the eye up to your face and create that slimming vertical line.

- Pay attention to the neckline of your jackets as well. A deep V-neck cries out to be filled. With a shallower neckline, you can get away with wearing a simple shell under your blazer. If you choose a jacket with a deep V-neck, fill it with a necklace, scarf, or collared blouse to bring the eye back up closer to your face.

- If you choose a suit that buttons up close to your face, you will not have to pay as much attention to what you wear beneath it.

- Shawl collars can soften and flatter your face. Mandarin collars are a nice change as long as your neck is not too short.

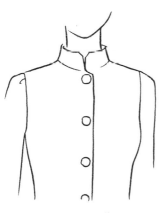

Mandarin Collar Shawl Collar

| Insider Tip |

Jacket Pockets

If you choose a jacket with slash pockets, leave them sewn shut. Many women cut the threads because they want to use the pockets. If you do this, however, the pockets will droop and bag as you wear and dry clean them. This is especially true for more delicate fabrics such as linen, silk, and some polyester blends. If pockets are important to you, choose a blazer with patch or flap cover ones. Better yet, use the pockets in your skirt or slacks!

- For a slimming effect, choose jackets with vertically placed slash pockets instead of ones with horizontal or patch pockets. These will draw attention to your hip area, where you might not want it.

Vertical Slash Pockets Horizontal Patch Pockets

Trousers and Pants for All Occasions

Women's pants have evolved from casual wear to business casual to the place they occupy today: every-occasion attire! They're worn in public and for all purposes by everyone from first ladies to socialites to attorneys. I have all but given up on wearing skirts for business purposes. Pants are flexible, comfortable, and fashionable.

That said, pants do have one drawback: They're hard to fit. From my research with private clients, I know that finding the perfect pair of pants that not only fits but also flatters can be one of the most difficult and frustrating of all shopping experiences.

Fortunately, pants come in many different styles, so you are bound to find a pair that flatters your figure. There are pleats, smooth, flat fronts, front zippers, side zippers, and elastic-waist pull-ons.

Pant length also varies from style to style. As was discussed earlier in the

alterations guide, the dressier the pant and wider the hem, the longer its length can be. A conservatively cut pant will look better with a hem that clears the shoe heel while resting on the front part of the shoe, creating a slight break.

At the risk of having you all think that my middle name is Morticia, I thought I would tell you the story of the 14 pairs of black pants in my wardrobe at this time. This baker's-dozen-plus-one takes care of my many roles: mother, corporate image consultant, fashion spokesperson, entrepreneur, and sometimes-hot date (one can wish, anyway!).

It is my hope that hearing about my collection of pants will help you identify a pair that might be missing from your own wardrobe (no matter what color you decide to buy).

A Tale of 14 Pants

Suited styles: I have three black pantsuits and, therefore, three pairs of black pants, which I often wear as separates. Here is the breakdown:

- **Slim cut, made of polyester-blended fabric.** These were bought with an elongated jacket. Worn with the jacket, I have a dressy, fashion-forward outfit. Worn alone, the pants are easy to top with dressy shirts, in both the summer and winter. I have had these pants taken in twice, as the polyester fabric that I love for its drape can also "grow," making the pants look baggy after a certain amount of dry cleaning. I wear these pants with sling-back pumps in the winter and strappy sandals and mules in the spring and summer. My dress boots stay in the closet, however, as they are too heavy with this fabric.

- **Wool gabardine.** I wear these pants from September through March. They are significantly belled at the bottom with a cuff. In September, I wear them with a classic pump. From October on, I wear them with high-heel ankle boots. Even though I wear the pants more than the

jacket, I always have them dry cleaned together to prevent them from wearing separately. Because they are unlined, I often wear a pair of tights under them for extra warmth when it is really cold.

- **Lightweight wool.** When the wool gabardine goes away for the summer, these pants with their matching jacket come out. These, like the previous two pairs, have a flat front. I like their smooth line, and the absence of belt loops means I don't have to worry about finding a matching belt. I wear these pants more often with a twin set than I do with their matching jacket, because my summer business wardrobe tends to be more casual.

Wool crepe dress trousers: I searched high and low for these and ended up paying full price for a designer pair that fit me like none other. These pants have given me extra mileage from a few suit jackets I used to wear with skirts that have long since retired. A slightly tweedy Armani jacket, for instance, looks smashing paired with these pants and a black turtleneck. Because the pants were such a hit with this jacket, I also bought a cranberry-colored ruffle-front blouse to wear with the pair as well. I was as thrilled to discover that a waist-length black wool crepe jacket I bought at a vintage clothing store was a dead-on match with the pant. As you know, it's difficult to match up blacks that don't go together.

Side Zip

Side-zip casual pants: These are the anchor of my casual wardrobe. I picked up a pair of side-zip pants from The Limited with a percentage of Lycra spandex. With a boot cut, these pants are comfortable as well as flattering. I have worn them out!

Matte jersey pull-on pants: I could not live without these in the summer. The fabric is ideal for travel, because it barely wrinkles and takes up very little room in my suitcase. I wore

Elastic Pull-On

these on vacation to Florida one year and lived in them. They were particularly handy at the beginning of the trip when I wanted a full-length yet lightweight pant to cover my Northeast winter legs! This fabric also transitions easily from daytime to eveningwear. I wore my matte jersey pants with a flat sandal for shopping and a strappy sandal out at night.

Linen drawstring culottes: I picked these up after my boys were born and have had them taken in as my waistline returned to normal. These are cut like a skirt but offer the versatility of pants. I wear them with a T-shirt for daytime and a dressier top for evenings out.

Leggings/exercise pants: I own about five pairs of these at all times, including a unitard (i.e., all one piece) style. I top all my leggings with coordinated athletic tops, fleece pullovers, and sweaters. For an uninterrupted, monochromatic look with no obvious sock or panty lines in the winter, I wear them with tights and a pair of zip-up black sneakers. Yes, a thong is the best underwear choice if you are committed to no lines!

Cotton capris: These are my answer to shorts on those warm weather days when I'm feeling less than confident about my legs. My capris are cool and

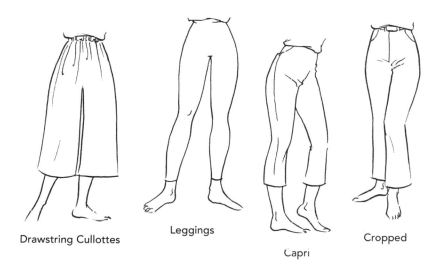

Drawstring Cullottes Leggings Capri Cropped

comfortable, and because they fall at mid-calf, providing modest coverage, they're perfect for running errands on a hot summer day.

Leather pants: Attitudes have significantly changed over the years when it comes to leather apparel. My black leather pants, for instance, are conservatively cut and styled. I wear them with a red blazer and white, crisp shirt to some client meetings and even to church in the fall and winter. I dress them down with sweaters and low boots for casual day looks and dress them up with a variety of embellished tops for nights out. Head-to-toe leather is out of style. However, wearing one piece—whether it is a jacket, pant, vest, or skirt—and combining it with other pieces in your closet you might not have considered is a great way to add an interesting edge to your wardrobe.

Although this constitutes my black pant collection at the moment, there are certainly many more options for all you more colorful pant wearers! You'll find more information on capri pants, jeans, corduroys, and khakis in the professional and casual dress sections at the end of this part of the book. Although 14 pairs of black pants might sound like a lot, when you look at how versatile they are from season to season, my collection is really not all that excessive.

Skirts: An Economic and Feminine Indicator

Some say that skirt lengths are as accurate an economic indicator as consumer confidence: They rise and fall with the economy. When the nation's income plummets, so do hemlines, signaling a more conservative outlook among the populace. When things pick up, well . . . so do hems. Skirts get shorter as people feel more optimistic about their future.

Economy aside, if you're wondering what length you should wear to

work, avoid styles that are higher than three inches above your knee, even if the trend of the moment is ultra short. A longer length typically sets a business tone. Whether for work or for play, be sure skirts fall at a flattering point on your leg. For example, if your knees are not your best feature, have the skirt hemmed to just below the knee, or even longer.

Here are some skirt ideas that are easy to incorporate into your wardrobe.

The long and short of it: Short, slim skirts emphasize the legs. If you weren't blessed with great gams, part with any skirt that stops above your knee. Longer, fuller styles flatter a variety of figures as long as they are made of fabrics with a soft drape. Stiff, heavy fabrics don't move well and will add bulk to your frame where many women don't need it.

Suit skirts: Many of my clients have a collection of skirts in their closet that originally came with a jacket as part of a suit. If the client works in a business casual environment, these skirts are often collecting dust and haven't seen the light of day in years. If they are not too dated (i.e., made of overly heavy and stiff fabrics or have heavy pleats that don't lay flat), they often can be reincarnated into a great business casual outfit by pairing them with a twin set or shirt jacket and a low-heeled pump. Even a loafer can work with this type of outfit as long as the fabric and length of the skirt can support a heavier shoe.

Flat-front A-line skirt: My personal favorite way to wear this type of skirt in the winter is by pairing it with a form-fitting sweater on top and a leg-grabbing, knee-high boot on the bottom. In the summertime, a lighter weight A-line skirt looks feminine when paired with an equally soft and flowing top featuring detailing such as ruffles, embroidery, or ethnic-inspired prints. It becomes more appropriate for work with a more tailored top. Sandals are the obvious footwear choice with any summer skirt you

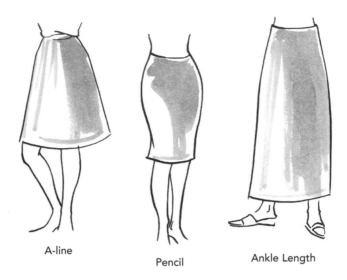

A-line

Pencil

Ankle Length

wear for fun. A sling-back pump can set you up better with this type of skirt at the office.

Pencil skirt: Think Katherine Hepburn or your favorite librarian, and you'll get the picture. What makes pencil skirts modern and, yes, sexy, are the new fabrics in which they are cut. This style starts at the waist and follows the natural line of the leg to its most flattering point. A kick-pleat inserted into the backside or center hem will provide greater mobility. Pencil skirts look most modern when worn with dainty heels.

Ankle-length skirt: If they are thin, the ankle can be a surprisingly sexy part of the body. They can be emphasized with a hem that lands where they begin. Many women favor this length skirt if they don't like to be overexposed after five. If you buy an ankle-length skirt that is very simple, it can look stylish for years as long as you update the accessories you wear with it. Petites, you can wear this style, too. Like so many of your other fashions, it's best to start your search in the petite department.

A Word on Dresses

Dresses can be fun, flattering, and a no-brainer on days when you don't want to think about coordinating an outfit. They can be ultra-casual, such as a sundress or beach cover-up, or make the most formal of statements such as when heading down the aisle to say "I do."

Dresses can work as professional attire as long as they are not too frilly or send the message that you'd rather be at a party. Work dresses are actually a nice change from suits and can be a simple choice in the morning. Like skirt lengths, it's best not to wear them shorter than three inches above the knee if you're concerned about setting a business tone.

Because dresses are not the easiest garment to fit if your proportions are different on the top and bottom, you need to pay particular attention to the styles that will fit and flatter you best.

Here are a few of my favorite styles and how I incorporate them into the wardrobes of clients looking for the quick, feminine fix that a dress can often provide:

Classic sheath: As mentioned earlier, this style dress is the most simple you can own. Paired with a jacket, it is a welcome change for women tired of skirt and pantsuits at the office. It is also an excellent office-to-dinner garment and looks great with pearls. Think Jackie O.

Wrap dress: Diane von Furstenburg first introduced this style dress in the 1970s, and it's hard to think about them without connecting them to the colorful printed fabrics she first made them in. Selected in a solid color (or more muted print), they are ideal for year-round social activities. I'm constantly telling my clients who date to pick one up! Those made of matte jersey define the waist, flatter a variety of bustlines, and hug the body instead of clinging to it. The deep V neck elongates the neck, and the slanted vertical line created by the wrap can slim the body.

A-line dress: This is a flattering silhouette if you are bigger on the bottom than on the top. It is fitted on top and then gently floats away from the hips, creating an A-line shape on the bottom. Wearing it with a slight heel will balance out heavier legs best.

Sundress: This type of garment works as daywear or beachwear and is easy to care for. You can fit a T-shirt under some of them, especially if the one you select has adjustable straps. Sundresses with the most simple lines and detailing tend to last for years, making them a true investment.

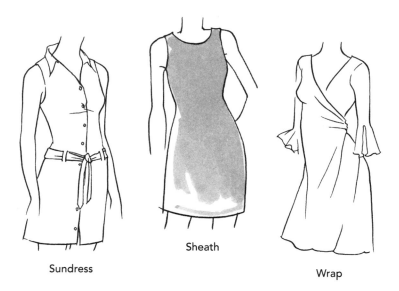

Sundress

Sheath

Wrap

9

Accessories: Make Your Look Your Own

The accessories you add to your suits, jackets, pants, skirts, and dresses can turn ordinary basics into signature fashion statements.

In my view, accessorizing extends beyond the "traditional" elements such as jewelry, shoes, scarves, belts, and handbags, to include all variety of tops and even buttons and undergarments. Why? All these items—including tops made with different necklines, fabrics, and embellishments—can dramatically alter your look.

Wow 'em one day by topping black pants with a zebra-print blouse. Go conservative the next day by pairing those black pants with a simple black cardigan. Punch up a solid-colored dress with an ethnic-inspired necklace, or tone down the same dress a notch with a demure set of pearls. Wear a black cotton sweater in the summer with mother-of-pearl buttons and white pants. For the holiday season, switch the buttons to a rich gold, and wear the sweater with burgundy velvet jeans. Show up to work wearing a well-tailored suit with a red turtleneck. After five, slip out of the turtleneck and into a lace camisole. Leave it peeking out of your suit for a night on the town.

I advise clients to invest 60 percent of their wardrobe budget on this expanded definition of accessories. You, too, can use this seldom-revealed yet

obvious accessorizing formula to create a new outfit every day from your existing wardrobe.

This chapter will walk you through the many ways you can incorporate both traditional and nontraditional accessories into your wardrobe. Because many accessory choices are tied to a particular season, you will find information about how to accessorize during different times of the year in Chapter Fourteen, the "Fashion Through the Seasons" chapter that concludes this part of the book.

For now, let's get started with undergarments. After all, what is underneath your base wardrobe is as important as what you top it off with, especially when you want your clothes to uniquely fit and flatter who you are on the outside.

The ABCs of Selecting Undergarments

As with alterations, clothing can go from good to great with the proper underpinnings.

While we all have our personal favorites in terms of brands and styles, the following is an overview of the types of bras, underpants, slips, and camisoles that will supplement your basic underwear collection.

- **Smooth-cup T-shirt bra:** This lightly padded, seamless style looks smooth under even the most form-fitting T-shirts and sweaters.

- **Racer-back bra:** The straps crisscross across your back to help eliminate wandering bra straps, especially handy when wearing sleeveless tops. If you have small or sloping shoulders and slipping bra straps make you nuts even with long sleeves, consider wearing this type of bra every day, regardless of the time of year.

- **Strapless bra:** The strapless is an important style bra to have because when you need it there is no alternative.

- **Invisible bra strap bra:** This newer style has clear, plastic straps (similar to clear Band-Aid strips), which are less noticeable and less prone to slippage than ordinary bra straps.

- **Convertible bra:** This provides you with many of the above styles all in one bra. You can go from strapless to racer-back to one shoulder to traditional and more—just by hooking the straps in different configurations.

- **Silk underwear:** If wool against your bare skin irritates you or if you spend a lot of time in a chilled environment, silk underwear will keep you warm without adding bulk. Because it is virtually weightless, it layers nicely without adding pounds.

- **Camisoles:** Use them for warmth, fashion, and fun. Get rid of the ones from yesteryear that are flimsy and not all that flattering, and opt for newer styles made with a percentage of Lycra or spandex to give yourself a more flattering and comfortable fit. Remember, although a hint of a lace camisole can be sexy in personal situations, underwear is meant to be left under wraps in professional settings. In other words, resist the urge to wear a camisole as a top in a business situation.

- **Briefs, bikinis, and thongs:** Whatever your preference, all these work well as long as they are large enough not to cut into your skin and produce lumps and bumps under your clothes. Consider substituting pantyhose with a lined crotch if panty lines are causing an unwanted distraction in your outfit. Whether you wear panties, nylons, or both, a cotton-lined crotch nearest your skin is important for the flow of air and to prevent infections.

- **Nude, black, and white underwear:** Contrary to what many women have been taught, white underwear under white tops and bottoms will show through. If your skin tone is very white to light

brown, wear nude underpinnings. If your skin is medium to very dark, wear black underpinnings under white clothes.

- **Body shapers:** These can shave ten pounds off your figure and often ten years off your age! Thanks to the addition and interesting mixes of spandex and Lycra, today's styles aren't exactly the same as the girdles your grandmother might have worn. Depending on your particular figure challenges, you can buy one to reshape your entire torso or enhance or slim a particular area such as your bustline, derriere, and/or thighs.

Although tossing undergarments in the washer and dryer along with other clothes might be faster and easier, be aware that heat destroys spandex fibers. Wash delicate undergarments (i.e., bras, body shapers, and lingerie) by hand or alone in a gentle wash cycle to increase their life span. I have a small rack in my laundry room for drip-drying delicates. I hang hosiery and bathing suits to dry here as well.

The Right Tops

Shirts, blouses, T-shirts, sweaters—they all add life to professional, casual, and dressy wardrobes. Here's a guide to wearing them well.

Topping Off Suits

- Blouses with conservative styling and necklines are the most traditional type of top to wear with suits. However, they can be fussy, hard to find, and hard to fit. I always joke with clients that you have to try on twenty blouses to get one that you keep, so don't give up too easily!

- Pay particular attention to how collared tops rest over the lapels of your jackets. You always want blouses and shirts to flatter a jacket, not overpower it.

- Dressy knit tops with a variety of necklines that flatter your figure might be all you need for your suits. Knits often stay put better than blouses, and they are easier to shop for. The colors I add first for most of my clients are black, cream, and brick red. Of course, the sky is the limit for adding any color that represents your personality and works well with your skin tone. Vibrant colors placed on user-friendly fabrics such as wools, cottons, and silks mixed with nylon, spandex, and Lycra make knit tops ideal layering pieces.

- Both flat and ribbed knit tops are handy. To show off a special necklace, wear a flat knit style. Its smooth finish will serve as a nice backdrop for the necklace, making it the focal point of your outfit.

- If you are top-heavy, ribbed Ts can make you appear even more full-busted. This, of course, has the opposite effect on small-busted women.

Know Your Neckline

- Turtlenecks, with their high, close-fitting neckline, look best on women with thin, long necks. A mock style is better suited for women with shorter necks.

- Chances are that you already have a few traditional turtleneck or mock-turtleneck

| Insider Tip |

Neck Check

Want to know whether you have a short or long neck? Do a neck check. If you can easily touch your chin to chest, you are short necked.

knit tops in your wardrobe. If you enjoy these styles, you might consider upgrading your collection to include cashmere. Pure cashmere and cashmere blends are available at many different price points today.

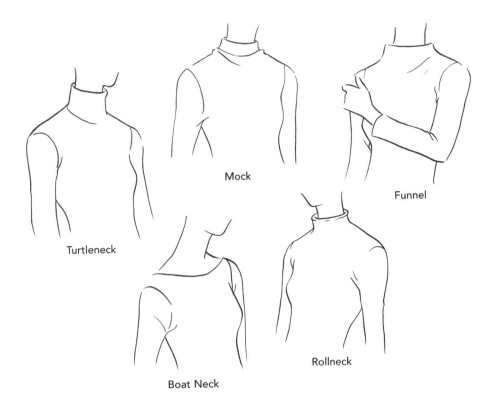

Mock

Funnel

Turtleneck

Rollneck

Boat Neck

- Overly casual cotton "skier"-style turtlenecks (think L.L.Bean or Land's End) are not the best choice to wear with suits or dress skirts and slacks. They are much too informal and are best saved for the slopes or for wear with jeans or khakis.

- A boat-shape neckline runs from one shoulder to the other and is the same depth front and back. If you have a thin neck, complement the line created with this silhouette with a choker. Flatter a fuller neck by wearing opera-length beads. The beads will create a flattering V line that will offset the strong horizontal line of the boat-neck silhouette.

- If you have a very casual lifestyle, add a few cotton roll-neck sweaters to your wardrobe. They look terrific in natural shades such as winter white and olive green. Like cotton turtlenecks, they are easy toppers for jeans and khakis.

Arm Yourself

- In addition to covering thick arms year-round, three-quarter-sleeve blouses, shirts, and T-shirts can eliminate the need to have sleeves shortened. Because they also call attention to lower arms and wrists, wearing a three-quarter sleeve is also a great way to show off bracelets and watches.

- Cotton T-shirts often look nice layered under casual sweaters with various necklines. White T-shirts in particular will help brighten your face. Wearing a T shirt under a scratchy wool sweater is also a great way to eliminate the itch.

- Sleeveless chunky-knit cotton sweaters are great for early fall and late spring, especially if you are happy with your arms. Funnel necks (yes, they create the illusion of a funnel at your neck) look particularly nice on chunky, sleeveless sweaters.

More Helpful Top Tips

- Details such as hoods, kangaroo pouches, and drawstrings give casual tops a high-style look on their own. Be careful not to overdo such tops with too many accessories.

- Peasant blouses with details such as puffy sleeves and smocked and embroidered fronts easily complement bohemian styles. They look great over slim-fitting denim skirts and jeans. They also flatter a variety of figures because they are cut fairly loose and tend not to be tight and clingy.

- Whether long sleeve, three-quarter-sleeve, or sleeveless,

Peasant

wrap shirts are handy to wear on their own and as a layering piece. The slanted vertical line created when you wrap the top is slimming and flattering on a variety of figure types. I love these tops over simple sheath dresses, especially for weddings and other formal occasions when you might need a little extra coverage during a formal service but still want to look feminine and fashionable.

■ Although it makes sense to stock up on thin sweaters and knits that can be worn on their own or as layering pieces, it doesn't make sense to have a whole bunch of big, bulky sweaters. These bulky creatures take up a lot of room in storage areas and chances are that you don't wear them all that frequently anyway—unless, of course, you are a ski instructor or are still in college. A few great sweaters that you love sure beat a whole bunch of pilled and dated ones that make you look frumpy!

■ Details such as a cable knit down the front of a sweater will build depth into your outfit. Wear a cable-knit sweater over heavy wool bottoms for a more balanced look than a slim, clingy-knit sweater can provide. I often recommend that clients who have a business casual work environment add a few of these sweaters to their wardrobe. The cable knit builds a nice boundary into the outfit, giving you a more dressed appearance than if you were to wear a flatter knit top alone over the same bottom.

Cable Knit Sweater

■ Blouses with ruffles, ties, and other embellishments can look particularly feminine and stylish. Many float over the body and are flattering to women of all sizes because they don't cling. Wear them peeking out under suits in conservative settings; wear them without

Ruffles

To Tuck or Not to Tuck

Women frequently ask me whether they should tuck in their tops or leave them out when putting together an outfit. If you have been pondering this same question, here are a few guidelines:

- Most pleated pants have belt loops and are designed to be worn with a top tucked into them and a belt secured through the belt loops. Just because a pair of pants has pleats, however, doesn't necessarily mean you have to tuck something into them. A loose fitting knit top worn over the belt loops can often be more flattering if you are sensitive to calling unwanted attention to your mid-section.

- Knit tops should be no longer than an inch below your hipbone. When tops that are too long are left untucked, your overall look can appear out of proportion.

- If you tuck a cotton shirt with tails into a pair of pleated pants and it feels and looks too bulky, consider having the tails shortened by a tailor or seamstress. Avoid wearing a shirt with tails untucked, especially if you are petite.

- Shirt jackets, on the other hand, look fine untucked over pants and skirts. They do not have tails and are cut evenly around the bottom. They often have side vents to give the shirt an easier fit over the hip.

- Flat-front pants have become just as popular as pleated pants. Many women prefer them because they flatter their figure better than pants with pleats. It's best not to tuck anything into flat-front pants. Doing so can create bulk. Ditto for elastic-waist pants.

Enhancing Communication One Top at a Time

During the November sweeps (TV lingo for the rating period that stations use to attract advertisers), I spend a considerable amount of time working with television news anchors and reporters.

This is an intense time in the news media world, and the stations that hire me appreciate my expertise in creating outfits that help viewers focus on the message rather than the messenger. The goal of this work is to eliminate wardrobe choices that can be distracting and, therefore, call attention away from the news at hand.

I always coach these clients to use the "light-with-dark and dark-with-light" method of dressing. This is a simple way to coordinate tops with suits, and anyone who wears suits can use this dressing strategy with their own wardrobe.

Here is how it works:

Technique #1: Light with Dark Coordinate a light blouse with a dark suit to frame the face and allow viewers to easily concentrate on what is being reported. This is why a classic navy or black suit works so well with a cream blouse, especially when paired with a pearl necklace and earrings. I also love introducing interesting, nontraditional color combinations to give dark suiting extra pizzazz. For instance, a chocolate brown suit with a lilac turtleneck or a navy blue suit with a soft green blouse can enhance communication as well as the client's personal style.

Technique #2: Dark with Light A light suit with a dark top can be more sophisticated than pairing the same suit with a light-colored top. Case in point—one of my television clients bought a camel-color, light wool pantsuit to wear on TV. Because it fit her beautifully, the only thing she needed to look more powerful on television was the correct top and accessories. We chose a black turtleneck knit top (i.e., made of cotton, silk, and a small percentage of Lycra) for her to wear with it. It fit her snugly at the neck, making it more visually appealing.

We also had the buttons on the suit changed from gold to black to build more depth into her overall appearance and to help all the elements of the outfit connect nicely with each other. I suggested gold "button-style" earrings as opposed to silver-based earrings to complement the gold undertones of the camel-colored suiting. Button-style earrings (the size of a quarter) also show up best on television and balance well with the weight of turtlenecks and wool suiting.

Although a necklace would have looked fine with this outfit, I suggested she leave it off so the outfit would not appear too cluttered on television. The result was excellent. Viewing her in this outfit was a treat. Because light coloring is a maximizer and dark coloring is a minimizer, the black turtleneck drew the eye in and framed her face in the same way as the dark suit/light top combination.

the jacket over skirts and pants for more dressy and/or casual situations.

- Although many silks cost more to maintain because of their dry-cleaning requirements, blouses containing a significant percentage of synthetic fibers such as polyester tend to wear out more quickly and produce more static electricity when worn in the winter.

- Twin sets (i.e., cardigan sweaters with matching shells) made of various fabrics are excellent wardrobe staples. They can be worn together or as separates. In addition to being stylish on their own, cardigan sweaters tied around the shoulders over suits, dresses, and tops (including the shells they match) can also serve as a shoulder pad, creating a balanced look over full hips.

Putting Your Best-Dressed Foot (and Leg!) Forward

Finding shoes that are comfortable *and* flattering to a particular outfit can be a challenge. Client after client shares with me her insecurities about not having the "right" shoe with the "right" outfit, and how much stress this situation causes in boardrooms, at weddings, and even strolling the beach.

It's one of those funny facts of life. People often do notice your feet first. Footwear that has been neglected or that has not been properly coordinated with an outfit can ruin an otherwise polished appearance.

The good news about shoes is that you really don't need many pairs to get dressed and out the door looking terrific each day. Yes, you might need

One of my favorite fashion quotes, "Give a girl the correct footwear, and she can conquer the world!" sits on my desk. Bette Midler first said these words, and she was dead on. I share her sentiments with many women who wonder if their shoe insecurities are valid.

a few extra pairs to get you through a weekend-long wedding affair or a trip to the Bahamas, but you sure don't need a ton of shoes, boots, and sandals in your wardrobe unless, of course, you have been diagnosed with an incurable shoe fetish!

The following is a guide that details a very basic shoe wardrobe. It is the same one I share with participants at the seminars my company provides for corporations and the general public. Use it as a quick checklist to evaluate the shoes you already own and to plan new purchases.

- **Traditional dress pumps:** Whether square-toe, pointy, or round (all these come in and out of style from season to season), be sure to choose a heel height that is most comfortable for you. Dress pumps work best with suits (both skirted and pant styles), as well as dresses and dressy or professional skirts or pant separates. Please refrain from wearing pumps with capris, khakis, jeans, or corduroys!

- **Sling-back pumps:** These can be worn year-round with a variety of fabrics. I like them best during the holidays and transitioning from season to season with clothes that feel too light for pumps yet too heavy for sandals. They can be worn with and without hosiery, making them even more versatile.

- **Loafers:** Loafers in a variety of heel heights and fabrications are a versatile shoe choice in all seasons. Choose chunky styles if you want to achieve an urban look. Stay with classic styles to dress down tailored pants and some skirts on business casual days or to throw on with jeans and khakis anytime. Buy the best pair you can afford. High-quality loafers can be re-soled over and over.

- **Ankle boots:** Client after client has thanked me for encouraging them to supplement their shoe collection with a pair of these handy cool-weather footwear basics. The heel height and toe shape are up to you. They look great with everything from pantsuits to jeans if

you live in an area with seasonal temperature changes. Ankle boots work well in early fall and throughout the winter. If you add knee-high boots to your wardrobe, save them until October.

- **Mules:** This closed toe, backless shoe remains my favorite casual transitional shoe style. I like high-heeled dressy mules as well, but there's nothing like a few pairs of more casual styles to get you through late spring and early fall casual dressing situations. Socks can be worn with casual-style mules in the spring and fall.

- **Dress sandals:** These aren't just for special occasions anymore. They can look as good with pantsuits as they do with an after-five cocktail dress. If you do find you wear them often, buy a few pairs—one to wear with clothing during the day and another pair to be worn exclusively with more delicate evening looks.

- **Casual sandals:** Black and brown are obvious good starter colors. The more colorful your summer shorts, capris, dresses, and other warm-weather clothes, the more colors of sandals you will probably

> | Insider Tip |
> ## Commuter Shoes
> Traditional white sneakers worn with a suit (even if you are commuting somewhere) are very passé! There are simply better comfortable shoe options today that don't draw unnecessary attention to your feet.

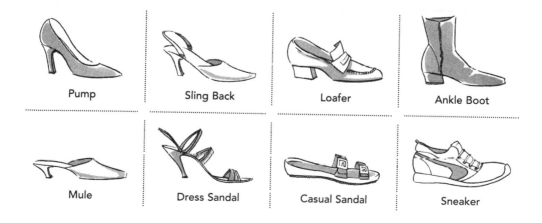

| Pump | Sling Back | Loafer | Ankle Boot |

| Mule | Dress Sandal | Casual Sandal | Sneaker |

want to add. It's also good to have a few pairs of flip-flops or thongs to wear exclusively to the beach and or pool.

- **Sneakers:** Although many of us like to have one or two pairs that lace up for sport activities, don't limit yourself to these styles if you'd like to make more of a fashion statement with your sneakers. Look for slip-on or zip-up white sneakers for warm weather and the same styles in black for the cooler months. I slip mine on and off all the time as I dash in and out of the house, every season of the year.

Fashion Focus: Tricky Shoe Q&A

Over the years, I have received many questions on our website about shoes. Here is a collection of those most frequently asked:

Do brown shoes ever work with anything other than brown or Earth-tone clothing? Brown shoes can be a nice option with navy clothes, especially when they are well coordinated with other pieces of the outfit. A casual pair of navy pants, for instance, worn with a cream twin set can be well coordinated with a brown loafer and belt. Adding a scarf at the neck that has navy, cream, and brown in the pattern is a great way to further pull together this outfit. While we are on the topic of brown shoes . . .

I have a brown dress pump that I seldom wear. Any suggestions? Contrary to what many women think, chocolate-brown pumps are not always the best choice with dark, chocolate-brown suits because dark-brown clothing today has a significant amount of black in them. Black footwear will often work better. Because it is a good strategy to wear a shoe with a darker color value than your hem, save brown pumps to wear with outfits that are lighter in color with a trace of brown in them. For instance, I wear a brown sling-back pump in the summer and early fall with a gold, cream, and

Shoe Pledge

At the beginning of every summer, many people in our on-line community send us this lighthearted shoe pledge and ask us to post it on our website. Every year we oblige. Here it is for you to read and enjoy:

Please raise your big toes and repeat after me:

As a member of the "Toe-Exposing Cute Girl Sisterhood," I pledge to follow these rules when wearing sandals and other open-toe shoes:

I promise to always wear sandals that fit. My toes will not hang over and touch the ground, nor will my heels spill over the backs. And the sides and top of my feet will not "pudge out" between the straps.

I will go polish-free or vow to keep the polish fresh, intact, and chip-free. I will not cheat and just touch up my big toe.

I will sand down any mounds of skin before they turn hard and yellow.

I will not live in corn denial. Rather, I will lean on my good friend, Dr. Scholl's, if my feet need him.

I will shave the hairs off my big toe.

I won't wear pantyhose even if my misinformed girlfriend, co-worker, mother, or sister tells me the toe seam really will stay under my toes if I tuck it there.

If a strap breaks, I won't duct tape, pin, glue, or tuck it back into place hoping it will stay put. I will get my shoe fixed or toss it.

I will resist the urge to buy jelly shoes for the low, low price of $4.99 even if my feet are small enough to fit into the kids' sizes. This is out of concern for my safety and the safety of others. No one can walk properly when standing in a pool of sweat, and I would hate to take someone down with me as I fall and break my ankle.

I will take off my toe ring toward the end of the day if my toe swells and begins to look like a Vienna sausage.

I will be brutally honest with my girlfriend, sister, or co-worker when she asks me if her feet are too ugly to wear sandals. Someone has to tell her that her toes are as long as my fingers, and no sandal makes creepy feet look good.

—Anonymous

brown printed skirt and chocolate-brown twin set. If you have an olive-green-colored suit, black shoes (not brown shoes, as many women assume) are the best choice with this color as well.

Can I wear black shoes with navy clothes? Black shoes often look best with very dark navy clothing. As I stated earlier, darker shades of blue have a lot of black in them and, therefore, coordinate well with black accessories. Light shades of blue clothing are more difficult to match. Black shoes can appear too harsh with lighter shades of blue, and it often takes a lot of hunting (and a well-trained fashion eye) to find an exact navy match. Still confused? Avoid navy suits and dresses completely!

Can I wear black shoes with light-colored clothes? Yes, as long as you train your eye to do it well. If a suit is made of silk or a man-made fabric such as tri-acetate that has a silklike sheen to it, a black patent shoe is ideal because the fabric and the shine of the shoe coordinate well. A sling-back style makes the outfit look even lighter and less harsh than a pump that is completely closed in. Consider wearing accessories such as a scarf or necklace that have black and the color of your suit in them to further pull your look together. I often replace light-colored buttons on a light-colored suit with darker buttons if dark shoes will be worn with it. Black patent leather shoes can be worn year-round as long as they are coordinated with fabrics that are not too heavy.

Simple Hosiery Guide

Many women who live in warm climates year-round go without hose entirely, opting for a barelegged look. Of course, not all of us were born with legs that look good without hose or have jobs that support the notion of bare legs, even in warm weather.

If you do choose to sport hosiery, the first thing to know when building your collection is how to read the packaging.

Whether the hosiery you select is dark or light colored, sheer or opaque in weight, look for those made with a percentage (at least 10 percent) of Lycra and/or spandex. This fabric mix is less apt to pill and bunch and will be more comfortable and durable than those made of 100 percent nylon. Lighter shades labeled "natural" and "nude" that are 100 percent nylon often have an orange tint to them that can take you back a few decades in terms of presenting a fashionable look.

Once you find a brand of hosiery that fits you well and are comfortable, stock up on them. Saving the packaging of those you like will also help you remember what to buy when you run out (or get a run!). You'll also need to know how to match them with the shoes and clothes in your wardrobe. Here's a simple guide:

| Insider Tip: Spanx |

A Bare Necessity!

When Oprah revealed Spanx as one of her fashion secrets, these body-slimming footless pantyhose flew off the shelves. What's so great about Spanx? They give you the support of pantyhose while allowing you to go barelegged. Most body slimming products are too thick or stop right at the thigh, causing discomfort and an obvious line, especially when worn with pants. The folks who make Spanx have broken through all these limitations to give women the benefit of waist, derriere, and thigh control while allowing them to show off their pretty bare legs and feet. Oprah always knows a winner when she spots one—Spanx are no exception! Visit spanx.com for more details.

- **Black hosiery.** In the cooler months, black hose conceal all sorts of leg imperfections and can be a logical choice to wear with black shoes and a black hem if you are less than confident about your legs. Black hose that have the word *sheer* on the packaging will look lighter and less harsh on your leg. Avoid black hose in warm weather. They will look heavy and out of place, even after five.

- **Nude/natural hosiery.** The new nudes (think Donna Karan on the high-end, Hanes on the moderate end) have perfected the natural look of hosiery. Sling-back and fabric pumps are a better choice than sandals if you like (or your employer requires you) to wear hosiery in warm weather. Nude hose go with every color in your wardrobe, even black.

- **Buff hosiery.** These are not quite nude but far lighter than cream. If you would like more coverage than nude can provide, buff is for you. Like nude hosiery, you can wear it with every hem and shoe color in your wardrobe.

- **Navy hosiery.** Nude and buff hosiery are better choices to wear with navy clothes and shoes. Navy knee-highs can be handy if you want to connect a navy hem to a navy shoe. Be sure all three navys (shoe, knee-high, and hem) are the same color value. A full navy leg can look dated with a skirt or dress. Many of my twenty-something clients have never heard of navy hosiery—honest!

- **Cream or white hosiery.** If you choose cream, be sure to select a very sheer pair. Forgo white altogether, or risk looking like a nurse on duty in the 1950s!

- **Opaque hosiery (a.k.a. tights).** These are fine for colder weather in the fall and winter, but avoid tights during warmer months. Even in winter, be advised that they can make your legs look heavier if they are worn with fabrics that are a lighter weight than the tights. You can start wearing them in September. Put them away in March unless you have an April snowstorm where you live!

- **Fishnet stockings.** The easiest way to successfully pull off a fishnet leg is to show just a hint of this texture. For instance, wear fishnet hose with knee-high boots and a knee-grazing skirt. Another popular way to incorporate fishnets into your dressy wardrobe is to wear them under pants with a mule shoe. Unless you work in the fashion industry (or other creative industry), be advised that wearing fishnet hose in a professional business environment is extremely risky.

A word on socks. When choosing socks, match the color to your shoe and the texture to your pant and top. A heavier sock will balance a textured

sweater or wool pant, while a thinner sock will work more naturally with a lighter fabric.

Parting thought on hosiery. If the entire topic of hosiery causes you to break out in hives, wear pants! Your hosiery choices become less important when wearing pants.

Tying a Look Together with Jewelry—It's as Easy as One, Two, Three!

The rule of three I mentioned earlier in this book in relation to accessorizing (i.e., it takes three points of similarity to pull a look together) is a particularly easy strategy to adapt when accessorizing with jewelry. If you are wearing a black sweater with a silver zipper, for instance, a silver pair of earrings is an easy choice. Not only will you be tying your look together with the silver earrings, but you will also be bringing attention up to your face.

When selecting jewelry, proportion and balance are also important. If you are a tiny petite, stay away from overpowering jewelry. If you are a plus-size woman or are on the taller side, you'll need bigger jewelry pieces to bring balance to your frame. Choosing jewelry that is the right proportion for you is the first step to wearing it well.

When a client is particularly overwhelmed with accessories, I'll ask her to slip on a monochromatic base (i.e., an outfit that is all one color from shoulder to hem) and to think of this outfit as a canvas and herself as an artist. Adding bold and whimsical jewelry such as beads, bangles, and pins to an uncluttered canvas is a great way for anyone to get these pieces out of their jewelry boxes and onto their bodies. Once you get comfortable wearing these items the easy way, you can start to connect your favorites to specific shapes, patterns and colors in your clothes for even more unique looks.

If you are looking to build a solid collection of earrings, necklaces, pins, bracelets, and rings, here are my top picks for building a basic jewelry collec

tion. I hope you have some of these items already in your wardrobe and get an idea or two of what you might like to add to supplement your collection.

#1. Classic Pearls

Whether real or faux, they add beauty and elegance to any outfit. There is a reason why so many women receive a pearl necklace and earring set as graduation gifts. They are an excellent jewelry starter kit for professional, social, and even casual dress situations. I love the way they brighten the face of anyone who wears them.

#2. Diamond Studs

Nothing is more elegant with many fashions than this simple stone at the ear. You might find that they are the only earrings you need, especially if the accessorizing game stresses you out. Wear them year-round with most outfits. If you can't afford the real deal, pick up a pair of cubic zirconia. You'll probably be the only one who can tell the difference.

#3. Two-Tone Earrings

A pair of two-tone earrings (possessing both a silver and gold finish) is terrific to own. They automatically add interest to your face and coordinate well with both silver and gold details on jackets, vests, glasses, belts, shoes, watches, and rings. They can also complement both dressy and sporty outfits. I call these a "no-brainer" accessory and recommend them to all my self-described "low-maintenance" clients.

#4. Gray Pearls

When you take your cues from buttons, the accessorizing game gets a little easier. With the emergence of gray as a significant base wardrobe color over the past decade, many buttons on shirts and blouses are now gray. When sporting these buttons, throw on a pair of gray pearl earrings. You will look instantly coordinated and pulled together.

#5. *Silver and Gold Cuffs*

Delicate chains and beads can get lost when worn with chunky sweaters, textured leathers, and stiff denims. Sterling and gold cuffs in a variety of sizes worn on your wrists with these fabrics look dynamite. I particularly like silver cuffs worn in the summer with whites and light-colored and dark-rinsed denims. They make a strong visual statement.

#6. *Vintage Pins*

A quick way to make a unique statement on a favorite suit or coat is by adding a "one of a kind" oversize vintage pin to the lapel. The more sparkle it has, the better—even for some daytime activities. Strategically pinning these vintage heirlooms to eveningwear, say on the straps of a gown or at the bottom of a backless dress, is also a stylish way to incorporate them into your wardrobe. Visit upscale secondhand and vintage stores for the best selections.

#7. *Garnet*

This deep-red gemstone (either real or faux) is a safe way to add color to black and gray suits and separates. Adding a few more items in this color to your outfit such as a shawl wrap, shoe, purse and/or top may be all you need to add a signature look to winter and holiday fashions.

#8. *Cocktail Rings*

Having one or two of these overstated rings that you wear specifically with certain evening outfits is a fun accessorizing option. Although you can't beat the real deal when it comes to diamonds, rubies, and sapphires, flea markets, vintage stores, and consignment shops are chock full of costume jewelry cocktail rings that are as fun to search for as they are to wear.

#9. *Watch*

A fine watch is a classic accessory. I always recommend that my clients purchase the highest-quality watch they can afford. A quality timepiece con-

Doubling Up

I was once called by the media relations department of a large international company to work with the company's newly appointed president. Because she was also slated to be the company spokesperson, they wanted her to receive some professional image coaching.

She was a self-described minimalist in terms of jewelry. She didn't want to be bothered with anything other than a watch and her wedding band. After getting all her clothing squared away at the store, I urged her to walk over to the jewelry counter with me. I wanted her to see for herself how her communication could be further enhanced with some visual interest at her face.

I gathered four pairs of clip earrings—pearl, gold, silver, and two-tone—for her to try. I was careful to select pairs that were not much larger than a nickel so they would look more natural than larger pairs on a gal who had short hair, wore little makeup, and had just bought very tailored and simple suits and separates.

The clips sat comfortably on her ear without pinching. She was happy that she would easily be able to take them off while she was on the phone. Once she agreed to purchase all four sets, I suggested she buy four additional pairs of the exact same earrings. Sensing her puzzlement, I quickly explained my rationale. She was to keep one set at home and the other in her desk for emergencies (e.g., Tom Brokaw calls for an interview on the day she forgets her earrings!).

The next day I called her secretary to let her in on the strategy. I asked this willing assistant to put together a professional image desk kit for her boss. In addition to buying static guard, a lint brush, some safety pins, a few extra pairs of hose, some clear nail polish to stop an unexpected hosiery run, and a few shades of lipstick to match various outfits, I also suggested she pick up a small jewelry case for the new earrings. When she delivered this handy package to her boss, she scored big points! And of course, with a permanent home, I knew the backup earrings would be easy for both my client and her assistant to locate and incorporate into her new professional image when they were needed.

Whether you work in or outside the home, wear clip or pierced earrings, or favor real or costume pieces of jewelry, this formula is handy to adapt. An extra benefit to this system is that if you lose one of the earrings, you have a backup. Of course, costume earrings are the most cost-effective way to make this strategy work!

notes prosperity, confidence, and success—just the messages you want to broadcast in your personal and professional life.

#10. *The Choker*

Wear this style necklace as a safety mechanism with a plunging neckline (it brings the eye back up!) or peeking out of an otherwise "buttoned-up" blouse to add a hint of sex appeal. It's traditionally an evening look but is increasingly worn during the day. It looks best paired with small earrings, or no earrings, it's up to you. *F.Y.I.:* You need a long, thin neck to carry off a choker.

Accessorizing with Scarves

Scarves are always in style in some fashion, but how you wear them does go in and out of style from year to year. Fashion, after all, does have to justify its existence!

If you are tall, scarves are easier to wear. Petite women have to give scarf wearing more thought, as this accessory can often overwhelm a smaller frame.

When I work with private clients, we often throw all the client's scarves on the bed and then go through each of her outfits to find scarf matches. When we find an ideal match, we hang the scarf with the outfit in the client's closet. By the time our session is done, we play with different scarf tying and draping techniques to be sure that the scarf is indeed worth adding to an outfit. It's the part of the shop-in-your-own-closet routine that I most enjoy.

Following are three classic scarf styles (i.e., always in fashion!) and some tricks for incorporating them into your wardrobe:

| Insider Tip |

Scarf Diet

One of my dear friends who is in her sixties confided to me that she always drapes an oblong scarf over tops and inside jackets to hide a thick midsection. I have shared this tip with many women, and they have been grateful for this advice.

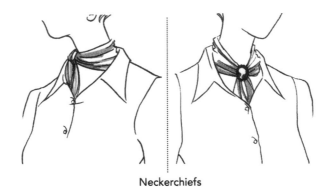

Neckerchiefs

- **Neckerchiefs:** These 21-inch-square scarves are easier to tie than larger ones, and they won't produce extra bulk on your frame. If you have a long, thin neck, you can tie them tightly on the neck to complement both casual outfits and suited looks. They can also be loosely tucked into the collar of a shirt or a jacket that buttons up close to your face to add color and interest to these necklines. If you wish to camouflage an aging or pale neck or are often chilly in cool weather when your neck is exposed, these scarves are handy. This size scarf is particularly useful for petite women.

- **Shawl wrap:** These oversize scarves provide instant drama for a night out on the town and plenty of warmth when worn casually over almost anything. Whether you look for one made of pashmina (a light, fine-fibered cashmere available in different weights), a more affordable merino wool, or one made of silk, polyester, rayon, or a fabric blend, they are available in a wide range of neutrals and a rainbow of colors. Lightweight wool and silk wraps are perfect for summer; heavier wool wraps often replace the need for a coat in cool weather.

Shawl Wrap

- **Oblongs:** The two easiest ways to wear these are tucked into jackets with various necklines to create the appearance of a shawl-collared blouse, or worn loosely or tied over both casual and dressier tops. When they are tied properly, they create a flattering V line that draws the eye in and up while adding an interesting dimension to your outfit.

Here are a few more useful scarf ideas and insights:

- **Divide and conquer.** As mentioned earlier, separate your winter outerwear scarves from your fashion scarves. If you have some big, oversize fashion scarves (i.e., made of silk, polyester, or very lightweight wools) you seldom wear, hang them with your trench coats. It's nice to drape these scarves inside a trench coat to connect the coat with your outfit (i.e., you are wearing a black trench over a navy suit—select a scarf with navy, black, cream, and some other colors that you like to pull the outfit together). Silk and

 Scarves

 polyester scarves tend to get lost when worn with wool coats. You are better off sticking with wool scarves with heavy, wool outwear.

- **Know when to leave them.** If a top has ruffles and other style details built into its design, leave off scarves. Wearing a scarf with one of these already adorned tops is overkill.

- **Punch them up with pins.** Wearing a necklace when you are already wearing a scarf can also look cluttered and distracting, but pins can look great with scarves when they are coordinated well. I love how Barbara Walters wears brightly printed scarves tucked into the neck-

line of both colorful and dark suiting. To complete her look she often secures pins that capture both the color and style of her scarves on the lapel of her suits. The pins are large enough (and placed high enough on her collars) to add a signature punch to her outfits without overpowering her small frame (yes, she is a petite!) or causing a distraction for her viewers. I turn on *20/20* all the time just to see what she is wearing.

- **Don't dangle and tangle.** Like necklaces, long, dangling earrings can look out of place when worn with scarves unless you are fairly tall, have a long neck, and know what you are doing. As I alluded to earlier, height and long necks are truly fashion assets when it comes to accessorizing!

- **Eliminate bulk and crowds.** Fabrics have been perfected over the past few years. More and more suits (even wools) are much more lightweight. Big, heavy scarves often look too bulky and outdated paired with these new fabrics. In addition, jackets with three and four buttons will crowd some oversize and oblong scarves. When a blazer has one button, there is more room to use a scarf to "fill in" the outfit, so to speak, than if the outfit is more "buttoned up."

- **Retire them gracefully.** You might notice that many young women wear long scarves through the belt loops of low-riding jeans. This look works on the young when the rest of their outfit is also hip and bohemian. After a certain age, wearing the young trends is more difficult to pull off and can look silly. If you have a lot of scarves you are not wearing, consider donating them to your favorite charity. High school and college students who frequent these stores will be grateful, and you'll never miss them!

Accessorizing Dos and Don'ts

By now you should know how to create your own personal fashion statement through the clever use of accessories. You've seen how the right top can dress up an outfit or tone it down. You've witnessed the power of the neckline and seen how undergarments can restore confidence (not to mention a figure).

But just to be sure that your signature fashion statements are not too bold, cluttered, or loud, I would like to step into the role of fashion police for a moment and leave you with a few accessorizing do's and don'ts to finish out this chapter of the book.

Do . . . Wear a belt that is very close in width to the width of the loops on your pants and skirts. Wearing a skinny belt, for instance, with a pair of pants with wide loops will throw off your style as much as forgetting to wear the belt at all.

Don't . . . Wear a sports watch to a business meeting.

Do . . . Scuff the bottoms of new shoes. Put them on and slide them along a rough surface (your driveway is a good place) to avoid an embarrassing fall at work or on the dance floor.

Don't . . . Load up on loud and distracting jewelry in a business environment (or church or synagogue for that matter). Wearing multiple bracelets can often be fun, but too many can be distracting in some settings.

Do . . . Pick up a straw hat to protect yourself from the sun's damaging rays in warm weather. Remember, straw accessories go away after Labor Day. They really are a summertime fashion.

Adored and Adorned

There are many things I adore about my friend June, who also happens to be a fashion consultant for my company. She is smart, funny, and always has a great read on proper social and business etiquette.

When it comes to accessorizing, nobody outshines June. She has an excellent eye for size, proportion, and detail, and she knows how to select bags, jewelry, hats, and scarves that add to outfits instead of detracting from them. Every season I (as well as her clients!) can't wait to see what she adds to upgrade this area of her wardrobe.

One of her signature ways to accessorize is with an assortment of silver and gold hoops. She wears them on her wrists, neck, and waist with style and class, knowing that small hoops can be worn anytime and larger hoops look best as an accent on more dramatic evening or fashion-forward outfits. One fall I started wearing a chain hoop belt with some of my separates after I saw June wearing hers over a sweater and pair of leather pants. Like me, June is a bit short-waisted. In addition to looking chic, this style belt slung loosely over a top or a dress is a great strategy for lengthening the torso.

June is also my favorite bag lady. Year in and year out, the bag she favors during the workweek is a medium-size, lightweight, black leather tote with compartments for both business and personal items. This bag has come in handy for many of the models in the fashion shows my company sponsors. If they need a pin, lint brush, or instant shoeshine, June's bag is the place to go!

Yet it's June's smaller bags that are most memorable. One day after delivering a professional image seminar together at a conservative law firm in Boston, June and I stopped for lunch. As we parked the car, she reached into her tote and pulled out the funkiest pony print clutch bag I had ever seen. While she would have looked inappropriate walking into the law firm a few hours earlier with it under her arm, it looked absolutely perfect with the black suit and cream shell she was wearing that day as we entered a restaurant in Boston's upscale shopping district.

At the beginning of each season, she takes note of what prints are being featured and adds them to her wardrobe through her evening, daytime, and, in the summertime, her beach bags. This strategy is a way for her to be on trend without committing to a fad long term.

The key to wearing any whimsical accessory is to make it the focal point in your outfit. You'll never catch June wearing competing accessories all at once. She knows it takes just one bold statement to give an outfit sophistication and pizzazz.

Don't . . . Skimp on your shoes and handbags. They can make (or break!) your style.

Do . . . Purchase suits, jackets, and tops with fur or beaded detachable collars if you would like to try these trimmings without committing to them.

Don't . . . Wear too much of any accessory. Jewelry in particular is meant to enhance, not overwhelm an outfit. To paraphrase Coco Chanel, the well-dressed woman is someone who looks in the mirror before leaving the house and removes one accessory!

Maximizing Your Wardrobe with Color

When I was in junior high school, my Aunt Joan gave me my very first fashion book, *Color Me Beautiful* by Carole Jackson. I was completely smitten by Jackson's concept of using color to bring out your natural beauty and spent hours in my room studying the different color combinations.

As a redhead growing up in the 1970s and 1980s, I often felt awkward with my pale skin and freckles. Discovering I was an "autumn"—one of the four seasons Jackson uses to help you determine your clothing color palette—gave me extra guidance on how to put outfits together. At the time, I had a chocolate-brown suede vest that I adored. I wore it with jeans over a cream, brown, and orange plaid shirt. The light bulb went on after I read the book. The reason this was one of my favorite outfits was because its warm undertones made my skin look healthier.

As her gift suggests, my aunt was also my "color" mentor. It became my hobby to study her outfits. For everyday wear, she would don soft hues and wear little makeup. For special events, she wore stronger colors and more dramatic makeup and accessories. Her strategic use of color has always taken years off of her age. To this day, I love chatting about color with her.

Knowing what to wear to make myself look better was a wonderful tool

to have at such a young age. Today, Carole Jackson's book sits prominently on a bookshelf in my office for both sentimental and reference reasons. I will always be grateful to my Aunt Joan for taking a special interest in me. By giving me the gift of color as a child, she taught me to give this gift to others in my adult career.

Your Color Comfort Zone

Even though I am a big fan of the *Color Me Beautiful* system, I caution clients against becoming a slave to their color palette. Fit, fabric, comfort level, and the appropriateness of certain colors in different situations and for different lifestyles are equally as important when deciding what to wear.

For instance, moms with small children are probably better served in dark base pieces even if their "palette" suggests they wear brighter and lighter shades of clothes. It's also a safe bet for a woman in financial services to have at least one navy blue suit regardless of what her color palette dictates. The trick to wearing color well is to honor your reactions to it, wear your best colors next to your face, and tap into your common sense.

Signature Colors

We all have "signature" colors as well. These are colors we are naturally drawn to. They become a theme in our lives, showing up in our clothing, accessories, and home décor. I work with three women, each of whom has her own personality, fashion style, and lifestyle. The colors that come to mind when I think of each of them are as different as they are.

Donna, who does the bookkeeping for my company, favors purple. She is a fair-skinned blonde with brown eyes. In the summer, she wears lilac, a soft, pretty pastel that looks great with her hair and skin tone, especially

when she has a bit of a tan. In the fall and winter, Donna wears deeper shades of purple. A plum pantsuit she frequently accents with a lighter purple blouse is one of my favorites. She also has a beautiful chenille scarf with various shades of purple woven into its design. This scarf looks great with all of her outerwear, especially a light gray duster she wears to dressy, evening events. Not only does purple look great on Donna, it fits her personality. Purple represents stability. Donna certainly has a stable presence in our office. Everything falls into place when she is around.

June is African American with blue undertones to her skin. She is a classic "winter." As a fashion consultant, June can pull off any color well, regardless of whether it's in her palette. She looks particularly good in blacks and whites and often sports a black pantsuit with a crisp white shirt on calls to our clients. It's a good choice for doing business, but when June wears bright, vivid shades, she really comes alive.

In wintertime, the color that defines June to me is a true red. I love when she shows up for one of our fashion seminars in a blue-red jacket or top. This strong color next to her beautiful skin helps create passion for our message from the audience. In the summer, I associate June with turquoise. She wears it with bright whites and silver and finishes the look with brown bags and footwear.

Christine, who handles our communications, looks best in Earth tones. We have dubbed Christine "The Ivory Soap Girl" for her natural beauty and sunny disposition. Her light brown hair, brown eyes, and warm skin coloring help her carry off warm, rich colors particularly well. Read "Color Christine's World" later in this section to learn more about Christine and her signature color.

As for me, I think all my colleagues would agree that I wear a little too much black! Although I know chocolate brown and olive green are better base neutrals for me, I consider black to be my "working" color. Interestingly, in my industry there are many people (especially when I'm in New York!) who wouldn't take me as seriously if I wore anything other than

black. Strange, isn't it, that for people working in an industry that thrives on variety in color, there is such an unspoken "uniform" requirement? Regardless of this rule, I really do feel great in black.

Of course, when I am photographed and in front of an audience, I pay more attention to my colors. As I age, I will undoubtedly want to add more color to my wardrobe, but for now, black serves me well.

Creating Your Own Personalized Palette

If you'd like to determine which colors look best on you, consider working with a professional color consultant. You can find one in the Yellow Pages, under the category of "Image Consultant." A color consultant will determine which shades look best on you by draping you with a white sheet and holding swatches of fabric next to your face. The family of colors that bring out the undertones of your skin will become your color palette.

This is a terrific service that typically comes with a fabric swatch kit of your best colors that you can take shopping with you or refer to as you play dress-up in your closet.

You can also try this exercise on your own. Stand in front of a well-lit mirror and hold a piece of bright, white fabric under your neck. Then do the same with a yellow-based, cream-colored piece of fabric. Note how each color brings out the coloring in your face. Which makes your eyes come alive? Which makes you appear more vibrant and healthy?

If the white fabric is most flattering, you have a cool undertone to your skin and you will look best in the following colors:

- Black
- White
- Emerald green
- Royal blue
- Blue-based red
- Shocking pink
- Silver

If the cream-colored fabric brings out your coloring, you have a warm undertone and you will look best in such colors as:

- Dark brown
- Cream
- Olive
- Teal blue
- Coral/orange
- Camel

Wear the right colors next to your face, and your skin glows. Wear the wrong colors, and you can look drab and unhealthy. Reviewing photos of yourself over the years will also help you to zero in on what looks best on you.

Subtle Messages

Something else to keep in mind when injecting color into your wardrobe is the subtle messages that different hues and shades send.

Think of your own reactions to color. Different shades of the same color can communicate very different things. Fire engine red screams emergency, while a brick red imparts a quiet stability.

Trial attorneys are masters of using color to their advantage with juries. I worked with a powerful criminal defense attorney many years ago who opened my eyes to this strategy. She often would wear a chocolate-brown suit when giving her closing arguments. She told me this color helped her come across to the jury as more down-to-earth and grounded. She would often wear a splash of hot pink or red with a conservative suit if she wanted to elicit passion from the jury. Of course, wearing either one of these bolder colors head to toe would scare the jury right out of their seats!

As part of my company's sales training programs for corporations, I ask participants to list their reactions to color as a way to increase their awareness about how co-workers and customers react to the very same colors. This

is a fun exercise that always gets a positive reaction from participants because of its practical implication and impact in the selling process. It is also an interesting study in human nature.

Following are some of the popular responses I have collected from participants I have engaged in this exercise over the years. Consider these responses (and your own reactions to color) when putting color into play in your own wardrobe:

- **Red:** Women tend to regard red as an energetic, emotional, and passionate color. Although many men feel the same way, I have had many male participants tell me it initially conjures images of romance and/or seduction! Same color, very different reaction. Wearing head-to-toe red on Valentine's Day with your beloved might be a big hit. Wearing it the same way in business could be disastrous.

- **Brown:** Based on my research, my trial attorney client is right. Even though this color can be a bit boring, it is also widely viewed as a grounding, sensible color. Both men and women tend to identify easily with someone who wears brown. Many women also think of chocolate-brown with black undertones as a sophisticated fashion color. I'm one of these women.

- **White:** Across the board people think of white as pure and angelic. Many also associate it with being casual and cooling in hot weather. Although the *Color Me Beautiful* loyalist would disagree, I think anyone can wear white during certain times of the year and for different circumstances. A crisp white dress shirt can instantly present a tidy appearance. A white T-shirt instantly brightens your face, and the strategic placement of this natural enhancer in an outfit can call attention to your finest physical attributes. Even when the fashion reports indicate it to be the "in" noncolor of a given season, be careful of how you wear it. It can look ridiculous worn head to toe, unless, of course, you are a bride!

- **Black:** This is the traditional symbol of mourning. But (as you all are well aware by now if you have read this entire section of the book!) it's also a fashion color and logical base neutral for building a wardrobe. It can communicate a cutting edge attitude or a more grounded one, depending on how it is presented. It can also come across as soft and feminine or severe and masculine. It's all about the styles you wear it in and the colors you pair with it.

- **Purple:** This is traditionally the color of royalty. Purple instantly imparts stability, dignity, and a calming presence. Most people like it and react well to it. Because it is available in so many shades, there is a place for it in your wardrobe year-round. It's particularly useful for ceremonial situations such as weddings when you don't want to wear more somber colors such as black, brown, or gray.

- **Blues/greens:** These are the colors of tranquility. Everyone looks good in certain shades of these two colors. They photograph well and are often good choices to help communicate your message. There is a reason news directors favor them on their news talent. Viewers are less likely to tire of these colors and, therefore, might stay tuned into a program longer.

- **Pink:** Both men and women commonly associate pink with baby girls. Women tend to like it better than men as a fashion statement, so be careful of wearing too much of it in certain business situations. I love it worn as an accent in its palest shade on women who are light-skinned and light-haired. I prefer darker shades such as fuchsia on women who are darker in complexion and have darker hair.

Interesting Color Combinations

The appropriate use of color can bring out your natural coloring, create moods, and send subtle messages. How you mix and match colors can add

interest and style to your everyday look. Following are a few unexpected color combinations for you to try in your wardrobe:

- **Khaki and red:** Chances are that you have a khaki-colored bottom in your wardrobe. Pair it with a red cotton top for a flattering look. If you're confused about what shoes to wear with this combination, stick with red. A sandal or loafer in the same tone as the top will tie your look together. Add a red belt and bag to further complete the outfit.

- **Brown and navy:** Dark-brown shoes can give navy clothing a new look. I once had a client who had a navy blue skirted suit. The skirt fell just below her knee and had a slit on one side. The suit was very flattering on her, yet she felt it was too boring worn with her standard pumps and a cream blouse. When we added a fashion-forward brown crocodile pump, the suit took on a new edge. She wore the combination with a slightly ribbed cream turtleneck untucked and belted with an interesting brown belt with the same croc finish as the shoes. It became one of her favorite outfits both with and without the jacket. I also love dark shades of denim with brown sandals in the summertime and early fall.

- **Camel and gray:** Camel always looks good with brown, cream, and black, but pairing it with gray will create a softened look. If you have warm skin tones, add a splash of brick red. Or if your skin tones are cool, wear white with your camel and gray combination for a more striking presentation.

- **Gray and beige:** This is a winning combination for those who aren't keen on a lot of color in their wardrobe but want to conservatively lighten their look for spring. It's a great alternative to the standard navy and cream combination so many women wear in the springtime. An easy way to get started with this look is by taking a light-

weight gray slack and pairing it with a beige twin set and a beige trench coat. Think of adding sophisticated geometric prints, such as the popular Burberry print, to this combination for an easy, classic, yet stylish flair.

- *Navy and lilac:* Many of our television clients opt for this combination with great results (i.e., the viewers love it). These two colors can be soft, like the aforementioned cream and navy, yet this combination is more interesting and offers a more feminine look.

- *Red and chocolate:* This is a winning combination when the weather gets cooler. The fall transitional season is very hard to dress for, so that's when I turn to brick red as an accent color. In fact, one of my favorite autumn outfits I throw on the minute the temperature drops is a brown cotton cargo pant and a brick red cotton sweater. My brown mules and a brown leather jacket are all I need to finish the look. For spring, take a lighter approach to this color pairing by mixing pink with brown.

Color Christine's World

One day in early May after work, my friend Christine—who is the communications manager at my company—and I headed off to the mall to supplement her summer wardrobe. She was preparing for a trip she would be taking to California with her husband later that month.

By zeroing in on a soft, green chartreuse color that looks particularly nice with Christine's warm coloring, we were able to zip through the store in no time and get her wardrobe completely updated and organized for her trip.

We started in the casual clothing department and picked up a chartreuse cotton twin set for her to wear on the plane. She planned to wear it with jeans until we saw a great pair of khaki capri pants with a colorful chartreuse, pink, and white ribbon trim at the hem. They looked great when she tried them on with the twin set, and she then had two great outfits to consider for the plane ride. The jeans would be great if it was cool and rainy; the capris would be perfect if it was sunny and warmer.

When we hit the bathing suit department, our chartreuse antennae went into action again. We gathered all the suits that had this color in them and headed to the fitting room. The one she selected also had pink in it, giving her a few more accessorizing options. A white linen shirt and pink flip flops already in her wardrobe would be perfect for coming and going from the pool at the California resort. Even the capri pants could easily be thrown on over this simple, one-piece maillot-style swimsuit. I suggested she look for a straw hat and beach tote with flowers in shades of green and pink to further pull together her growing chartreuse-themed warm-weather wardrobe.

By the time we got to the shoe department, our work was easy. She got a funky wedge-heel sandal with a chartreuse leather strap across the toes. They look adorable with the capri pants and with a green and gray halter-style sundress she picked up later that summer. She also picked up a practical (i.e., lower heel height than the sandals) pair of chartreuse mules to wear more casually throughout the summer and into the fall with white, navy, and khaki bottoms in her wardrobe.

Selecting one color as a wardrobe enhancer cuts down on impulse shopping. You also end up with a closet full of clothes that mix and match well. To this day, Christine supplements both her warm- and cool-weather wardrobe with chartreuse each season. She also has me trained. I can't go into a store without calling her if I see something great in "her" color. With her consistency (and me working as her scout!) she really has maximized her wardrobe with color and has outfits she loves to wear.

11

Your Professional Image

Getting dressed for the office used to be a relatively simple matter for the professional woman. Each morning, she would don a suit, slip into her pumps, and set off for work. Then came dress-down Fridays.

In many workplaces, what originally was a once-a-week opportunity to dress down has filtered into the rest of the workweek, leading to a downward spiral of the office dress code. While many women welcome the opportunity to shed their formal business attire, many more are unsure where to draw the line.

And rightfully so. Your appearance at work can affect your career. Business is about communication, and your clothing is an important way to get your message across. It might seem unfair, but how you present yourself at work does speak volumes about your all-around professionalism.

The woman who consistently shows up for work in revealing skirts and plunging necklines might be seen as frivolous. Co-workers might wonder whether she takes her job seriously. The woman who shows up each day more "buttoned up" has a much better chance of being regarded by colleagues as someone committed to her job.

"Business casual" is actually an oxymoron. When building your profes-

sional wardrobe, think business first, casual second—or never, if that is your preference. The best thing to come about after the casualization of the workplace in the 1990s (and the predictable shift back to a more formal style of dress in the new century) is women now have many more options when deciding what to wear to work.

If you work outside the home (or are planning to sometime soon), this chapter is specifically designed for you. Combine the information already covered in earlier chapters with a few of these extra business-wardrobe-building insights to further assemble a professional wardrobe that best reflects your personal style and career goals.

The New Professional Image in a Snapshot

We've covered the following categories of dress throughout this book. Here they are again with a twist toward how to interpret them specifically for business situations:

- **Traditional business attire:** Both skirted and pant suits fit the bill. Work dresses are also handy. This is the easiest level of dress for most professional women to pull off. No matter what industry you are interviewing in, you can't go wrong with a suit. In fact, human resources professionals tell me all the time that not wearing a jacket to a formal interview is risky and can send big red flags about your judgment and business acumen.

- **Business casual:** There are two types of business casual suitable for work. Each is a step down from the traditional styles, yet neither is sloppy or provocative. Use your common sense when practicing both options:

 Classic business casual: If you work in a fairly conservative industry such as accounting or law, this is likely the most appro-

priate casual style for you, whether your company is casual every day or only on "dress-down Fridays." Think layers even if you forgo a jacket. Pantsuits worn with knit shells and loafers, skirts worn with twin sets, and tailored pants worn with shirt jackets are an easy way to practice a classic business casual dress policy.

Relaxed business casual: In less-conservative industries such as advertising and manufacturing, other options such as khakis worn with polo shirts or even jeans and T-shirts are sometimes considered appropriate all week long and most always on Fridays. No matter how relaxed your business environment is, always get clarity from supervisors about whether jeans are acceptable before wearing them.

- **After five:** When you are dressing for an after-five work event, there is a lot to be said for looking festive without sacrificing your professionalism. A work invitation that calls for "cocktail attire" is often quite different than what you might wear to a party with family and friends. Parties held on work nights (including company holiday parties) don't necessarily require the same formality as a Friday or Saturday evening affair. Get into the habit of asking party planners for specific dress guidelines when attending these types of events.

Design Your Own Dress Code

In my role as a corporate image consultant, I am often called in to implement company-wide professional image programs that reflect both the industry of the company and its unique culture.

Although I love developing policies, delivering seminars, and conducting dress code research on behalf of my corporate clients, what I really love is when I am asked to work one-on-one with an individual employee.

Whether they are CEOs, salespeople, receptionists, or front-line people serving customers, they all have the same issues, questions, and insecurities when it comes to dress.

Helping these professionals understand how their professional image is directly linked to their success as well as the success of their employer is at the core of these individual sessions.

Here are the five steps I use to conduct private, one-on-one corporate image consultations to women (as well as men) in a variety of positions and industries. You can easily put these steps to use to help you build your own career wardrobe with more style and confidence:

Step One: Consider How Your Image Can Impact Your Professional Goals and Objectives

What are your career goals? What do you hope to achieve in a year, two years, five years? A promotion? A new job? Because your image can have a direct effect on your professional goals and objectives, your appearance at work should match your ambitions. Do a quick check by visualizing yourself reaching your career goals. How do you look? Will your current wardrobe carry you to the fulfillment of your goals? If not, some updating might be in order. Remember, dress for the job you want, not necessarily the one you have.

Step Two: Fit in While Standing Out

If you're concerned about how to dress for work, start by studying your industry and the culture of your workplace. As mentioned earlier, some businesses are more buttoned-up than others. At a financial services firm, for example, you will find employees wearing suits, even on some business casual days. This might not be the case in a more relaxed, creative environment such as an ad agency or a publishing house, where a looser style is the norm.

Your position will also dictate to some extent what you wear. If you're in high-tech sales and interact frequently with corporate clients, you should probably opt for a more conservative look. Your co-workers who write soft-

ware and rarely leave their workstation can probably get away with more casual attire.

There will be days when you find yourself in a range of situations and interacting with a number of different people. Plan ahead for days like these. Step back before you get dressed in the morning, and think about what you'll be doing that day, where you'll be going, and who you will be meeting with. Going on a sales call or to an off-site meeting? You might have trouble connecting with your clients if you arrive in a formal suit while everyone else is wearing khakis and sweaters. Call ahead and ask about the dress code. Receptionists and secretaries are accustomed to answering such questions. However, when in doubt, err on the side of being conservative.

Step Three: Understand the Messages You Are Sending

The way you present yourself at work sends management, clients, and colleagues powerful messages. Your professional image is the most important factor in showing management where you want to go within the organization. It also can help you gain the respect of colleagues and establish instant trust and credibility with clients who are making critical decisions about your company and its products and services.

Consider the following:

A polished, appropriate on-the-job image says:

- I'm ready for any situation.

- I'm the type you can promote with confidence.

- I deserve your respect, because I already respect myself.

An unkempt, inappropriate on-the-job image says:

- I'm not ready for further responsibility. I can't even get dressed properly.

- I'd like to stay entry-level, where it's safe.

- I don't care how my image impacts this company. I'm not a team player.

- I have no boundaries. Treat me as you wish.

There are three key factors in business clothing that have not changed over the years:

If you want the job, look the part.

If you want the promotion, look promotable.

If you want respect, dress at or above your industry standards.

When dressing for work, always reach for the clothing that shouts, "I'm a professional!" If you are standing in front of the mirror in the morning wondering whether an outfit for work is too casual, it probably is.

Step Four: Recite These Three Words Constantly

Appropriateness. Boundaries. Respect. Adopt that string of words as your mantra when you get dressed for work in the morning and when purchasing new clothes for work.

Appropriate dress is clothing that fits neatly into your work environment and will carry you through to meetings, lunches, or any other activities you have planned for the day. No matter what day of the week or what industry you're in, consistency in the way you dress goes a long way in establishing trust and credibility with all your business contacts.

Clothing that sets *boundaries* provides proper coverage at the neckline and hemline. In the workplace, you don't want to call attention to the wrong places. When setting boundaries through your clothes, don't neglect your feet and legs. Closed-toe shoes, hosiery, or socks are a good idea in most

workplaces if you are interested in maintaining a high level of business boundaries.

Finally, always demonstrate *respect* for yourself, your colleagues, and your customers by being mindful of how others may view your dressing choices. Jeans, sneakers, hats, and T-shirts—especially with logos not associated with the company—all have the potential to be viewed as a sign of disrespect when worn to work. If you choose to wear these pieces, remember to make sure your organization's dress policy clearly states that they are okay.

Step Five: Remember Those Three Other Important Words

Remember line, proportion, and balance from Chapter Five? When you assess your professional wardrobe, keep these basic criteria in mind. If you train your eye to meet these standards, the rest should come more easily.

Resorts, Conferences, and Off-Site Meetings: When Work and Fun Collide

Business travel poses a host of additional fashion dilemmas, especially when the trip involves a conference. Because conferences tend to be held at resorts, you will undoubtedly find yourself tempted to cut loose by the pool and the sauna, not to mention at least one work-related social event.

So what happens if you run into your CEO en route to the pool? Or you're jogging to the spa and see that prospective client you've been hoping to sign up? Never fear. It's possible to project a confident, polished image, even in these tricky work environments.

- **By the pool:** A one-piece swimsuit with a well-coordinated cover-up gives most women the confidence they need to talk business between dips. Manicures and pedicures can also help you feel more polished and confident in resort settings, especially if you will be poolside.

Investing in Yourself

I often tell clients that investing in themselves pays dividends. Splurging on the best suit one can afford for the job interview, for instance, can subtly add extra credibility to your potential net worth in the marketplace.

Many years ago I invested in a full-price Chanel jacket for myself that literally launched my career in a new direction. I have to admit I had no intention of buying this jacket when I first tried it on. The price tag was outrageous, and because it was made of a gold lame fabric (i.e., a fabric woven with flat, metallic threads), it appeared a little over the top even for me.

When I tried it on "just for fun," with my friend Rachel, a sales associate at Bloomingdale's, I fell in love. I also immediately knew it was just the thing to help me feel my personal best commentating the first charity fashion show I had ever been asked to host. It fit beautifully, and it actually looked more elegant on than it did on the hanger. With Boston celebrities and the media invited, I admit I was a little nervous about what I would wear for this engagement.

Wearing it the night of the show, I felt confident, poised, and ready to deliver my message. This night was also the first time I met the fashion director of the store who had hired me to commentate the fashion show. Because he is every bit as much the fashion enthusiast as I am, we immediately hit it off. He was one of the few people in attendance there that night who understood couture fashion and the significance of the fashion statement I had chosen to make. The beauty and elegance of this jacket was a wonderful icebreaker and conversation piece.

We shared the stage and the microphone that night and have remained good colleagues ever since. My relationship with both him and the people who work for him has been one of the most significant factors in allowing me to get my message out to a broader audience. They have referred me to many clients and continue to sponsor many of the charity fashion shows my company now initiates.

Although I do not wear this jacket frequently anymore, it has a permanent home outside my closet on a mannequin. Every day it reminds me of the importance of investing in yourself and how clothes can significantly impact your personal and professional goals as well as your bottom line. Yes, that's my Chanel mannequin on the front cover of this book!

- **At the gym:** Leave the business attire behind, but do make sure your workout wear is tidy, not too revealing, and in good repair. You could be riding in the elevator on your way to the gym when your next client appears in the elevator with you!

- **Conference social events:** Here's where you might be tempted to cut loose the most. Doing so is fine, but remember, you still want to keep the focus on business. That means forgoing the extra-low-cut neckline and ultra-short hem for an outfit that provides adequate coverage.

- **Special reminder:** Matte jersey—a soft, stretchable knit fabric ideal for summertime casual situations—is an excellent wardrobe staple, especially if you travel. I've raved about it in other sections of this book and feel the need to bring it up again here. If you attend off-site meetings, put this fabric on your shopping list. The four pieces I couldn't live without in my business and personal life are a flared pant, an A-line skirt, a tank top, and a cardigan. These pieces are great poolside over a bathing suit and can be dressed up and down for other resort activities.

Shed Your Baggage

In the first part of this book, I talked about the importance of coordinating your bags and briefcases with your personal style and professional image. I'd like to revisit that notion here.

Many women treat their bags as an afterthought. They grab them on their way out the door, never considering whether they go with what they're wearing or even if they're appropriate for the day's schedule. Here are some general guidelines for bags and briefcases:

- Keep it neat. A bag overstuffed with papers can give people the impression that you are disorganized and sloppy.

- For a slimming effect, choose a bag with a vertical rather than horizontal profile.

- Keep it proportional. If you are petite, choose a smaller bag that won't overwhelm your frame. Larger women can scale up in size.

- Adjust the straps. A good cobbler might be able to shorten or lengthen the straps on your bag to better fit your frame.

- Finally, remember that as with shoes and belts, it's important to take good care of your pocketbooks and totes so they don't detract from your overall image.

Business Casual Pant Choices

If you're like most women, you probably have a healthy selection of casual pants in your wardrobe. And chances are, you've spent quite a few mornings getting ready for work staring at them, wondering if you can (or should!) wear them on the job.

The following guide will help you know when to slip them on and when to leave them home when dressing for work. Remember, as with all other fashion choices, common sense prevails. Check with your HR department if you need some more clarification about how any of these fabrics and styles fit into your particular business culture.

- **Jeans:** Jeans have come a long way in the century and a half since Levi Strauss secured the pockets of his "waist overalls" and sold them from his San Francisco dry goods store. These days, jeans come in a plethora of cuts, colors, and styles and are the garment of choice for a variety of casual situations.

 For the most part, jeans, in any color, remain inappropriate for business situations. The problem is that although some folks look

great in them and understand the importance of making sure they are presented professionally, others will always look sloppy and, well, too casual in them. Also, you have no control over how customers and colleagues view jeans. As I mentioned earlier in this chapter, many people (especially those over a certain age) regard jeans as a sign of disrespect. They were never allowed to wear them to school, never mind to work.

- **Corduroys:** Corduroy pants are certainly more casual than traditional dress slacks—those made of light- to medium-weight wools. However, there is a place for them in a business casual wardrobe as long as they are in good repair and are presented professionally, which means pressed, tailored to fit, and coordinated with tops that are equally professional.

 Generally, the wider the wale, the more casual a corduroy pant will appear. Also remember that anything made of corduroy is classified as high maintenance. If corduroy items are washed excessively they will begin to look washed out and older than they might in fact be. Pay particular attention to the seat and knees of the corduroy pants you wear to work. These two areas of the pant often get worn out quickly and can look too casual for a work environment. Having them dry cleaned instead of washed can sometimes give them more longevity.

- **Khakis:** With the casualization of the American workforce over the past decade, khaki pants are not just worn in the warmer months anymore. In fact, entire industries claim them as their unofficial "uniform" all year round. If you choose to wear yours for work on business casual days, be sure they are in excellent condition. If you look like you are ready to rake your lawn in them, they are probably too casual for even the most relaxed business environment.

Khakis made out of 100 percent cotton generally do not wear as well as those made of light-weight wool or a combination of a synthetic fabric (like polyester) with the cotton. If you do choose to wear 100 percent cotton styles, consider having them dry cleaned if you are not disciplined enough to keep them wrinkle-free on your own. Dry cleaning can also give them a longer shelf life.

- **Capris:** Capri pants—generally defined as ending mid-calf—are considered a very casual, summer dress pant choice and are not the best pant length to wear in most business environments because they tend to scream "take me to the beach, please!"

 Having said that, a cropped pant—defined as ending just above the ankle—can be okay for work if they are presented professionally. A sling-back shoe or mule can give cropped pants a more professional look than overly casual or overly dressy sandals, especially if they have a matching jacket or conservatively styled top. Many capri pantsuits are designed for social events such as showers, special brunches, and rehearsal dinners. Be sure the ones you choose are not too frilly or light colored. These styles can look as out of place in an office environment as beachwear!

Picture Perfect

A professional portrait—referred to in the business world as a "head shot"—can serve a multitude of purposes. It can be added to your company's website or sent to trade journals and newspapers with press releases touting your latest achievements.

Whether you are in business or not, having an updated photo of yourself is handy. The following are some tips to help you prepare for a professional photography session:

The Power of Red

No other color is charged with as much energy, emotion, or passion as red. Its popularity in clothing is universal, spanning all ages, professions, and cultures. Contrary to what many think, anyone can wear red. The trick is to find the tone that best compliments your skin tone and personality.

When choosing to wear red clothing to an office or other professional setting, keep the following in mind:

- Pay attention to the shoes you wear with red. Black is usually your best bet, especially in the winter months. Black patent leather works well with smooth red fabrics such as wool gabardine and silk, while black suede shoes can provide a nice balance for heavier and/or textured red wool fabrics such as crepe or boucle.

- Nine times out of ten, black stockings appear too harsh when worn during the daytime with a solid red outfit. A sheer nude or buff hose will often create a softer, more professional daytime look.

- If you prefer to wear red suits with black stockings or black tights in cooler months because of the extra coverage they provide for your legs, do so strategically. For instance, change the buttons on the suit to black, if need be, so they connect nicely to your hose and shoes, lessening the severity of the combination. A black turtleneck worn with a heavier red wool suit, black tights, and black suede pumps can also help you achieve a well-balanced and figure-flattering appearance.

- Finally, remember that red is an intense color that elicits a wide range of reactions depending on how it is worn. Used wisely in business settings, it can enhance communication and create excitement for your ideas. Be aware that it can also be distracting when it is not presented professionally.

- Interview your photographer, and review his or her work.

- Schedule a portrait sitting for the time of day when you are most alert.

- Make the portrait sitting the day's priority.

- Get plenty of sleep the night before, and avoid alcohol, which can make your face look puffy. I've heard that eating watermelon for a few days before a photography session can greatly decrease water retention and eliminate puffiness. Hollywood celebrities swear by the watermelon trick!

- Ask beforehand about the color of the background to be sure your outfit won't clash.

- Consider wearing a jacket. It projects authority. A more casual outfit can work well for some industries. Be aware that a nonjacket look is harder to pull off in a professional photograph.

- Avoid patterned clothing, such as stripes and checks, which can make the photo appear cluttered.

- Keep jewelry to a minimum. Large pieces can be distracting. Button-style earrings—between the size of a nickel and a quarter—create just enough visual interest at your face.

- Avoid bulky fabric. The camera usually adds about ten pounds. Counteract the risk of looking heavier than you are by wearing a trimly cut outfit.

- Choose natural fabrics that will keep you cooler and more comfortable during the photo shoot. Grays, browns, blues, and pastels photograph best, even in black and white photography.

- If you wear glasses but prefer not to be photographed in them,

remove them a day ahead of time to get rid of any marks they might leave on your face.

Photos for business purposes should last up to five years, so treat them as investments. Consider enlisting the services of a hair stylist, makeup artist, and wardrobe consultant for the best results.

Fast Fashion Wisdom

I've never been on a game show before, but I sure got a feel for what it must be like when monster.com—the Internet's largest career site—called looking for some fast fashion wisdom for its online community.

In less than ten minutes, monster.com columnist Dona DeZube fired away, asking me to give her the first answer that popped into my head for more than a dozen questions. I was sure she was going to have to call me back for some clarity, but the call never came. In fact, the article was posted on monster.com so quickly, I didn't even realize it was the reason behind why my website was suddenly experiencing so much new traffic. Everyone seems to love fast, bite-size fashion tips.

Maybe I do perform best under pressure. The list she developed after our "Internet-speed" interview was one of the most accurate reflections of my *Dressing Well* corporate philosophy ever recorded.

By now I hope you will be able to recite the answers to most of these questions for yourself. As I close out this chapter on professional image, I thought it was worth repeating these themes in Dona's upbeat and fun style.

Not ridiculously thin like Calista Flockhart or Lara Flynn Boyle? Jackets camouflage a lot.

Your wallet a little thin? Buy a black pantsuit and wear the pants three days a week. Pair them with less-expensive tops from discount stores. Buy the matching skirt and dress when you save more money.

Not into trends? Twin sets (shells with a matching cardigan) are a no-brainer.

Need to hide a thick midsection? Wear tunic tops. (*Hint:* They have slits on the sides.)

Minimum number of shoes needed for work? Three for women: dress pumps, loafers, and ankle boots.

What's the best coat length for women? Three-quarter, or knee-length, to go with pants or skirts.

What's the best coat choice for everyone? A trench coat with zip-out lining.

How do I clean my closet? Get rid of the 80 percent of clothes you don't wear, and keep the 20 percent you wear 80 percent of the time.

Are manmade fibers really okay? Don't be a polyester snob. High-quality polyester travels well without wrinkling or wilting.

Do details matter? Yes. Shoes and belts must match, please.

I have money, so what's the key to looking good? Shop twice a year. Buy the whole outfit and get it tailored. Stop buying mix and match.

Does size matter? Yes. If you're a perfect size 8, you can buy cheaper clothes and they won't pull on you. If you're bigger and don't have much to spend, get one great suit.

How do I draw the eye up to my face and away from my (fill in your worst asset here)? Gold or pearl earrings instantly draw attention to your face. Collared shirts work, too.

Personal Time Casual

When I think about personal time casual dress in my own life, I think about the outfits I wear when I'm hanging out with my kids, running errands in town, having very casual dinners with friends and family, or catching a movie with my husband.

When I coach clients about how to define and then build this level of their wardrobes, I first ask them what they like to do in their spare time and what they envision themselves wearing.

If they have children, the topic of how to dress stylishly incorporates wash-and-wear fabrics and items that allow for a lot of mobility. If they are athletic or spend a lot of time at the gym, the conversation focuses on workout wear that will enhance their self-confidence when doing an activity that exposes a lot of their bodies.

I find that client after client neglects this area of their wardrobes. Somewhere along the line they were taught that you should only spend time, attention, and money on your work clothes and special occasion outfits. But think about it. You often spend the most amount of time wearing very casual clothes.

If this area of your wardrobe is underserved, this chapter is for you! When it comes to personal time casual, my *Dressing Well* strategy is to have a minimum of three "go to" outfits you feel great in. Whether those outfits consist of jeans, sweat pants, or running shorts, thinking about them before you wear them and then taking the time to be sure they are properly coordinated will help you slip into them with confidence.

Here are some additional tips to help you celebrate some of life's very casual moments looking and feeling your personal best.

The Skinny on Blue Jeans

During the Q&A portion of a corporate seminar I was delivering in Chicago one day, a young woman in the audience asked me how I stayed thin. As a way to deflect the question and stay on track with the audience I responded, "I have good genes."

When I was packing up to leave after my session, this same young woman approached me to ask if she could have the name of the "jeans" that make you skinny! At that point I knew what marketers to women have been keenly aware of for years—you can sell almost anything to a woman when an emotional promise is made with it!

According to consumer reports, blue jeans are an $11 billion business. And yes, a considerable amount of money is indeed spent by advertisers to seduce women into buying not just one but several pairs. In fact, most of the wardrobes I visit contain at least five pairs of these casual pants.

Yet women in general are notoriously unsatisfied with the fit or comfort level of any of their jeans. Because the thought of shopping for a new pair is more painful than wearing those that don't properly fit or flatter their figures, they often settle for mediocrity in this area of their wardrobes.

I happen to love blue jeans and have searched high and low for perfect pairs for clients and myself. Gone are the days that you have to settle for

stiff, denim fabrics that cut into your skin and/or for a boxy or ridiculously low-cut "relaxed" fit that leaves you feeling like a poor imitation of a teen rock star.

Here are some ideas to consider if you would like to upgrade this area of your wardrobe:

- **Go the distance.** If you have a particularly hard time finding jeans that fit and flatter, plan a shopping trip solely to purchase one pair. Like bathing suit and undergarment shopping, it can be emotionally and physically exhausting to try on style after style until you find one that flatters your figure and pocketbook. I can't tell you how many clients have kissed me after we found the perfect pair of jeans! More often than not, our success was based on trying on brand after brand, from store to store, until we found a style with the correct measurements. Due to the sheer volume of stores they contain, malls are a great place to start your search for jeans.

- **Hone in on your destination.** Some designer jeans go for more than $200 at high-end boutiques and department stores. Others can be picked up for a song at retailers such as JCPenney and the Gap. House brands at mainstream retailers often offer a broad range of sizes as well. Some of my clients with "boy-bodies" (i.e., wide waist, no hips, no fanny) have even reported finding their favorite pair in the boys' department for less than $18. I must admit that my favorite pair came from a tony boutique and cost more than I wish to disclose. When I put them on and the twenty-something sales team *oohed* and *aahed*, I fell for them hook, line, and sinker and headed to the cash register. Three designer jean brands I find particularly stylish for aging (but not over the hill!) bodies are Lucky, Diesel, and Cambio. Liz Claiborne, Talbots, and Jones New York work well for women of all ages. Many of my taller clients favor Eddie Bauer jeans because they carry styles with extra long crotches and legs.

- **Bump up in size.** If you are typically a size 10 pant, you might want to try on a size 12 jean. Rip the tag out if you don't want to look at a bigger size in your closet—getting the proper fit is much more important than pride!

- **Look for a percentage of spandex and Lycra.** Thanks to the addition of these two wonder fabrics, many jeans are actually much easier to fit and flatter these days. Many women unnecessarily shy away from these stretch styles thinking they will look too tight and cling to them in all the wrong places. I have found the contrary to be true. These modern fabrics, combined with sophisticated styling, actually allows many women who never thought they would see the light of day in jeans again feel quite comfortable and stylish wearing them. A boot cut leg will further relax the fit.

- **Consider customization.** Retailers such as Levi Strauss and Lands' End offer services where you can send in your exact measurements and have a pair of jeans made just for you. Although I was a bit skeptical of this concept when I first heard about it, several of my clients have had positive results with these services.

| Insider Tip |

The Skimpy Side of Jean Shopping

I often hold up a pair of pants in the exact same size as a pair of jeans as a way of showing clients how tricky it is to fit jeans. There is often a considerable difference in size at the waist, through the thighs, and in the crotch between the two pants. The jeans are the ones that come up on the skimpy side.

No matter where you get your jeans, be sure to allow up to an inch of shrinkage in the length when you purchase them. I suggest washing jeans before having any tailoring done to them. Like so many other items in your closet, jeans can go from good to great with the proper alterations.

April Showers

Creating a rainy day wardrobe for my sons has actually raised my awareness of the importance of having the right rain gear for myself and clients.

One rainy spring day, I put my boys in the car and headed to a children's boutique in our town that specializes in children's outerwear. It had rained every day for two weeks, and we were all going stir crazy. I picked out a rain slicker with a hood for both of them and also got duck boots and an umbrella for each. We dashed home, and we all went out and played in the rain. What a worthwhile investment. We were finally able to go outdoors, and everyone stayed dry. The umbrellas and boots in particular were a big hit!

The next week I went to an art festival with my friend Eleanor. I came across a beautiful raincoat that was as practical (i.e., it was full length and had a hood) as it was a piece of art. It was made out of a dark navy paisley fabric and edged with an interesting brown trim. It also had sturdy, decorative snap buttons that gave it even more of an artistic flair.

Because it was also priced like a piece of art, I originally passed on it. It did not have a lining, so my negative reaction to the price was further impacted by the fact that it was seasonal and I thought I would only have a limited amount of time during the year to wear it.

At Eleanor's urging, I went back and tried it on again before we left the festival. The color combination was flattering to my skin tone, and I started to think about all the times I was stuck in the rain wishing I had a stylish raincoat with a hood. My sharp (but hoodless!) collection of trench coats (and my husband's slicker that I had been wearing outside with the kids in my backyard) didn't hold a candle to the whimsical and useful casualness of this raincoat. As I started to count in my head how many times it would come in handy—(and Eleanor continued to whisper in my ear how great it was)—I decided to take it home. Of course, I further rationalized the price by considering it my souvenir for the day!

Now, years later, I can't imagine not having this coat in my wardrobe. I wear it all the time in the spring and fall. It is an ideal layering piece over both sweaters and lighter-weight spring and fall clothes and looks as nice with blue jeans as it does with dressier separates.

Taking a cue from my sons' practical rain gear collection, I completely upgraded this area of my wardrobe once I got the coat home and started wearing it. I purchased a pair of spring rain boots (both at home and on the road, moms often have to jump in puddles, too!), a sturdy black umbrella, and a few stylish rain hats that look as good with the new raincoat as they do with my short and long trench coats. I even picked up a pair of gardening mules that I love. I haven't had to think about or spend another dime on my rain gear in years.

April showers do bring May flowers. The right outerwear lets you weather both rain and shine in style.

Good Role Modeling

Many women who leave careers to be home with their children full-time have a hard time creating an image for themselves that reflects their new lifestyle. Some struggle with how to dress casually because for years all they wore were suits. Others get in the sweat suit rut and slowly lose confidence in their appearance.

I have worked with many stay-at-home moms over the years who struggle with putting together a new look to reflect their new lifestyles. In preparing this book, I asked three savvy moms (yes, one is my sister she's the certified therapist in the family—I'm the fashion therapist!) who have successfully mastered their stay-at-home looks to share their fashion insights:

"When I worked in public accounting, my wardrobe was fairly simple— suits, suits, and more suits! Getting dressed for work was easy because my industry is conservative and selecting clothes was somewhat predetermined. Now that I'm home, I can dress however I like. I've had fun dressing down some of my blazers with jeans, boots, and colorful tops and scarves. How I feel about myself has a direct impact on my kids. I want them to know I care enough about myself to take the time to look good. Hopefully, they're getting a positive message."

—Susan Rossi, CPA, mom to Ashley and Shane
Arlington, Virginia

"I think the suit I bought in college for interviewing is still hanging in my closet with the tags on it! I was a social worker for my entire professional life and never had to get super dressed up to do my job. In fact, dressing casually made me more approachable when working with clients. It was important that I wasn't too casual in order to create the appropriate boundaries, but I also felt it was respectful to always present myself neatly and pulled together. I dress pretty much the same now that I am

home with my daughter and son and hope to be as good a role model to my kids as I was to my clients."

—Kathleen Wunderlick, MSW, mom to Maggie and Bobby

Dallas, Texas

"I keep it pretty simple in the morning. All my power suits are long gone, and now I wear comfortable separates that are easy to get around in. I really believe that how I dress each morning shapes both my own mind-set and the reactions of others to me. I take my kids everywhere, and I like them to see me having confident and respectful exchanges with others. Spending a little extra time on myself also makes me happier. Buying a great new casual outfit each season is a good boost in a very hectic life. Of course, I'm also practical. I own very little that can't be thrown in the washing machine."

—Helen Jursek, Esq., mom to Kevin, Christopher, and Laura

Needham, Massachusetts

Workout Wear

When it comes to exercising, you want to wear comfortable and stylish clothes that you don't feel self-conscious in yet set you up to succeed in terms of shedding pounds or getting in better shape.

Here are some tips to building this area of your wardrobe:

- **Get organized.** Like all other areas of your wardrobe, the first step to feeling really great about your workout clothes is to visit the area of your home where you store these items and ditch all the ones that don't fit or that make you feel dowdy. Also get rid of items that aren't comfortable or are made of fabrics that don't allow you to move freely or breathe and sweat efficiently.

- **Think about your exercise routine.** If you change clothes at the gym, an oversize gym bag you can pack and unpack easily is a good investment. Consider keeping it in your laundry room so you can wash items and re-pack it conveniently. If you leave home dressed for the gym, a new running or sweat suit that flatters your figure can be the single best new item you add to your wardrobe. You'll feel good entering and leaving the building. You'll also feel better about running errands and meeting up with friends before and after your gym visits. Think of a well-coordinated sweat suit as both an image-enhancer and a time-management tool—I know I do!

- **Stay focused.** Selecting your actual gym clothes, especially when you feel less than great about your figure, can be daunting. Take a deep breath, and stay focused on the importance of pulling yourself together in a way that will make you feel good enough about yourself to keep exercising. My recommendation is to stay away from stirrup pants (they are dated and will do nothing for a full figure in particular) and other legging-style pants that fit tightly around the ankle. This silhouette will only draw attention to your hips and stomach.

- **Rethink your bottoms.** Instead, purchase a great pair of boot-cut Lycra gym pants if you don't already have them. The flair style of the boot-cut leg will balance out your hip and tummy area, giving you a slimmer and more hip look, no matter your age. If you have a more conservative style, you can also achieve this look with a pair of looser fitting running pants that have zippers at the ankles.

- **Layering works.** Top off the bottoms with a variety of exercise tops that further flatter your figure. Show off a toned upper body with a sleeveless, cropped top. Cover up arms and midsections with a short-sleeve leotard. Load up on T-shirts and sweatshirts that you can throw over your base workout look as you enter and leave the work-

out area. Long-sleeve tops can be thrown around your shoulders and waist to give you extra coverage when and where you need it. It makes sense to purchase a few updated sweatshirts and T-shirts that are not cut too long (ending no lower than mid-thigh) so your look is tidy and as current and stylish as possible. Older T-shirts and sweat-

| Behind Closed Doors |

Mother's Intuition

Although it's great to have things in your closet that help you celebrate life's happy moments, it's also helpful to have wardrobe basics that are appropriate and comfortable under the pressure of an emergency.

Case in point—several years ago, a routine "well" visit at our pediatrician's office when our twins were fifteen months old turned into an emergency road trip to Children's Hospital in Boston when the doctor detected an abnormal growth on the neck of one of our sons.

Before we left for the emergency room on the night of this petrifying experience, I stopped at home and changed from wearing a black Lycra bodysuit with a polar fleece top and running shoes into a fresh pair of khakis, a black turtle-neck, and black loafers. It has been my experi-ence that when I feel more pulled together going into an uncertain situation, I have more confi-dence. When meeting with the doctors that night, I felt respectful and respected.

When we were finally settled into our hospi-tal room early the next morning, my leggings and polar fleece went back on. I remember being grateful that I had recently updated this area of my wardrobe—purchasing a few new exercise type outfits and sneakerlike black shoes that zip up instead of tie. Having these items organized in my closet made it easy for me to pack for a few days away from home. Because these items are also machine-washable, they are a particularly stress-free way to dress when you are around children in any type of sit-uation.

I'm happy to report that my son came home ten days after checking into the hospital healthy and happy. For those of you who are parents, I'm sure you can all tell similar tales of being com-pletely caught off guard by an emergency involv-ing your children. It's times like these that organization in many areas of my life, including my wardrobe, is a true bonus.

shirts tend to look ratty. In addition, if they are oversized and sloppy, they will actually make you look and feel bigger than you are.

- **Color counts.** If you are self-conscious about your weight, choose your base workout pieces in black or gray. These dark neutrals are not only "minimizers," they are also stylish choices for exercise wear and double easily as street wear. If you are happy with your figure, wear any color you like. No matter what base color you choose to build your workout wardrobe around, you will automatically look slimmer in a monochromatic color scheme.

13

Special Occasion Dressing

I consider all life's happy moments special occasions. Weddings, vacations, bar mitzvahs, and the arrival of new babies are a few such celebrations I have helped clients (and myself!) prepare a wardrobe around.

Yes, there certainly is some amount of stress associated with dressing for all these situations. By setting aside some time well in advance of these events to do some wardrobe planning, you can pull them all off with style, confidence, and grace.

Here are some dressing well tips for getting you through some of the most special occasions in a girl's life.

Weddings: The Crown Jewel

Gone are the days when brides wore only white, members of the bridal party got stuck with dresses that could never be worn again, and mothers of the groom were expected to wear beige and blend in with the crowd.

I asked an etiquette consultant, fashion designer, and bridal magazine editor to share their best tips on the subject.

For the bride and bridal party:

According to Debbi Karpowicz Kickham, contributing editor at *Bridal Guide* magazine, although many brides do still wear white, color is also prevalent on the dresses of many brides today. Pale lavender sashes, pink bows, coffee accents, and even an entire dress in a soft pastel are what many fashion-forward brides opt to wear.

Gowns have also become more seasonless. It's not uncommon to see a sleeveless gown in winter with gloves and a pretty shawl or a gown with long, sheer sleeves at a spring or summer wedding. Gowns, headpieces, veils, and other accessories are often sold as a package, making it easy to complete your look with the same designer.

If you are more interested in coordinating your own bridal ensemble or you are a hard-to-fit bride, some designers now offer mix-and-match separates in every shape. You can get an instantly custom-designed and custom-fit bridal gown that is generally more affordable than a traditional gown and can be broken up into separate pieces to wear after your big day.

The mix-and-match concept can suit bridesmaids as well. You can flatter the figures of everyone in your bridal party with a customized top and bottom in the same style, or even allow each bridesmaid to select her own pieces in one common color.

For the mother of the bride or groom:

"Elegant, sophisticated, and timeless clothes are the best bets for mothers of the bride and groom who are after a more modern look," says designer David Joseph, who specializes in "occasion dressing."

Like today's mix-and-match brides and bridesmaids, David's mother-of-the-bride and mother-of-the-groom clients often request designs that can be worn beyond their daughter's or son's wedding day. Special occasion suits and dresses are not inexpensive, so women want to get as much mileage as they can from these pieces.

In general, and for spring weddings in particular, David recommends

that mothers include very little "flash" in their ensembles. Beading, rhinestones, or big shoulder pads are too heavy for the warm-weather season and can actually call attention away from the bride. Luxury fabrics such as taffeta and imported silks and clean, elegant lines are a much better choice for any well-dressed mother of the bride or groom regardless of the season in which the wedding is being held.

For wedding guests:

Etiquette consultant Jodi R. R. Smith coaches many women on appropriate wedding guest dress—a complicated issue these days. According to Jodi, in the summer (or for those who live in warm climates year-round), it is tempting to pick a white outfit to wear to a wedding. Dressy, tailored white suits or flowing white sundresses seem like an ideal choice. However, this is a definite etiquette faux pas. At best, you will be seen as thoughtless; at worst, you will be seen as competing with the bride. This is especially the case when you are in a similar age range. According to Jodi, the no-white rule is unbreakable.

Also beware of the above-mentioned color trend in wedding gowns. Jodi reminds that brides nowadays choose nontraditional gowns and dresses in pale pinks, pastel lilacs, champagnes, platinum, and more, so there's more of a risk of arriving in a matching shade. Destination, nontraditional, and second-time weddings will often have brides in unusual bridal apparel as well. You should not take the risk that you will be mistaken for the bride. When in doubt, pick a print!

And finally, many women ask about the appropriateness of black. According to Jodi, in the past, if a wedding guest or family member wore black, the symbolic color of mourning, it was because they disapproved of the match. Nowadays there has been a relaxing of the black restriction. Only the most conservative brides will object to black on guests. Many fashionable guests can and do wear black to evening receptions. The key here is to be sure the cut and style of the dress leave no doubt that the dress is designed for a party, not a funeral.

Special Occasion Q&A

Here are a few situations posed to me over the years about special occasion dressing. I hope you glean a few more dressing well tips that you can put to work in your own wardrobe:

Q: I have a pair of black matte jersey slacks with an elastic waist. On the same day, I have to go from a bridal shower at the bride's sister's house in the afternoon to a graduation party that evening for my nephew at my sister's home. Can you suggest a top to wear with the slacks that is appropriate for both parties? I wore the slacks last year but have gained a few pounds around the midsection, so the tops I wore with them then don't look as good.

A: If you are sensitive about your midsection, consider wearing a white linen shirt/jacket (i.e., ends mid-thigh) unbuttoned over the slacks. A silk T in a color flattering to your personality and skin tone worn underneath the shirt will pull the outfit together. This look will take you to both parties with ease and comfort. With an elastic waist pant, be sure to leave the silk T untucked over the pant for an even more slimming effect. Linen goes nicely with the matte jersey, and shirt jackets in general are quite handy for dressy casual events. A black sandal and some interesting jewelry will complete your look. All the major department stores have linen shirt/jackets in their house brand collection at reasonable prices.

Q: I have just purchased a two-piece plum velvet outfit for a black tie November wedding. The top is V neck with sheer ruffles around the neck and down the front covering the buttons, and the skirt is long with a slit up the front also ruffled around

| Insider Tip |

All Linen Is Not Created Equal

Irish linen is typically more expensive yet wrinkles less than some other linens. You usually get what you pay for when purchasing linen.

the bottom and slit. The color is a very dark plum. What would be the best shoes (type and fabric) and color stockings to wear? Also, I saw a plum-colored velvet evening bag with a satin trim and handle in a lighter plum. Would this be a good choice or too matchy?

A: I suggest purchasing a dressy black sling-back pump. Very sheer black or nude stockings both work with long skirts after five in cooler months. I'd go with a black purse so you can use it more than once and have it connect easily with the shoe. The shoe can have a satin finish or be a combination of leather and patent—plain leather will be a little drab.

Q: I'm attending an afternoon tea party for a few friends, and we've been encouraged to dress the part. What is appropriate dress for such an event?

A: If your tea party is in a city at an upscale hotel or restaurant, I would advise wearing a dressy suit and a classic pump. Pearls are an easy accessory choice for an elegant afternoon affair. If the tea is at someone's home, I would choose an embellished twin set (i.e., with some beads or sequins) and a dress slack. No matter where your tea party is being held, err on the side of being too conservative rather than too "after five"!

Five Steps to Smart Travel Packing

Many special events involve travel, and travel means packing. The good news is that an organized wardrobe, the right basics, and a few packing tools can make packing a breeze. So before you take your trip, take a trip to your closet and follow my five-step packing system:

Step one: Jot down each day you'll be gone and the number of outfits you'll need. Keep in mind the activities you'll be doing, the image you want to project, and the climate you'll be visiting.

Step two: Using this list as a guide, assemble complete outfits on single hangers, including belts, scarves, and other accessories that can be easily hung around the metal hook.

Step three: To make packing even easier, set up a portable rack outside you closet and line up all the outfits you plan to bring. Place the shoes and unhangable accessories and undergarments needed to complete each outfit on the floor, under the rack.

Step four: If you find you have too many outfits or need too many different shoes or bags, start to eliminate pieces that aren't versatile or replace outfits that need odd shoes with ones that go with shoes you are already planning to bring.

Step five: Next, slip the outfits, hanger and all, into a garment bag or remove them from their hangers and fold and pack them in your suitcase or overnight bag. When you identify and lay out everything first, you can then use your luggage space more effectively rather than stuffing things in as you go.

If you don't think your closet contains the necessary pieces to give you the style and confidence you want on the road, follow the above system, jotting down the missing pieces as you assemble your outfits. Make it a priority to fill in the missing pieces before your trip so you can relax and enjoy your vacation without being disappointed with your wardrobe.

More Tips for Travelers

- **Choose a basic color scheme, and stick to it.** Use two neutral colors such as black and white or khaki and red as the basis of your travel wardrobe.

- **Select fabrics that won't wrinkle easily.** Silks, cotton knits, and lightweight wools travel well. Avoid linen and rayon unless they have a synthetic blend.

- **Wrap them up.** Try putting a piece of plastic from the dry cleaner over each item of clothing in your suitcase. The plastic will form air pockets between your clothing and prevent wrinkling.

- **Pack hosiery in the original packages so you know they're run-free.** The last thing you need when you're headed to an important event is to be caught off guard by a run.

- **Create a getaway bag for weekend trips, and store it in your laundry room.** Wash frequently worn items and put them immediately back into the bag. Double up on toiletries and store them in here, too. Packing will become a snap.

- **Update your luggage.** When shopping for luggage for your travel needs, pay attention to the new items from luggage manufacturers. In the wake of the September 11 tragedy, manufacturers are attempting to become more sensitive to the changing needs of the traveler. For instance, some luggage now features clear plastic inside casings for easy viewing by security personnel.

- **Protect yourself.** Luggage can sometimes get lost. Always take a carry-on bag packed with medicine, toiletries, valuables such as jewelry, and a change of clothes, and label everything with your name and address.

| Behind Closed Doors |

Special Delivery

I thought I would end this section of the book with my own favorite special occasion dressing situation—my pregnancy!

When I found out I was pregnant with my twins, I must admit one of the first places I visited was my closet. At just six weeks pregnant, many of my clothes were already feeling a little snug at the waist, and I knew it would be only a matter of time before my tailored suits and slacks would be useless for a while.

So what remained in my closet? Everything with an elastic waist proved to be wearable through months three and four. Because tucking in anything was out of the question almost immediately, tunic tops that were perfectly good but seldom worn on my prepregnancy body also took on new importance.

When I had an occasion that required a suit, I used the rubber-band trick. For those of you in the dark about this handy gimmick (I know I was!), it is achieved when you loop one end of the elastic around your pant button, thread the other end through the button hole, then bring that loop back around the button again. This technique proved invaluable because I was still too small to wear full-blown maternity clothes but definitely needed a few more inches around my waist.

One of my favorite outfits during the first half of my pregnancy was my dad's tuxedo I had tailored down to fit me. With an adjustable waistband and funky boot-leg pant, I felt really great in his tux. I could dress it up and down, and I wore it to several Christmas parties that year. In fact, the boot-leg cut did so much to balance my protruding belly that the first official maternity pant I bought was also cut in this style.

The most enjoyable aspect of building a maternity wardrobe was realizing how few pieces I actually needed to get by and feel good. I decided to practice what I preach by looking at my business and personal calendar of events first, shopping in my own closet next, then making a list of what I needed before I ever stepped foot in a store. This focused approach to dress continues to be a winner no matter what dressing situation I find myself in—even pregnancy.

True to my *Dressing Well* philosophy, when my pregnancy was over, I moved my maternity clothes out of my main dressing area and into a spare closet in a guest bedroom in our home. Over the years, these clothes have visited the closets of two special sisters-in-law, many special girlfriends, and a few special clients. The best part of spending the time and energy building a beautiful maternity wardrobe is the fun you can have sharing it with other moms-to-be.

Fashion Through the Seasons

For those of you who live in an area of the world with seasonal temperature changes, knowing how to enhance your wardrobe through the seasons is the next step in being well dressed 365 days a year.

Here are some additional tips to help you recognize some of the gaps that might be worth filling in your wardrobe as you transition it from season to season.

Winter

Covering Up in Style

Having a cold-weather coat collection that complements your outfits, figure, and lifestyle is key to leaving the house feeling your personal best every day during the winter months. In professional situations, it's particularly important that outerwear not be an afterthought, as it can distract from an otherwise polished image.

Here are a few ideas to get your cold-weather-coat collection in outstanding condition:

- **Three-quarter-length wool coat.** Longer than a pea coat, yet far shorter than a full length formal style, it's more casual in its presentation yet still long enough for a blazer to fit underneath. It works well with both pants and skirts.

- **Camel-colored coat.** Camel-colored coats in any length are classics and can be coordinated nicely with black, gray, brown, winter white, olive, rust, and navy basics.

- **Shearling coat.** Real shearling coats are luxury items that allow for less-obvious conspicuous consumption than, say, a mink stole. If an authentic shearling seems out of reach for your budget, be aware that some fake shearlings look as good as the real deal. You might even be able to get one that is machine-washable.

Concealing Winter Footwear

A common winter fashion concern is how best to conceal winter boots so they don't detract from an otherwise polished appearance. Here are a few suggestions:

- **Save your pant outfits for snowy days.** Slacks are often better than skirts for concealing winter footwear and will provide extra warmth against the elements.

- **Be smart about skirts.** If you prefer to wear skirts, longer styles are obviously most practical on snowy and cold days, and your winter boots won't stand out as much as they might if you are wearing a knee-length (or above) style skirt.

- **Winter boots with zippers are the easiest to get in and out of.** Look for a pair low enough to stow in a tote if you frequently have meetings outside your office and will be changing into a regular pair of shoes. It's a good idea to have a plastic bag on hand to protect other items in your bag.

- **Choose a style of boot that will not look out of proportion with the rest of what you are wearing.** For instance, a knee-length boot that is rather bulky coordinates well with a long skirt, chunky sweater, and heavy overcoat. On the other hand, taller-style boots can often make you look "all feet," especially if you are petite and wearing a more conservative outfit and lighter-weight coat.

- **Winter boots don't have to be ugly!** Designers and retailers at all price points have stylish winter boots that are waterproof and salt- and stain-resistant. It's a good idea to inventory all your winter footwear at the beginning of the season, replacing and updating while the selection is at its best in stores.

Curing the Winter Fashion Doldrums

There's nothing like a new outfit to cure the cold-weather doldrums. Why not give yourself a mid-winter wardrobe lift by adding a bright, colorful sweater? As an added bonus, late-winter clearance sales might help you find a terrific bargain.

Colors such as cobalt blue, fuchsia, bright red, and sunny yellow look great this time of year over a favorite black pant or skirt. You certainly won't be committing any crimes of fashion with muted colors such as olive green, mustard, or cinnamon, but the brighter colors look especially crisp and fresh against the winter landscape and can do wonders for your psyche.

Chenille sweaters, made of cotton, silk, rayon, and wool, hold color particularly well and are often less bulky than sweaters made of 100 percent wool.

Fun in the Snow

Gone are the days when you have to forfeit comfort and style for warmth while enjoying outdoor activities in the colder months. Thanks to a variety of new "techno" fabrics, performance-driven style details, and a whole new range of fashion colors, ski clothing truly has transitioned from skiwear to street fashion.

If you are particularly fashion-forward and/or spend a lot of time on the slopes and are looking for variety in your skiwear, sporting goods stores in cosmopolitan areas and at ski resorts typically have the best selections. Sales are at their best in January and February. Skiwear featuring embroidery or made in such fabrics as waterproof ultra-suede is more and more popular on ski slopes all over the world.

Fur-trimmed hats, headbands, and collars are the rage for the fashion-forward set and can further help you develop a sophisticated ski style. Snow boots are available everywhere at a variety of prices. Real and faux fur linings make many styles extra warm and comfortable.

Spring

Wool Options for Winding Down Winter and Preparing for Spring

As the winter winds down, it's always good to get a few more wears out of all your heaviest woolens before packing them away for spring. Many wools can be worn year-round, so it's also time to start thinking about sprucing up your lighter-weight wools for warmer weather.

Because there are many different types of wool used by designers to make clothing, it's handy to know a few definitions about each along with how they will work for you from season to season.

- **Boucle:** A soft and thickly textured wool that is knit or woven to produce a looped or knotted look, boucle is commonly found in tailored jackets and dressier suits. Because the look is bulky, be aware that boucle can add pounds to your frame if it is not coordinated well. Many boucle suits in soft pastel colors are available in the spring. If you like boucle, wear it for dressy spring events such as weddings, showers, and graduations.

- **Crepe:** This is a very lightweight wool with a slightly pebbled surface. Commonly used in dresses, suits, and separates, crepe has day-

to-dinner flexibility. Many crepe separates can be worn ten months of the year. They do need to go away in really hot weather.

- **Gabardine:** Commonly used in separates and trench coats, gabardine is a highly woven, smooth, and strong wool, also referred to as worsted. Gabardine is a great transitional fabric. I love gabardine suits with cotton shirts because of the way the cotton connects to the smooth finish of this wool. Consider pairing a French blue dress shirt with a black, navy, gray, or chocolate-brown wool gabardine pant or pantsuit for a smart, year-round business casual look.

- **Lambswool:** Shorn from lambs up to eight months old, lambswool is a very soft fabric primarily used in sweaters. Because it sheds a lot, I recommend keeping it away from black pants and skirts! To lighten your look a little before the really warm weather hits, consider wearing a pair of cream wool trousers with a bright-colored lambswool sweater. This is a great way to dress casually elegant at social events in early spring.

- **Merino:** This thin, woolen, twilled cloth was developed during the nineteenth century from the wool of the merino sheep. Although it was intended primarily for outer garments, today merino is most often used for sweaters. This wool tends to be very warm but can cause itching for women with sensitive skin. Merino is usually more affordable than many other wools.

- **Cashmere:** Cashmere is more expensive than both lambswool and merino but worth the cost if the itch of other wools bothers you. Cashmere has come down significantly in price at many retailers over the years. Visit winter clearance sales to stock up on a few cashmere sweaters in classic styles that will last a lifetime.

Summer

Spotlight on Short Pants

Here's a guide to knowing what is what when it comes to short pants.

- **Capri:** The term *capri*, in relation to pants, was actually trademarked by Lee jeans in the 1980s. At that time, they introduced tight-fitting jeans that were shorter in length and had a slit on the outside of each leg. The name comes from the Isle of Capri, where this style first emerged. It is also the term given to any three quarter-length tight pants with outside slits.

- **Clamdiggers:** These are mid-calf, tight-fitting pants. Not surprisingly, the term *clamdigger* originated from cut-off jeans often worn while wading to dig clams.

- **Cropped:** Cropped pants is the general term used for pants that stop right at the ankle. You can start wearing these in the spring. They can set a business tone when worn with a light-weight business shoe (i.e., sling-back or fabric pump or mule).

- **Culottes:** Culottes are pants of various lengths that have been cut to hang like a skirt. Shorter culotte styles are also referred to as "skorts."

- **Gauchos:** Gauchos, or Charros, are wide, calf-length pants usually made of leather and inspired by the pants worn by South American cowboys known as Gauchos.

- **Pedal pushers:** Pedal pushers were so named because of their popularity for bicycle riding during World War II. They are straight-cut pants that fall below the knee and are usually cuffed.

Extra Tips for Warm-Weather Legs and Feet

- Many office environments require that you wear hose and closed-toe shoes with skirts, dresses, and dress shorts. Why? These organizations are sensitive to exposing large areas of bare skin in a business setting. Wearing hosiery can set a business tone and create a subtle business boundary, as can closed-toe shoes.

- Remember, sheer, nude stockings are the best choice for warm weather. Black and navy hosiery with a skirt or dress is a bit dated and can look too dark and heavy with lightweight fabrics.

- Some employers allow you to forgo hose, socks, and closed-toe shoes when you are wearing "appropriate" office clothes such as knee-to-ankle-length skirts and pants. No hose is a nice option—especially when the temperature soars—but keep your shoe choice professional. Flip-flops and platform sandals are not the best shoe choice in a professional business setting.

- An easy professional shoe choice for warm weather is a shoe with a heel height no higher than two inches, a closed toe, and either an open back (mule) or one with a strap across the heel (sling-back). Check your corporate dress policy before buying mules, as some label them too casual for work. Both mules and sling-backs can be worn with hosiery in warm weather. However, they both look more fashion-forward without hose.

- Don't wear heavy, leather dress pumps (ditto for boots!) with warm-weather fabrics such as linen, matte jersey, or silk.

- Sandals also go well with pantsuits, as long as both the suit and the shoes are very up to date. If you want to incorporate a colored sandal with this look, try matching the color of the sandal to your blouse.

- Finally, don't wear hose or dress pumps with capri pants. It defeats the purpose of wearing this casual trend.

Swimwear

It's an annual ritual as dreaded as tax time and as unsettling as a trip to the dentist: bathing suit shopping. Ease the pain of bathing suit selection by educating yourself on the styles most flattering to your particular figure:

- **Small bust:** Look for a suit that provides subtle enhancement—over-padding will look obvious.

- **Large bust:** Find a suit specifically designed for a long torso. The extra fabric will give you the coverage you need.

- **Thick middle:** Opt for design elements such as diagonal stripes to make your waist appear narrower.

- **Midsection that needs concealing:** Try stretch fabrics that will hold in your stomach.

- **Pear shape:** Select suits that conceal large hips, such as sarong, skirted, or short-bottom styles.

- **Long torso:** Look for high-cut bottoms to make your legs appear longer, taking the emphasis away from your middle.

- **Thick arms.** Try halter-style suits. Bathing suits that are tied around the neck create a flattering silhouette at the shoulder line that takes attention away from your arms.

And one final tip for painless bathing suit fashion—invest in some self-tanning lotion. A bronzed body will make you look and feel more confident!

Choosing Linen

The late Erma Bombeck once said, "My second-favorite household chore is ironing. My first is hitting my head on the top bunk until I faint!" If you love linen but don't like to iron as much as Erma, here are some tips for you:

- **Blend it.** Look for linen blends—fabrics that combine linen with other fabrics such as rayon to keep wrinkling to a minimum.

- **Extra starch, please.** Another way to control wrinkles in linen is to ask your dry cleaner to use extra starch when they launder your linen pieces. Your linens will be a little stiff when you first put them on, but as you wear them, they will relax a bit and hold up much longer than linens without the extra starch.

- **Dry-cleaning bags work wonders.** Frustrated with all your favorite vacation clothes coming out of your suitcase in a wrinkled mess? Try folding your clothes in plastic dry-cleaning bags before packing them. We are also big fans of using hanging garment bags whenever possible when transporting clothes.

- **Invest in dry cleaning!** In addition to sending linens, silks, and wools to be dry cleaned, consider sending cotton shirts, khakis, and the like to be professionally cleaned and pressed as well. With today's busy lifestyles, being able to grab clothes quickly from your closet knowing they are ready to wear is an excellent time-management— as well as confidence-building—tool.

Fall

Successfully Transitioning Your Wardrobe for Cooler Weather

The rules for what is and isn't acceptable to wear after Labor Day have changed over the years. No longer is it necessary to pack all your whites and linens away the minute September 1 rolls around. It's also not uncommon to see sandals, bare legs, and sleeveless looks being worn into October.

So how do you mix and match what is currently in your wardrobe in a way that is appropriate for the fall season? Here are some handy guidelines for remaining fashionable in fall:

- It is still best to pack white linens away after Labor Day. Ditto for white shoes, white sandals, and white denim.

- Follow the same guidelines for white when determining when to pack pastel and other light-colored cotton and linen clothes and accessories away.

- Pastel-colored wool tops, particularly in cashmere, can be handy wardrobe transition pieces. For instance, consider wearing a short-sleeve or sleeveless apricot sweater under a lightweight black wool suit.

- Darker linens such as black, chocolate brown, and hunter green are fine to wear through September.

- White T-shirts are great for layering, and crisp, white shirts are excellent year-round, especially for those choosing to practice a business casual dress option.

- Not ready to part with your sandals after Labor Day? Black or brown "city sandals" (i.e., a little chunkier in the heel with more coverage across the foot) are a better transitional sandal choice than strappier styles that automatically scream summer.

- If you work outside the home, be sure to review your company's dress policy. The list of what is and isn't acceptable often changes after Labor Day.

Expanding Your Footwear Collection

Many women only wear black footwear because it is the easiest color to coordinate and makes dressing a snap. However, brown is also an excellent neutral and can be added to your wardrobe nicely when you follow a few simple strategies.

Here's a simple strategy for adding brown boots to your wardrobe:

- **Belts matter.** Because matching your footwear to your belt can instantly pull an outfit together, have at least one belt in the same

color and finish as the boots. A thin, two-inch belt to go through the loops of jeans and other pants with belt loops is a good first choice; a larger, more interesting brown belt can be worn belted over sweaters and is handy hung low on your hips, depending on your personal style preference.

- **Top them off.** Wearing a belt is not always an option, so I also suggest picking up a chocolate-brown sweater in the same color as the boots to be worn untucked over the waist of a pant or skirt. Other obvious sweater choices to wear with brown boots are beige, cream, orange, and those with interesting patterns composed of neutral and Earth-tone colors. Brick red, turquoise, and various shades of green also work well with brown.

- **Hosiery is key.** Although blue jeans and khaki pants with a boot-cut leg are the most obvious bottoms to wear with the new brown boots, long and short skirts also look good with ankle boots. A pair of chocolate-brown tights in the same hue as the boots is a sophisticated choice that can make your legs look longer and leaner. Yes, it's always best to match your hose with your shoes instead of the hem of your outfit.

- **A special tote.** Having a brown tote that you can easily grab when you are sporting brown footwear is smart. Select one that is roomy so you have the option of fitting other bags inside if you are in a rush and don't want to completely switch bags.

- **The proper coat.** Outerwear should not be an afterthought when adding a new shoe color. Consider adding a brown leather or suede jacket to wear with your brown boots to get you out the door looking extra sharp!

Choosing Knits

Knits are warm, comfortable, and make a reliable travel companion because they seldom wrinkle.

They can also solve the professional woman's dilemma of what to wear on business casual days. Cardigan styles worn over coordinated knit tops, shirts, or blouses provide a softer look than a blazer while still setting a business tone.

In addition, knits can be very artistic when they are woven with interesting combinations of textures, colors, and threads. They can also make you feel feminine, festive, and romantic, especially when you choose them in luxury fabrics such as cashmere.

Some larger women think they can't wear knits because of the "cling" factor. Yet knit designers at various price points have developed techniques that lend a flattering drape no matter your size.

For extra comfort, many designers sew elastic waists into knit skirts and slacks. The elastic is easily masked through accessorizing and layering.

If you travel, consider buying five easy knits—a skirt, two tops, a layering piece such as a cardigan or pullover, and a pant. The key to wearing these knit separates well is to buy them together from the same manufacturer to ensure that the fabrics and colors flatter one another, and also to have plenty of accessories to make them look different night and day.

Last thought on knits: Put your jewelry on last. Knits can snag easily, so don't take the chance of getting a bracelet, watch, or necklace caught in the loops.

Reviewing Your Autumn Outerwear

In early fall, lightweight blazers, sweaters, and shawls are good layering options to ward off the chill that is often present first thing in the morning and then again as the sun goes down. Barn jackets and jean jackets are also handy this time of year, depending on your casual style.

Both long and short trench coats without heavy linings also come in handy on September days when it's either stormy or unseasonably chilly. If a trench coat has a zip-out lining, the lining typically goes back into the coat in October.

Leather jackets, always a popular fashion item, can be introduced back into your wardrobe anytime in September. When wearing leather outerwear, make sure the rest of your outfit is properly coordinated. For instance,

a leather jacket worn with jeans, a leather loafer, and a crisp, cotton shirt most likely will look better than a leather jacket worn with a linen skirt, sandals, and straw bag.

Before you know it, real cold weather will arrive. Don't forget to take an inventory of your wool coats, scarves, gloves, and hats so you can stock up on these essentials while merchants have the best selections.

Holiday

Jazzing It Up

There's no need to buy lots of new clothing every holiday season. You can easily jazz up your regular clothes for some glitzy party looks. Here are some ideas:

- **You guessed it...Start with black:** Black separates in your wardrobe are the easiest items to dress up and down. If you have a black suit, consider slipping a beaded camisole underneath. Dressy jewelry, handbags, and shoes can give this type of outfit additional holiday appeal.

- **Holiday jeans:** Black velvet jeans are an excellent investment for winter. During the holidays, top them off with a red or green turtleneck or holiday sweater for a casual look. Pair velvet jeans with embellished sweaters for a more dramatic presentation. Black ankle boots and mules in a variety of heel heights and finishes look great with this type of jean.

- **Visit lingerie departments:** Some of the best (and most cost-effective) fancy tops to wear under suits for the holidays can be found in lingerie departments. Silk and lace tops can look great peeking out from jackets and tops.

- **Pumps versus sandals:** You can wear open-toe sandals after five in the winter, but opinions vary as to whether hosiery is appropriate. I

generally recommend wearing sandals during the holidays with long dresses, skirts, and dressy pants. Because most of your leg is covered with these styles, hose (or lack of them) are less obvious. If you are wearing a short skirt or dress, stick with dress pumps and hose. Opting for sling-back pumps will give you the best of both worlds.

- **Handbags count:** A great handbag can dress up a simple outfit. While it's always safe to match your evening bag and shoes, you don't necessarily have to do so. Some evening bags are special enough to accent your outfit on their own.

Voluptuous Velvet

When in doubt about what to wear to an evening or daytime holiday or winter celebration requiring a dressy casual outfit, consider wearing velvet. Velvet has lost its evening only status over the years and is available in both jean and pajama-style pants, tunic tops, dresses, and skirts of all lengths and styles. You can dress velvet up or down just by changing your accessories. With the addition of spandex, Lycra, and other fabrics that stretch, many velvet pieces also allow you to be as comfortable as you are elegant!

| Insider Tip |

Caring for Velvet

My friends at Quincy, Massachusetts–based Dependable Cleaners tell me that the best-quality velvet has a deep pile and is made from cotton or a cotton-rayon blend. Acrylic is also used to make velvet, but it is less durable and the pile is easily damaged when moist. Areas in velvet that show wear most after only a limited amount of use are the seat and crease areas at the hips, knees, and elbows.

Check the care label on all your velvets. Although some are machine- and hand-washable these days, it still might be best to have all your velvets professionally dry cleaned. Dry cleaning is the gentlest method of cleaning velvet. Reputable dry cleaners also have specialized equipment to help restore it after each wear.

Smart Shopping

THERE'S SOMETHING ABOUT SHOPPING. YOU EITHER LOVE IT OR HATE IT. REGARDLESS OF WHICH CATEGORY YOU FALL INTO, SEARCHING FOR NEW CLOTHES AND ACCESSORIES CAN OFTEN be overwhelming. When you walk into a store and see racks upon racks of clothes, it's hard to know where to begin, let alone how to select a complete outfit. A confusing array of merchandise along with special store sales and markdowns can lead to impulse buying and disappointing purchases.

Over the years, many women have shared with me why they don't like to shop. Some are intimidated by the process. They're not sure what looks good on them, and they're terrified of making costly mistakes. Others have busy lifestyles and resent the time they have to spend searching for new outfits. Women in both categories will put off shopping trips and settle day after day for the clothes and accessories they already own but which they know are holding them back from looking and feeling their personal best.

Then there are the shopping fiends. They're the ones who can't wait to add more clothes to their wardrobes. I always get a kick when people call our office completely overwhelmed with their bursting-at-the-seams wardrobes yet can't wait to whip out their calendars to schedule an appointment with us at the mall. They're always a bit disappointed when I suggest that we

devote our first session together to sorting through their wardrobes, rather than adding to them. In the end, these same women are always grateful that we slowed down the process of acquiring new clothes and helped them first develop an organized approach to dressing well. They come to understand, as I'm sure you have after reading the first two parts of this book, that the closet is where the magic of owning your personal style truly begins.

Whether you are a shopaholic or a shopping neophyte, the following chapters will help you set yourself up to be a savvy and, yes, ruthless shopper no matter where or when you hit the stores or what your budget might be. You will learn to avoid those shopping blunders that will cost you money and take up valuable space in your newly organized closet.

You'll also find in this part an overview of the many different shopping destinations available to you in today's modern economy. From department stores to catalogs to the Internet and your television, fashion is truly where you find it. This part of the book will help you fine-tune your shopping options and help you focus on where to spend your wardrobe dollars.

Finally, we'll look at those times of the year when retailers lure us into spending money on clothes. Our shopping-by-the-seasons guide will help you further fine-tune the amount of time, energy, and money you devote to this activity.

I encourage you to revisit this section often as you build a wardrobe that reflects your lifestyle and is full of items that are not only well coordinated but that you also love to wear. Here's to being a savvy and successful shopper!

Before You Shop:
Setting Yourself Up to Succeed

You know how airplane pilots have a preflight checklist? They follow set procedures before takeoff to ensure the flight goes smoothly. Well, before you take off for the stores, prepare yourself by following this checklist.

Pre-Shopping Checklist

- **Shop in your own closet first.** Two to three times per year, I plan a major shopping trip. My first stop? My closet. With my children safely out of distraction range, I spend the morning trying on things in my closet. This helps me easily identify items I need to replace and figure out what I need to update outfits. That afternoon, I set off for the store. Which brings me to my next tip . . .

- **Make a list.** I'm always amazed at how many women wouldn't dream of starting their day without a detailed to-do list, yet arrive at the store unsure of what they want or need to buy. These are the same women whose wardrobes are filled with clothing they seldom

wear. Remember to bring a pen and a pad of paper or your fashion journal when you take your pre-shopping excursion to your closet.

- **Peruse catalogs.** Remember, you'll clarify your priorities by browsing through catalogs before you go to the store. You might want to tear out the pages showing the type of fashions you are looking for and carry these pictures with you to help you focus your decisions.

- **Bring a sure match.** If you have an article of clothing or an accessory that you're trying to match, bring it with you on your shopping trip. Better yet, wear it. This will eliminate the guesswork—and potentially another trip to the store to return your newly purchased item!

- **Wear easy-on, easy-off clothing.** Remember, you have a day of disrobing ahead of you. Avoid anything with zippers, buttons, belts, or laces. Loafers, a T-shirt or sweater, and a pair of pull-on slacks make for speedy dressing room visits.

- **Consolidate.** For hands-free shopping, leave your heavy purse at home. Instead, wear a garment with deep pockets—a cardigan or a blazer, for instance—to store your shopping necessities such as credit cards, coupons, and, of course, your list.

- **Eat!** If you expect to be shopping for more than a couple hours, don't forget to eat before you leave home. Shopping is a true aerobic exercise. All that walking and slipping in and out of outfits uses up more energy than you might realize. Stash a protein bar and bottled water in one of those deep pockets you're wearing for a quick pick-me-up. It will keep you away from the food court when hunger pangs hit.

- **Leave your coat behind.** You'll wilt in no time under the weight of your coat. If possible, leave it in the car. Many malls offer valet service. Take advantage of this for front-door service during cold winter months. Either that, or you can dash for the door from your parking

space! Some stores, such as Bloomingdale's or Bergdorf Goodman in New York City, offer a coat check service.

Budgeting for Fashion

The shopping experience is not just about buying clothes. It's about parting with your money. One of the most sensible ways to part amicably is to avoid impulse buying. Decide well before shopping day how much you can afford, and use this figure to prioritize your wardrobe purchases.

A good first step to developing a wardrobe budget is to get a handle on how much you currently spend on building and maintaining a wardrobe. Look back through the last twelve months of your checkbook register and credit card statements to begin understanding what you spend annually on clothing and accessories. Grab a piece of paper and record the dollar amount you have spent on each of your wardrobe expenditures.

Don't forget to document the following:

- **Dry cleaning.** Looking at what you currently spend on dry cleaning will help you make better decisions about how many dry-clean only garments to add to your wardrobe going forward. In some cases, you can substitute a machine-washable garment and get more bang for your buck if, in fact, you find that your dry-cleaning bills are higher than you thought.

- **Shoe repair.** The money you spend for a cobbler might save you the cost of a new pair of shoes. You still need to count this as part of your overall budget.

- **Alterations.** Your bills from the tailor or seamstress will guide your future decision-making, too. It might be worth your while to spend a little more for designers whose clothing best fits your figure than to spend less for items that need costly altering.

| Behind Closed Doors |

Saving Money the Expert's Way

When I ask people what holds them back from having a winning wardrobe, the majority reveal that it is money—or more specifically, the lack of it.

Personal finance expert Dianne Webster says there are ways to control needless spending and free up cash for the things we really want. Here are some of Dianne's tips:

- Despite the abundance of books on achieving financial success, many people with various levels of income struggle with money management. Typically tied to a lack of record-keeping and/or a lack of awareness about the financial choices made each day, a lack of money management causes many people to live a life of fear and, often, remorse.

- Although it can be tedious, one of the best actions you can take to reclaim a peaceful relationship with your money is to become super-aware of the sources and uses of your money. Start with balancing your checkbook on a regu-lar basis. Challenge yourself to keep a comput-erized record of income and expenditures, broken down by categories. The software pro-gram Quicken is an excellent tool for tracking expenses.

- This system will also help you to make conscious choices about which expenditures are truly important to you and which are not. If having a new wardrobe is a high priority, for instance, consider cutting back on other expenses. With a little focus, don't be surprised if you discover painless ways to save money such as canceling unwanted magazine subscriptions, consolidat-ing bank accounts to qualify for higher rates of interest, or switching to a cheaper long-distance carrier.

Although it takes an investment of time and effort, the rewards you can gain by proactively managing your money (i.e., peace of mind and confidence in your financial decisions) are truly priceless.

If you pay cash for clothing and accessories and their maintenance and have lost track of what you have spent, tuck an envelope in your purse and use it to hold cash receipts so you can accurately track cash purchases. Do this for two or three months, then calculate your average monthly expendi-ture. Multiply this figure by twelve months, total your checkbook register

and credit card figures, and add together the two figures. Voilà —you have your annual wardrobe expenditure!

You might have to sit down when you see the amount of money you spend on your wardrobe written out in black and white—I know I did the first time I performed this exercise on my own wardrobe purchases. The dry cleaning and alterations really added up for me.

The good news is that once you know for certain what you're paying to purchase and maintain your wardrobe each year, you'll be in a position to make your dollars work harder for you.

For instance, if you find that you are spending too much on your wardrobe, you might want to cut back on new purchases and stick to what you have already bought for a while.

If you already know the reason you are not satisfied with your image is because you haven't been spending enough time and money upgrading it, doing this exercise can validate this knowledge and give you a jump-start in planning your new wardrobe in a financially appropriate way.

Your Budget, Line by Line

As you are determining a fashion budget number you are comfortable with, it's helpful to break it down into individual purchases. It's handy to transfer all the items you have identified as missing from your wardrobe on your Personal Action Plan in Appendix A to the Master Shopping List in Appendix C. Leave the shaded "Shopping Priority" box blank for the moment. List everything you need/want under "General Shopping List" on this form.

With this completed list in front of you, estimate the cost of each item you'd like to purchase. Remember the rule of thumb: Set aside 60 percent of your total for accessories. Don't be conservative with your approximations. If you underestimate, you might find yourself settling for marginal or poor quality in an effort to make your numbers. Instead, underpromise

Your Fashion Formula

To assess whether a garment is a good investment, add its cost to what you will pay for alterations and annual dry cleaning. For help with these estimates, visit a local dry cleaner and ask for their price list.

Divide your total by the number of times you expect to wear it. Your calculation will help you determine whether the garment is a worthwhile investment. Obviously, the more times you wear something, the better deal it is.

Here's an example of putting this fashion formula to work:

You find a pair of high-quality leather ankle boots that fit and flatter your personal style. The price is $150. At first glance, this seems too expensive for your budget. However, if you wear them four days per week for seven months out of the year for three years, you are going to wear them 150 times. You have them resoled twice during that period for a total of $50. That brings the total cost of the boots to $200.

Formula: $200 divided by 150 wearings equals $1.33 per wearing. Now that's a number many of us could live with!

yourself and overdeliver by taking advantage of sales and store promotions.

When you complete your line item budget, you might discover that you don't have the funds to cover everything on your list. That's fine. If need be, put off some purchases. You're better off paying higher prices for a few well-made garments than paying bargain-basement prices for a lot of things that won't last. When I shop with a client, I always identify the top five priorities as a way to be super-focused. If this makes sense for you, fill in the "Shopping Priority" box in Appendix C's Master Shopping List now.

When in Doubt, Window Shop

If you're uncertain about the likely cost of the items on your shopping list, embark on a reconnaissance mission. In other words, window shop.

Travel to the mall without your wallet, and scope out the merchandise. Pay careful attention to the price tags, and train your eye to recognize quality by studying seam construction, finishing details such as buttonhole construction, and the quality of the fabric used to make items at different price points.

People have often asked me to window shop with them as a way to gain this type of education. Window shopping is also a great opportunity to take stock of what's in style. Do you keep seeing the same shade of pink? What is the popular skirt length this season? Check out the mannequins for ideas on accessorizing.

By handling expensive merchandise and inexpensive merchandise at the same time, you literally will begin to develop a feel for the difference.

The better you educate yourself during your preshopping preparations, the more successful you'll be when you're ready to buy.

Stretching Your Dollar

Before you shop, decide how you will pay for your purchases. By thinking through your options, you can often save yourself a bundle.

Here are some ideas:

- **Use coupons.** You'll find them in newspapers, your daily mail, and at customer service areas within malls and at some stores. You can even find them online. When you see a coupon, tuck it into your two-pocket "fashion" folder, which we recommended to you in Part Two. On shopping day, transfer your coupons to your wallet.

- **Opt for low interest.** If you have a lot of shopping to do at once, consider opening up a brand-new credit card with a low- or no-percent interest rate for the first several months you use it. Commit to paying it off before you spend a dime on interest charges. Always be aware of finance charges and their potential to add unwanted costs to your fashion budget.

- **Open a store charge account.** Many clothing and department stores will subtract 10 percent from any purchase you make the day you open store credit. Added bonus: You'll automatically receive future store promotion notices as one of their credit card holders. Some upscale department stores offer enrollment in frequent purchase programs that pay you back a percentage of what you spend at the end of the year.

- **Pay in cash.** If you have a tendency to get into credit card trouble, limit yourself to cash purchases—it will keep you honest!

Final Preshopping Thought:
Know Thy Wallet Before Hitting the Stores

It's common sense to cancel all your credit cards immediately upon discovering that your wallet has been lost or stolen, but how many of us actually have a good sense of the contents of our wallets—never mind a list of all our individual credit cards and the numbers to call to cancel them?

Here are some handy tips I've collected over the years for helping keep your credit safe:

- Line up all the contents of your wallet on a copy machine. Copy both sides of all licenses, credit cards, and membership information that you rely on in either an emergency or on a day-to-day basis.

- On your photocopies, use a bright marker to highlight the account numbers and cancellation phone numbers on each card. File this paperwork in a safe, handy place, such as the filing system where you keep your credit card receipts.

- Have the numbers of the three national credit reporting agencies as well as the number for the Social Security Administration filed with your credit card information, and call them immediately to place a fraud alert on your name and Social Security number when any credit card is stolen. See our resource guide for a complete list.

- To limit the damage that can be caused if your credit card is stolen, file a police report immediately in the jurisdiction where it disappeared. This action can go a long way in proving to the credit card company that you were diligent—and it can possibly protect your case in court if that becomes necessary.

16

Shopping Destinations

A generation ago, a shopping trip was a big event. Women got all dressed up and traveled to the nearest metropolitan retail district, where they would spend a day in the department stores and boutiques.

My, how times have changed. These days, we don't even have to get out of our pajamas to shop the world's finest designers. We can visit London in our bathrobes and Paris without leaving our computer chairs. We can shop Nordstrom and L.L.Bean in the same half-hour, thanks to the Internet and catalogs.

Nearly every mode of communication provides a direct link between retailers and us. Clothing and accessories are available through our television, our computer, the U.S. Postal Service, and our telephones. If carrier pigeons were still popular, we could probably send one off with our credit card number and welcome it back a week later with a new blouse in its beak.

The following guide will help you sort through these myriad shopping options. The descriptions and tips will help you decide which shopping venues are best for you.

Department Stores

These are often found anchoring shopping malls and offer a combination of clothing, accessories, cosmetics, and household goods. Department stores are not all created equal. Some carry high-end designer merchandise; others specialize in more moderately priced clothing. Where I live in Boston, the big players are Bloomingdale's, Filene's, Lord and Taylor, Macy's, Neiman Marcus, and Saks Fifth Avenue. Another great department store, which is not in the Boston area but might be in your neck of the woods, is Nordstrom. The advantage of department stores is one-stop shopping and their close proximity to other stores. A disadvantage is that you might not find as interesting a mix of clothing that a small boutique offers. If you have a lot of shopping to do, it makes sense for a department store to be your first destination.

Women's Specialty Stores

These are smaller chain retail outlets that cater exclusively to women. Some are located in malls; some are located in high-end shopping districts. Some have an upscale feel to them; others are more moderate. Examples of high-end women's specialty stores are Escada and St. John. Other specialty stores include Ann Taylor, Chicos, J. Jill, Lane Bryant, The Limited, Express, Petite Sophisticate, and Talbots. You will often get better customer service at these stores. I often suggest that a client choose one of these stores that most reflects her style as a way of starting each season off with great pieces that mirror her lifestyle.

Co-Ed Specialty Stores

These chain stores offer fashions for men and, in some cases, children, as well as women. On the high end they include Armani and Barney's. More mainstream stores include Brooks Brothers, Gap, Banana Republic, Eddie Bauer, J. Crew, and select Talbots stores also offer fashions for men. I love the latter stores for casual attire for women. The one drawback is that if you overdo it at any one of these stores, you risk looking like one of their commercials! Although it might have been cool to look like all your friends when you were in eighth grade, it's a little embarrassing to show up at a cookout in your thirties wearing the same head-to-toe outfit as your ex-boyfriend's girlfriend! It's great to stock up on basics here, but you might want to supplement your look with more original pieces in your closet or fashions you pick up somewhere else.

Boutiques

These little gems are typically independently owned and operated. For those looking for a more intimate and personal shopping experience, boutique shopping is ideal. The owner of a boutique, who might be your salesperson from season to season, could also be doing the buying for the store. This personal interaction with the customer allows them to better merchandise the store with unique and interesting items specifically for their clientele.

Be aware that merchandise at boutiques tends to be more expensive than what you might find at some larger retail destinations. Boutique owners simply don't have the same buying power as a larger outfit. For those who like to approach shopping anonymously, you're better off sticking to the department stores. Although I love the unique merchandise sold at boutiques—especially when I am in a fashion rut—the sales pressure can be intimidating and the return policies limiting for some people.

| Behind Closed Doors |

Shopping Can Be a Sport

I find that boutique shopping in resort areas is a great way to add unique and fun items to a casual wardrobe that you might not find in your hometown. I also prefer it over many other sources of entertainment while vacationing and actually refer to it as a sport.

When I vacation at the beach, I enjoy looking for interesting sundresses, straw accessories, beach cover-ups, and short sets. When I vacation at a ski resort, I stock up on hard-to-find sweaters, hats, and ski wear.

During my annual mid-winter vacation to the west coast of Florida with my husband and two boys to visit my mom, my mom and I have a shopping ritual that includes hitting every boutique within a thirty-mile radius of her condo in Siesta Key. We try everything on, put things on hold that we are considering, and compare notes of what we will be going back to purchase.

The trick to successful boutique shopping while on vacation is to buy the entire outfit right off the mannequin (or even the salesperson, as I have seen some people do!). You might never have another chance to go back and purchase that T-shirt that matches your new shorts perfectly or the ski pants that are made of the exact same color and fabric as the parka you bought. Even when I shop the boutiques close to my home, I always implement this "whole outfit" shopping mentality—it just works.

My husband is a more traditional sports enthusiast and spends time during our Florida trip golfing, but my preferred activity is every bit as much of a sport. I get an aerobic workout dashing in and out of stores (never mind trying everything on!), and what makes my sport more attractive—to me, anyway—is that I have something tangible to show for it when I'm done!

Discounters

These include retail giants like Kohl's, Sears, Target, and Wal-Mart. They are always great for essentials such as socks, cotton underwear, T-shirts, exercise wear, bathrobes, slippers, and cold-weather accessories. Remember to check the tag to make sure these garments do not have a disproportionate percentage of synthetic fabrics such as polyester and acrylic that don't wear as well as natural fibers. Also, technology has narrowed the playing field

between brand-name and no-name clothing. Many of the jackets, pants, skirts, dresses, and tops you find at these stores with a house-brand tag are very similar as those you'll find at department stores with a more recognizable brand name and price. Oftentimes they are made in the same factories alongside one another. One of my clients bought a scarf and mitten set at Target for $16.99. She later saw the same set at an up-market boutique for $50 more. There's no need to pay top dollar for these types of items—unless your time is limited and you need the item immediately.

Off-Price Retailers

Stores in this category include Loehmann's, Marshall's, Sims, and TJ Maxx. At these stores, you'll find designer merchandise at significant discounts. However, you'll really have to look for it. I love shopping at off-price retailers. To me, it's like going on a scavenger hunt. I never know what treasures I'll find, and I can literally spend hours browsing through them. If you're not a fashion lover, you should mentally prepare yourself for the experience. Keep expectations low. That way if you do find something you love, you'll be thrilled. Many disappointing impulse buys take place at off-price stores because of the seduction of low prices.

Outlet Stores

Factory outlets have come a long way since their humble beginnings when apparel and mill stores offered excess and damaged goods to their employees. Now, there are more than 14,000 outlet retailers generating $14.3 billion in sales, according to *Value Retail News*. They offer discounts of 30 to 40 percent off retail. During sales, you can find unbeatable prices. Designers are able to move surplus inventory more quickly through their own outlet stores than through traditional retailers. Some, including Ralph

Lauren, Cole Haan, and Liz Claiborne, design lines exclusively for their outlets.

Outlet malls are typically located thirty to sixty miles from major metropolitan areas, so a shopping trip can easily turn into an all-day excursion. Many developers have taken this into consideration when designing outlet malls, incorporating food courts and play areas for children into the layout. In fact, many outlet stores have come to resemble traditional retail stores. This, coupled with the likelihood that you will find designer fashions at reasonable prices, can make outlet shopping worth the trip.

The downside, however, is that although the amenities certainly make the shopping experience more pleasant, they have had the unfortunate effect of driving up prices. In fact, you might be able to find the same fashions for equitable or even lower prices at department stores, especially if you use store coupons and shop during sales.

Before you buy at outlets, be sure you are truly getting a bargain. Here are some tips to help you get the most from your outlet shopping:

- **Call ahead or visit virtually.** It's likely that you'll be spending the better part of a day at the outlets, so find out beforehand which stores are having sales, what labels and sizes they carry, and what their hours of operation are. In many cases, you can visit the outlet's website for a store directory and the latest information on sales. The website www.outletbound.com offers a free searchable database of outlet malls around the country. Search by location, store name, brand name, and category for basic information, and click on the link to the website of the mall you wish to visit.

- **Dress for the occasion.** Outlet malls are generally open-air environments. You don't want to freeze in the winter or bake in the summer, so dress appropriately. Keep in mind my earlier advice about wearing easy-on, easy-off garments. And make sure you wear comfortable walking shoes. You'll likely put away a few miles during your shopping trip!

- **Stop at the information desk for a coupon book.** For instance, my AAA membership entitles me to a packet of store coupons at the outlet mall nearest me. Ask if an outlet mall near you offers any similar partnerships with membership organizations. If you are a member of an association, you can also visit their website to find special discount offers. Some outlets also feature a senior citizen discount one day a week—usually on Tuesdays.

- **While you're there, pick up a store directory and map.** While at the information desk and before you start shopping, take a moment to sit down and mark the stores you wish to visit, starting with the ones closest to your current location.

- **Inspect items carefully.** On average, 80 percent of the clothing you see will be first quality and in season. Still, never assume an item is flawless. Be on the lookout for irregulars (marked so because of small imperfections in the garment), seconds (a major flaw exists), past season, and/or samples (may have been handled quite a bit by store buyers, or during fashion shows).

- **Look for items with a cut or marked sewn-in label.** Usually, such items have come from the maker's retail store and aren't outlet knockoffs.

- **Sign up for store mailing lists.** This way you'll receive advance notice of sales and, in many cases, discount coupons in the mail.

- **Shop off-season.** Just as with traditional retail stores, out-of-season merchandise will be priced lower than in-season goods at the outlets.

- **Ask about the store's refund and exchange policy.** If the outlet is far from your home, find out if you can return items to one of the store's full-price branches.

Trunk Shows

The trunk show is the fashion equivalent of a Tupperware party (although a sophisticated one). The clothing offered at these fashion parties tends to be high-end and on the expensive side.

Like the "Tupperware Lady," the trunk show sales associate represents a manufacturer that sells its collection exclusively through a network of associates. Trunk show companies include Doncaster, The Worth Company, Carlisle Collection, Weekenders, and Premier Jewelers. Whenever a new line comes out—usually four or five times per year—the sales associate will show the fashions to clients in her home or at the home of a party host. Guests view the collection, maybe try on samples, and place their orders with the sales associate.

The trunk show concept appeals to busy women who would rather spend their free time in a relaxed environment socializing with friends than prowling the racks for the latest fashions. Trunk shows also offer unique clothing choices and an on-site fashion consultant. Additionally, the trunk shows' concept of showing mix-and-match items makes wardrobe planning easier.

Its main drawback, as I mentioned earlier, is the price point of the items, which tend to be on the high end and rarely discounted. Most trunk shows don't include shoes, so you will have to visit another merchant to complete your newly purchased outfit. Either that, or be sure you have shoes at home that will match your new outfit. Another disadvantage is that you will sometimes be ordering clothing without the benefit of trying it on in the size you order. Also, if you are into instant gratification when it comes to fashion, trunk shows might not be for you. It often takes up to six weeks for the merchandise to be delivered to you once you place your order. Having said all this, some of my favorite pieces have come from trunk shows.

Consignment Stores

I often think of consignment store shopping as traveling around the world, shopping on someone else's dime. I scour them in search of designer bags, vintage jewelry, and couture pieces that are difficult to find in the United States.

Upscale consignment stores selling gently worn, secondhand designer clothes offer savvy shoppers a cost-effective alternative for sprucing up your wardrobe without spending a fortune. Here are five handy tips to help you sift through the racks to find the gems:

- **Know your labels.** Visit an upscale department store to see how certain labels are priced at the retail level to better understand the value of consignment purchases.

- **Train your eye.** Learn to recognize design elements that date garments and make them look out of style, as many of the clothes at consignment stores are a few seasons old. If being on trend is important to you, pay attention to such details as shoulder pads, buttons, and jacket lengths. Also beware that some items have great hanger appeal but can look frumpy when you try them on.

- **When in doubt, buy black.** Dark clothing hides wear and tear the best. Lighter-color clothes and accessories in a consignment shop have the potential to look the most worn unless they have the original price tags still on them.

- **Personalize your size.** No matter what you pay for an item, there is no substitute for a proper fit, so make sure you have a good tailor. Keep in mind that high-quality basics can go from good to great with the help of an expert tailor. Revisit my advice in Part Two about whether garments are worth tailoring.

- **Be smart.** Remember that a bargain is only a bargain if it fits your lifestyle, personality, and figure. Most consignment shops don't take returns, so make your purchases wisely.

Catalogs

The USL (Use Less Stuff) Report states that the average American household received 59 mail-order catalogs in 1981. By the end of the 1990s, the number of catalogs had increased 140 percent to 142 catalogs per year. I'm sure it's even higher today.

The majority of catalogs are sent during the holiday season, but chances are, your mailbox is overflowing with catalogs all year round. Here are some tips to help you become a more effective catalog shopper:

- **Get organized.** Make a commitment to either toss, recycle, or save catalogs the minute they enter your domain. Devote shelf space, a portable file box, magazine rack or other organized place to store the catalogs regularly as new catalogs from the same companies arrive.

- **Combine online and offline.** Catalogs offer great ideas for coordinating a winning wardrobe. Try taking pages from your favorite catalogs to the store to bring focus to your shopping strategy and help convey to sales help a clear picture of what you are looking for. Likewise, it can be helpful to study an offline catalog before going online to shop.

- **Get to know your cataloger.** Check sizing guides, read product descriptions carefully, and talk with the operators who take your order. Many operators are well versed on their catalog's sizing particulars and can also tell you if a product will soon be sold out or discontinued—two helpful pieces of information if, for example, you plan to order a jacket later if the pants fit well on arrival.

- **Track it.** Develop a system for ordering, tracking, and returning catalog purchases. Start by developing a folder containing the pages of the catalogs from which you order with each order number clearly written. Refer to this folder when packages and credit card statements arrive. Then paper clip or staple the packing receipt and all relevant information to the corresponding sheets in your folder.

- **Return to sender.** Handle returns promptly to avoid carrying the charges on your credit card for longer than you need. Be aware that return postage fees can add up.

Online Retailers

No matter what you are shopping for, you are likely to find it online. But virtual shopping, like traditional shopping, is not without risks. Here are some tips from the Federal Trade Commission to help you shop safely online:

- **Know whom you're dealing with.** It's a good practice to be familiar with the name or reputation of any company you're dealing with. If you've never heard of the seller, check its location and reputation with the Better Business Bureau or your state attorney general's office.

- **Protect your privacy.** Provide personal information only if you know who's collecting it, why, and how it's going to be used. Be cautious if you're asked for a Social Security number or personal bank account information.

- **Guard your passwords.** Use different passwords when you're making a purchase than you use to log on to your computer or network.

So That's *How They Do It!*

Have you ever looked at a magazine or catalog and wondered how fashion models get their clothes to fit so perfectly? Well, according to fashion stylist Brooke Kanal, they get a great deal of help from clamps, pins, and tape.

Having worked in the fashion business for more than a decade, Brooke knows all the tricks—she has to because models often wear sample sizes, which might or might not fit well. This is because photo shoots take place months in advance of the season and before the designs are even manufactured.

Following are some of Brooke's tricks for coaxing the perfect fit from a garment. Remember these when you order something from a catalog, and it's not what you expected or you're in the dressing room, looking for that model fit yourself.

- Turtlenecks are usually tightly safety pinned in the back, so the fabric is flush against the neck. This gives a more fitted, clean appearance.

- Skirts are also safety pinned in the back so the fabric hangs closer to the body, especially in the hip area. A skirt will appear too wide if the fabric is not gathered behind the model and fitted closer to her legs.

- If a hemline is too long for the model, the skirt is often rolled at the waistband to shorten the length. Sometimes a skirt can fall at an awkward length (too far below the knee can make the legs appear heavier and shapeless, for example).

- Clamps (like the ones sold at The Home Depot) are often used to gather fabric. Stylists use these to give clothes a more tailored effect. For example, cinching a blazer at the waist and gathering the excess fabric behind the model's back allows for a better fit and shapelier silhouette.

- Clamps are also useful on bulky outerwear such as winter coats, ski jackets, and even on plush, heavy cotton bathrobes that never skimp on fabric. These garments are usually not flattering to any figure. By pulling and clamping the excess fabric behind the model's back, the clothes are snug to the body, eliminating the boxy, bulky look. Frequently on bathrobes the fabric belt is far too long, so the stylist will safety pin the belt in the back, shortening the length in front.

- Double-sided tape helps keep collars aligned, lapels from sticking up and out, pockets closed and neat, and a belt adhered to itself, gently curving to the model's waist. If you want to try this trick, double-sided tape is available for sale at www.hollywoodfashiontape.com.

- **Pay the safest way.** A credit card offers the most consumer protection.

- **Get the details.** Check for shipping and expected delivery dates, shipping and handling fees, warranties, return policies, and other important information. Look for an e-mail address to write to or a phone number to call if you have a question or need help.

- **Keep good records.** Make sure to print or electronically save any records related to your online transactions, including return policies if you're not satisfied. This will also help you keep track of shipping dates, shipping and handling fees, and other details.

- **Make your first stop Consumer Reports online.** If you're concerned about the reputation of an online merchant or are wondering whether a shopping site is easy to use, visit www.consumerreports.org. The site offers ratings and comparisons of online stores and auctions free of charge.

Online Auction Sites

Online auctions are the modern version of the old-fashioned bazaar, offering an astonishing range of items and connecting buyers and sellers instantly. Both individuals and businesses put new and/or used merchandise up for auction for a set period of time. At the end of that period, the item goes to the highest bidder.

With online auctions and Internet search technology, the savvy shopper can easily locate vintage and designer clothing and accessories, often at bargain prices. But the same cautions that go for online retailers apply to auctions, along with the added concerns of potential fraud and misrepresentation.

According to the Federal Trade Commission, the most common complaints about online auctions are that sellers don't deliver the advertised goods, they deliver something far less valuable than they advertised, they

don't deliver in a timely way, and they fail to disclose all the relevant information about the product or terms of the sale.

Before you step up to the online auction block, visit www.consumer reports.org, which rates and compares different auction sites.

The following tips will help you navigate the online auction world like a pro:

- **Learn about the seller.** Many auction sites rate sellers and post feedback from people who have bought merchandise from them. Check out the seller's feedback rating and comments from past customers. Just be aware that some unscrupulous sellers might plant positive comments from so-called customers.

- **Look for sites that offer fraud protection.** The biggies, such as Amazon.com Auctions and eBay, will cover purchases up to a certain dollar amount in the event the product is significantly different than described or never arrives at all.

- **Pay by credit card.** This will provide you with the greatest protection because you can cancel a payment if you're dissatisfied with the transaction, and most credit card issuers will cover your purchases in instances of online fraud or misrepresentation. However, many sellers won't accept credit. In these cases, you'll be expected to pay by cashier's check or money order.

- **Use other payment options.** Some auction sites will act as a middleman between the buyer and seller. Amazon.com Auctions will take your credit card information and transfer cash to the seller without disclosing your personal information. Yahoo! Auctions uses a service called PayDirect, which operates in a similar fashion. eBay offers its PayPal service, which allows you to electronically transfer money from your bank account to PayPal, which then transfers your cash payment to the seller.

- **Save your transaction information.** The Federal Trade Commission recommends printing the seller's identification; the item description; and the time, date, and price you bid on the item. Print and save a copy of every e-mail you send or receive from the auction company or the seller.

Television Shopping Networks

If shopping is sport, then television shopping shows are the equivalent of Monday Night Football—or more accurately, ESPN, as they're broadcast twenty-four hours a day, seven days a week, 365 days a year.

Shopping through your television is the ultimate passive buying experience. With a catalog, you flip through the pages, study pictures, and read product descriptions. Online, you point and click and can easily comparison shop. When you shop through your television, you sit, you watch, you listen. Then, if you like something, all you have to do is pick up the phone and dial the toll-free number. If you're a returning customer, you don't even have to give the operator your credit card number—it's already on file!

For clotheshorses who don't want to expend a lot of energy looking for fashions, shopping channels such as QVC and Home Shopping Network are a fantasy come true. But viewer beware: Television shopping is so effortless it can be addicting, and if you're not careful, you might find yourself answering the door to packages that you never intended to allow into your home!

If shopping from television appeals to you, prepare yourself in the following ways:

- **Do your research.** Study the networks' online sites beforehand to get a clear idea of their product lines. QVC's online site (www.qvc .com) has a feature that allows you to type in your zip code to get a

television viewing schedule for your area. ShopNBC (www.shopnbc .com) and HSN (www.hsn.com) list their program guide according to time zone.

- **Turn down the volume.** The constant chatter of the show hosts is distracting and might lure you into buying something you didn't intend to.

- **Keep your wits about you.** Shopping networks know their audience—women! In fact, more than 75 percent of Home Shopping Network's viewers are female and over 40 years of age. Their pitchmen and pitchwomen are skilled at convincing viewers to part with their money—often by preying on their insecurities. If you find yourself reaching for the phone, run, don't walk, to your priority shopping list. If the item you're about to buy is listed there, go for it. If not, turn off the TV.

- **Figure the cost of shipping into your purchase.** If you're disappointed with the item, you'll probably be hit with shipping charges again when you return it.

Custom Clothiers

If you are willing to spend the time and money, you can buy yourself a one-of-a-kind piece that will look great and last for years by hiring a custom clothier.

There are many reasons to hire a custom clothier, but the main motivation is usually fit. Custom-made clothes can accentuate your best features and fit your body to a T.

Although the appeal is obvious (everything fits perfectly!), having clothes custom-made is definitely not for everyone. A custom-made outfit

typically requires a substantial financial commitment and several weeks to several months to complete.

How do you go about finding a custom clothier if you are a novice to the process? The best way to find someone is through a friend's or colleague's recommendation. Otherwise, you can look in the Yellow Pages under "Dressmaker," go to a fabric shop and look for custom clothiers' posted business cards, or visit The Professional Association of Custom Clothiers' website at www.paccprofessionals.org.

When selecting a custom clothier, use the following questions as a guideline:

- **Rapport:** Do you have a good rapport with this person? Is she or he a good listener? The process of designing and fitting a garment is a true collaboration, so be sure you feel there is a personality match.

- **Specialization:** In what does this clothier specialize? They shouldn't be everything to everybody.

- **Fabrications:** Be sure your clothier works with natural fabrics like silks, wools, and linens.

- **Business practices:** How long has the clothier been in business? Visit his or her studio and check to see if garments are stored properly. Is the fabric stored neatly in sheets or bags where it will stay safe?

- **Hallmarks of quality:** Always ask to see garments the clothier has completed. Scrutinize them and make sure the inside looks as good as the outside and has a clean finish. The stitching should be small and neat in the hems. The fit should be smooth, with no wrinkles, pulls, or puckers. Collars should lie flat, jacket sleeves shouldn't pull, and seam lines should be vertical. Hems need to be even.

Once you have found a clothier you like, interview that person to ensure you are clear about the costs and scope of your project:

- How long will the project take? (The process, including an initial consultation, two or three fittings, and pick-up of the completed piece, can take from six to eight weeks or sometimes longer if fabrics have to be ordered.)

- Where does the clothier get his or her fabrics? Does he or she order them or have them in his or her studio?

- Does he or she charge for shopping time?

- Are items lined? Do clients have a choice on what to line their clothing with?

- Is there a choice in details like buttons? Do they cost extra?

There are certainly many issues to consider when buying a custom-made item, but you get what you pay for. I own two custom suits, and every time I wear one of them I feel like a million bucks.

Fabric and Button Stores

Even if you don't consider yourself a sewer, don't discount fabric and button stores from your shopping mix.

Both types of stores are treasure chests for wardrobe enhancements that can make your current clothing as well as new purchases more unique, figure-flattering, and durable. Many of these types of stores also offer instructional classes.

My friend once showed up at my house in an adorable pair of drawstring pants. When I asked her where she got them, she boasted that she made them in less than two hours at a class at her local fabric store. She even used

a tassel from the store's home decorating department to add a whimsical touch to the drawstring. With a full-time job and three kids, I was pretty impressed with her ability to fit this type of activity into her life, never mind complete it with such awesome results!

Here are some tips from Diane Isaacson, a special events director and fashion expert from The Fabric Place—a fabric store chain serving New England—to put fabric stores to work in your wardrobe:

- **Add a scarf.** Select a lightweight suede or chamois fabric to create a simple, no-sew scarf. You can cut the fabric as a triangle or as a long, skinny rectangle, depending on what you need. Finish the edges with a variety of trims or simply edge the fabric with "Fray Check," a colorless solution that reinforces and locks fabric threads to prevent fraying or tearing, available at fabric and crafts stores.

- **Perfect your underpinnings.** If you've got a favorite sleeveless top but your bra straps tend to show when you wear it, you can purchase strap holders to eliminate the frustration. Shoulder pads can be replaced or added to your clothes to best flatter your fit and style.

- **Secure your seams.** Steam-a-seam products are like Post-it Notes for your hems—sticky enough to create a temporary hem so you can try on the pants or top and see how it looks and then, once you've got it right, simply iron it in place for a permanent hem. This is a great product to carry when traveling in case of a last-minute repair need.

- **Trim your tops and bottoms.** Ribbons, beads, and embroidered tapes have become diverse and truly amazing. Update a favorite T-shirt, Capri pants, or jacket waistline by simply adding some detail at the edge. Also check out the beaded appliqués available these days that look hand-beaded and provide incredible details in seconds.

- **Don't discount home decorating fabrics.** Don't limit your options to the fashion fabric area of the store. The fashion runways are filled with tapestries, damasks, embroidered silks, and beaded fabrics that can be found right in the home decorating area of your fabric store. From a beautiful shawl in a wide embroidered sheer to a simple tote bag made from a tapestry remnant, there are infinite possibilities.

- **Study patterns.** Most pattern companies provide pattern collections to create a base wardrobe. Even if you don't sew yourself, you can have someone create an ensemble that is uniquely you.

17

At the Store

Now that you know where and how to find new items for your wardrobe, think about trying a combination of two or more of these shopping modes. Here are some ideas for combining shopping modes as well as additional strategies to ensure a successful shopping experience.

Making the Most of Your Shopping

- **Combine catalog and store shopping.** Use catalogs to order easy-fitting clothing such as turtlenecks and T-shirts. Visit stores for trickier items such as suits and shoes.

- **If the pricing game makes you stressed, limit yourself to two stores that carry most of the items you need.** Learn their merchandise, watch their ads, and plan to buy items on sale days. Once you find the stores you like, take advantage of not only the store locations, but also any catalogs or websites they have.

- As I mentioned earlier, clip and save coupons from your favorite stores, paying close attention to the fine print, including expiration dates and discount limits on sale items. File them in a handy place, such as a two-pocket folder mentioned in earlier sections, so you can easily find them when you're heading to the computer, to the store, or to the phone.

- **Limit your shopping trips.** Whether online or in the store, long shop-till-you-drop marathons usually lead to impulse buying, exhaustion, and frustration.

- **If you will be shopping in the evening, choose malls with well-lit parking lots and visible security patrols.** Never hesitate to ask for a security escort to your car if you are afraid or need help carrying bags. Always be aware of your surroundings and consider using a personal security device.

Two Is Sometimes Better Than One

Have you ever noticed that clothes shoppers seem to come in pairs? There's a good reason for this.

Shopping is the perfect excuse to spend time with a girlfriend, boyfriend, relative, or spouse. I particularly love hearing my in-laws, who have been married for more than forty years, talk about shopping together. Whether shopping for themselves or others, I swear it's one of the secrets to their successful marriage. It certainly seems to keep them connected.

No matter who you shop with, having another set of eyes (and opinions) can guard against fashion mistakes, and the extra set of arms (and legs) will come in handy when you're trapped in the dressing room with the wrong size and/or exiting the store (or stores) with all your packages.

But friends and family aren't the only ones who can enhance your shop-

ping experience. Good store sales associates can offer advice and opinions, and some stores offer personal shopping services. Then there's the independent personal shopper—the kind of shopping buddy I'm partial to!

Here's the breakdown:

- **Store sales associates:** Upscale stores and boutiques tend to have the most accessible and knowledgeable sales staff. Many of the ones I work with day in and day out are worth their weight in gold. But remember, not all sales assistants are created equal. If you are in the store on a slow day, you might find yourself the recipient of the clerk's undivided attention, which can be either a good or bad thing, depending on how much attention you want. One rule to remember: If a sales assistant constantly says everything looks good on you, question his or her commitment to you.

- **In-store personal shopper:** Most high-end retailers offer a complimentary personal shopping service aimed at the more affluent customer (even if they say it's not!). These are store employees who are typically paid on commission. Their knowledge of fashion in general and the store's merchandise in particular can be invaluable. But keep in mind that their paychecks are directly tied to the money you spend in their store. If this makes you feel uncomfortable, in-store personal shoppers are probably not for you.

- **Independent personal shopper/wardrobe consultant:** With an independent personal shopper, you get an unbiased opinion as well as the shopper's knowledge of fashion, trends, and area stores. Independent personal shoppers typically charge by the hour and/or the day. The amount varies according to where in the country they are located.

You can find an independent personal shopper under the "Image Consultant" category in your local Yellow Pages.

First Impressions Can Matter

Participants in my seminars often ask me whether they should dress up to shop for clothes. This is a personal decision. Whatever you choose to wear, make sure you are comfortable and you can slip in and out of the garments easily. Treat your outfit as part of your overall strategy. Your appearance can influence the attention you receive from sales help.

When I go into a store to preshop for a client, I dress casually and draw little attention to myself. This is great, because I'm there for research purposes only. I want to know what's in stock that will best suit my client's particular needs. I don't want to be "helped" because I'm not there to buy. The next day, when I'm with my client, it's a different story. I dress professionally, and I'm instantly noticed by the sales help. In this case, I welcome the attention because it allows me to be more efficient with my client's time.

Take It from the Top (of Your List)

Once you have explored the many shopping options, develop a shopping sequence for yourself.

Here is a sample:

1. Traditional shopping mall
2. Outlet mall

| Behind Closed Doors |

Waiting Games

My friend Elizabeth and I have a running joke about how much it costs her to come meet me after work.

We have been good friends since she lived in Massachusetts back in the early 1990s. Now that she lives in New Jersey, she often comes into New York City to meet me at the end of my workday when I'm in town. As I run around in the final hour of shopping with a client, she waits in the shoe department.

By the time I meet her, she typically has a half-dozen pairs of shoes for me to look at. With her good taste (and my blessing!), she goes home with a lighter wallet than she had when she arrived.

The shoe department continues to be the number-one place I meet clients and friends at the store. Why? The seats are comfortable, and if one of us is running behind, the view, as Elizabeth can attest, isn't too bad!

| Insider Tip |

*Yes, You Can Find
Good Sales Help*

Here's how you'll know:

- They greet you cheerfully upon arrival.

- They offer to gather your armload of clothes at the counter while you continue to browse the racks.

- They appropriately check in while you're in the dressing room to ask whether you need assistance.

- They know when to chat, when to offer help, and when to leave you alone.

- They're open to developing a relationship with you that includes calling when merchandise in your size comes in or an item has been marked down that they know you like.

- They respect your style and budget.

- They exceed your expectations of the store in which they work.

3. Off-price retailer

4. Virtual store

5. Consignment store

You might come up with a shopping sequence that looks much different—it all depends on your comfort level, budget, and shopping needs.

If a mall is on your list, park your car nearest the entrance you plan to depart from, even if you have to wait for a space. After the energy you spend shopping and carrying an armload of bags, you'll be grateful for the convenience.

As I mentioned earlier, I usually start at a shopping mall anchor store when my private clients have a lengthy shopping list and we have to accomplish a lot in a short period of time. Department stores have a wide range of brands and designers and typically have good customer service.

Once you've arrived at your destination, where do you begin? Depending on what you need, I recommend shopping in the following order for maximum efficiency and success:

1. Start with the basics on your list. Find suits, jackets, pants, skirts, and dresses first. Then move on to the accessories, which, as you read in Part Two, includes tops and blouses, to develop your basics into a variety of outfit choices. In the previous section you learned to look at your wardrobe like a puzzle. If you're stuck on a piece, look at the mannequins—even what the sales help is wearing—for ideas. Make sure you complete the picture before you hang up your purse for the day.

2. Hit the sale racks first. Of course buying the items on your list on sale makes sense. But if something you have identified as needing is not on sale and you find it at full price, think about buying it anyway. Remember what it will cost you if you return home empty-handed. Your confidence, for one! If that doesn't convince you, picture yourself standing at your closet in the morning with nothing to wear.

3. Refer to your priority list often. Keep in mind how your individual lifestyle will affect your purchasing decisions. For instance, if you're an entrepreneur and wear suits only for outside business meetings, it would make sense to pay extra for the suit you like best. If you work in a corporate environment, you'll need more suits and therefore, might have to buy several less costly ones.

4. Shop for shoes last. Your feet swell during the day, and this way you'll be sure the footwear will fit when your feet are at their widest. Usually you're exhausted by the time you get to the shoes, and shoe stores and shoe departments have seats! It's the one place where you can pretty much count on being waited on—a definite plus when you're tired. You'll also know by then exactly what shoes you'll need based on your other purchases.

5. Don't forget the hose. I'm always dashing off to the hosiery department for clients at the tail end of shopping trips. Remember, you don't want to go home without a completed outfit.

6. Put all your items on hold, and pay for them at the end of your shopping trip. If a client and I find her number-one-priority outfit, say a black pantsuit at Lord and Taylor, we'll put it on hold, then check out black pantsuits at a women's specialty store, such as Ann Taylor or Talbots. This strategy has several benefits. You will save time waiting in line in the middle of your shopping trip. You don't want to interrupt your flow when you're in the shopping groove. When you put items on hold, you can think about

them for a while and decide on final "keepers" before making any purchases. And if you find an item you like better at another store, you'll avoid the pain of kicking yourself for not checking there first!

Dressing Rooms: The Inside Story

Interior designer Penny Shuman, who works with a variety of retailers, designing their interiors to help market their products, has seen a lot of dressing rooms. Seldom are they big enough.

According to Penny, retailers will spend a lot of money on selling space, but they often neglect dressing rooms. By the time they get to that part of the store, many have used up most of their floor space and often their budgets. (Penny's clients excluded, of course!)

It amazes me how shortsighted this is. After all, the dressing room is where the action is. It's the make-or-break place for purchases. Over the years, Penny has shared some of her insights into proper dressing room design with me—and revealed a few secrets retailers prefer we don't know.

Here are some of her thoughts on the subject:

- Upscale boutiques often don't put mirrors in the dressing room. They want customers to come out for an opinion from the sales help (who are trained to close the sale).

- Stores are installing fewer mirrors on the sales floor. Not only do mirrors take up valuable display space, but they also thwart trips to the dressing room, which is one step closer to the cash register!

- Contrary to popular belief, retailers do not intentionally put "fat" or "skinny" mirrors in their dressing rooms. That's a function of the quality of the mirror. A poorly made mirror might cause you to look wider or thinner than you actually are. A good mirror will accurately reflect your image.

- Lighting is critical in dressing rooms, but many retailers short-change customers (and themselves) with inadequate illumination. Fluorescent lights are the least flattering, unless the bulbs are color-corrected. Lighting on either side of the mirror provides the best illumination. A light at the ceiling alone will cast unwanted shadows.

- Lights that give off too much heat detract from the shopping experience for the customer. (I suppose too cold is bad, too!)

- The typical dressing room is three-by-four foot—barely room enough to move around or to get far enough away from the mirror to get a good look. Before you decide on an outfit, step outside of the dressing room and search for a mirror in an open area. Distance will allow you to evaluate the full effect of the outfit.

The best dressing rooms have:

- Enough room to move around without feeling cramped.

- A place to sit down.

- More than two hooks (one for clothes to be tried on, one for clothes that you have already tried on, and the third for personal belongings).

- Side illumination of mirrors.

- Good ventilation.

The bottom line: The more high-end the store (think Saks, Neiman Marcus, and Nordstrom), the bigger, brighter, and more comfortable the dressing rooms will most likely be. You might even have a salesperson bring water and refreshments to you in a fitting room at one of these high-end stores if you spend enough time in there!

En-Trenched in an Old Way of Thinking

A good shopping strategy is to buy items on sale whenever possible. Many women have made a sport out of bargain shopping and beat the retail markup game at every turn. I have shopped with many women who get physically ill at the thought of paying retail for anything. It is often my job as their wardrobe coach to point out the often unspoken cost of not buying an item just because it is full price.

I once worked with a physician who was preparing to go on a national speaking tour with a pharmaceutical company to promote a new medical device. Because her professional wardrobe consisted of not much more than medical lab coats prior to this opportunity, she contacted me for help building a professional wardrobe appropriate for her new role as corporate salesperson.

She was thrilled when, in less than two hours, we pulled together enough suits, tops, and separates to get her dressed for five weeks on the road visiting more than a dozen cities in the United States and Canada. At this point, everything we selected was on sale, and we were well within the budget she had established. The only item left on her list was a trench coat.

We put all the suits on hold and headed to the coat department. Because she was a petite size 6, I knew the number of coats that would fit her well would be limited. When we did find one that fit her well—a charcoal gray trench with a zip-out lining made out of a beautiful micro-fiber fabric—she was thrilled. Moments later her mood changed when she realized the coat was full price and more than she had hoped to spend. She put it back on the rack, claiming she wasn't going to pay full price for anything.

I played along, searching for any coat that was on sale in her size. My intuition told me we were going home with the first coat, but I wanted her to come to this conclusion on her own. Each additional coat she tried failed miserably in comparison to the full-priced coat. She was about to call it a day when I started my lobbying campaign.

First on my list of arguments in defense of this truly perfect coat was practicality. She had no other coat in her wardrobe that would do her new wardrobe justice. This coat would travel well to a number of different climates (her trip was set for February and March), and because she would most likely be wearing the coat when she met people for the first time, I explained the positive impact it would have on the sales process as well as her self-confidence. She started listening.

I then told her it was most likely the only coat she would need to add to her wardrobe for the next five years. She really liked that line of thinking, as shopping was definitely not something she enjoyed. The coat had day-to-evening appeal and would also fit well with a renewed social life she was beginning with her husband now that her children were grown and off at college.

She reported back to me after her trip that the coat was the handiest item she had ever purchased. She quickly got over her sale-only mentality when she realized what it would have cost her if she didn't have the coat. I still see her regularly, and when the coat was finally retired after five years of heavy wear season-to-season, we figured out that the cost per wear was somewhere under five cents!

If the Shoe Fits

What's more fun than shoe shopping? You don't have to get undressed, no fluorescent dressing room lights—many women consider it a pastime. But even shoe shopping can go wrong if you're not savvy about your purchases. Here are some extra tips from Barbara Thornton, owner of Investments, a shoe salon on Newbury Street in Boston:

- Wear the appropriate sock when shoe shopping—heavy socks for boots, nylons for pumps.

- Fit your shoes to your larger foot. For most people, this is the opposite from your writing hand.

- Walk around and wiggle your toes when trying on footwear. There should be a ⅜- to ½-inch space between your longest toe and the end of the shoe.

Fitting Bras

According to Anna Castellani of the Bra Smyth, a New York City store/catalog that specializes in bra alterations and special orders, not all bras are created equal.

To find a bra suited just for you, Anna suggests the following:

- **Forget your supposed cup size.** Don't discount the possibility that you might need to go up or down a cup. When you try on the bra, the fabric should not gap, flatten, or squeeze you anywhere.

- **Leave yourself room to breathe.** Most people are wider across the back than they realize. To ensure a comfy fit—as well as to prevent skin-pinching and back bulges—fasten the middle clasp, then check

your rear view. Any sign of fabric strain means you need a larger band size.

- **Know when to get wired.** Underwire bras provide the most support for B cups and above. (A cups might get better shaping from a wireless, lightly lined, or padded bra.) The wire should rest flat against your breastbone, and its tips should not poke you under the arms.

- **Stock up.** When you do find a bra that fits, buy as many as you can afford so you're not "strapped" if the style gets discontinued.

I also suggest purchasing matching panties, camisoles, and slips in the same color and made by the same manufacturer as your bras whenever you can.

On Sale Now!
(And Tomorrow, and the Next Day, and the Next Day . . .)

If the time period we live in were to be given a nickname, it would be "The Sale Era." There are so many sales these days that sometimes it seems like we've hit the jackpot and the payout keeps coming and coming.

Not too long ago, stores held four sales a year timed to clear the inventory of seasonal items (remember when you could only get gifts on sale *after* Christmas?). Now, if stores aren't having a sale, they're enticing buyers with coupons—or both! The glut of sales is driven by the major retailers who view sales and promotions as a competitive advantage—and have the buying power to pull it off.

A number of factors have contributed to this sale saturation:

- **Discounters:** The rise of discount department stores, factory outlets, and off-price retailers have put fear into the hearts of large corporate retailers such as May and Federated department stores.

| Insider Tip |

Sizing Up Shirts

Topping off your favorite pants and skirts is never the easiest of tasks. Because many designers are now adding a percentage of Lycra or spandex to their fabrics, it's often difficult to find tops that fit and flatter.

I had to laugh when I overheard a woman in a fitting room say that size large tops simply don't exist anymore. I promise they do—you just might have to search a little harder and try on a lot more before you find one that makes you look and feel most confident and pulled together.

For instance, some full-busted women complain that they can't find shirts that stay buttoned when there is too much stretch. Some small-busted women find that clingy tops make their smaller chests look even more noticeably flat.

Don't be alarmed if you have to go up a few sizes from what you normally wear to get a comfortable top. When you take this approach, look for styles with a three-quarter-length sleeve to save yourself from having to get the sleeves hemmed.

If you like the look of a three-quarter-length sleeve, fitted shirt jacket but can't find one that buttons, consider layering a T-shirt in either the same color or a contrasting color underneath to eliminate the need to button it.

- **The Internet:** There's *always* a bargain to be found online. Consumers can comparison shop dozens of virtual stores and use that information to decide whether an item is worth a trip to a brick-and-mortar store. With free shipping on some sites, you can't go wrong. The Internet has created a more knowledgeable (and, therefore, a more powerful and less loyal) consumer base.

- **Innovations in mass production:** A decade ago, it was worth paying premium prices for brand names. But new technology has led to better quality in fabrics and finished pieces, narrowing the playing field between brand-name and no-name clothing. Consumers are willing to settle for slightly less if it means they'll save considerably more. Efficiency has also improved, so supply often exceeds demand.

- **An oversaturated retail market:** There are so many stores in this country that retailers are forced to hold sales and promotions to lure in shoppers.

Although so many sales might be great for us, in some ways, it has backfired on retailers. Businesses have unwittingly trained consumers to shop only when items are on sale, forcing the stores to have more and more sales and promotions to keep the customer coming back.

Consumers have also grown to mistrust retailers amid accusations that they mark goods with an artificially high price to give the appearance of deep discounts. Some people feel that too many sales weaken the brand of the store, as well as the merchandise in it.

I am a big fan of buying on sale, and these days it's certainly almost always possible. But don't let low prices drive your purchasing decisions. An organized approach to shopping starts at home when you identify what you need *before* you leave for the store. Without a shopping strategy in hand, you might find yourself aimlessly wandering the aisles and easily seduced into buying something you don't need simply because it is on sale. (I know women who have bought clothes two sizes too small because it was on sale, hoping someday to fit into it! It ends up becoming part of the 80 percent in their wardrobe they never wear.)

Remember, a bargain is only a bargain when you need it and it complements both your lifestyle and your figure.

Check Out and Check Back In

Well, you've made it to the home stretch. But your shopping trip isn't over yet! In fact, it will continue back at home in your own closet when you try on all your new purchases with the clothes you already own. But first, let's look at ways to make the checkout process flow easily.

Checking Out

- **Retrace your steps.** At the end of your shopping trip, go back to each store that is holding an item for you and pay for your final purchases.

- **Ask about the store's return policy.** Department stores generally have more liberal return policies, while boutiques and outlet stores often accept returns for credit only.

- **Watch closely!** I catch mistakes at the checkout counter in at least one out of three shopping trips. If you are buying several things, count each item on the sales receipt to make sure you weren't double charged for anything.

- **File your receipts.** Once you've paid and while your wallet is still out, tuck your receipts into your billfold. I slip mine into the back section behind my cash, and leave them there until I decide whether to return any of my purchases.

- **Transfer your receipts.** For the items I've decided to keep, I transfer the receipts to my home filing system. This makes it easier to track my expenses for budgeting purposes. If any of the purchases are for someone else, I write their name at the top of the receipt. This just makes it easier to locate in the event I need it in the future.

Back Home

Once back home, decide on a system for organizing your new purchases. I put the bags in my closet, then play dress-up with them when I'm rested. Try everything on so you can check yourself out in your home's own light. Then, start mixing and matching the pieces with what you already own. Check carefully that the new items bought to match existing garments do indeed compliment each other.

This is also a good time to get a second opinion—especially if you chose

| Behind Closed Doors |

Credit Card Caper

After a trip to the mall to purchase new clothes for her professional wardrobe, one of my clients received a call from her credit card company. They insisted on checking to see if her card had been stolen.

When she asked them what the problem was, they said they couldn't believe that someone other than a thief would make so many different purchases at so many different stores in so little time—approximately 45 minutes. She told them she had been with a professional wardrobe consultant who was helping her change her wardrobe. The credit card company representative said he still couldn't believe it—that nobody could shop through so many stores so quickly, not even a professional.

"Of course not," the client said. "We were shopping for much longer, but put everything on hold, then went back to buy all the items at the end of the day. It's the best way to shop."

And they finally believed her!

to shop alone. I usually ask my husband what he thinks of my new outfits. I can always count on him for an honest opinion (whether or not I want it!). You can also invite a friend, paid fashion consultant or tailor over. Yes, there are tailors who make house calls.

Once you've decided what to keep, make a commitment to return the unwanted items right away. You might even want to put them by your front door where they can't be missed. If you leave them in your closet, they're likely to languish there for months while your credit card finance charges creep ever upward. I put my returns in the trunk of my car. Do whatever works for you as long as you get unwanted purchases off your credit card in a timely fashion.

Shopping Through the Seasons

There are certain times throughout the year that it makes sense to stock up on the basics, take advantage of sales, and shop for special people in our lives. As I close out this book, here's a guide to help you make the most of seasonal sales while assisting you in further developing shopping strategies for a few seasonal wardrobe basics.

Winter

If the Coat Fits

Buying a coat is often one of the biggest wardrobe investments you make (and a decision that's tough to live with should it go awry), so here are some tips about how to purchase a coat that truly fits. They are courtesy of Fannie Doxer, a Boston-based retail entrepreneur with more than twenty years of experience running one of the largest independently owned coat stores in the United States.

- **Button up:** To determine if a coat or jacket fits, button or zip it up and hug yourself. If the fabric strains too much, the coat probably isn't the right size.

- **Steering wheel test:** Pretend you are driving a car. There should be enough room in the coat to comfortably steer the wheel.

- **Jump rope test:** Pretend to jump rope. There should be enough room for your shoulders to swing freely.

- **Perfect sleeves:** Sleeves should cover your wrist bone but not start to cover the back of your hand.

- **Pocket protection:** Make sure coat pockets aren't too low or too high. Pockets should be set at a comfortable height in order to be useful, while at the same time not interfering with the balance of your overall silhouette.

The two traditional times of year that coats go on sale are Columbus Day in October and after the holidays. Plan your coat purchases wisely, and you could save a bundle.

Winter Clearance Wonderland

An easy way to give yourself an end-of-winter wardrobe-lift while cost-effectively building your wardrobe for seasons to come is to take advantage of end-of-winter clearance sales.

Are you sick and tired of your sweater collection? Look for one on sale with classic styling. I picked up two beautiful cashmere sweaters at the high-end Burberry store one year for 70 percent off their original price.

Wool coats are another excellent sale rack find if you need one. With today's more casual lifestyles, many people have expanded this area of their wardrobes. Short, three-quarter-length car-coat styles and ankle-length coats are all popular and can complement different areas of your wardrobe.

Leather coats, pants, skirts, boots, and gloves can be added late in the winter if they are classically designed. Stay away from shorter skirts, trendy pants, and boots with funky heels. Skirt lengths can change overnight, and fashion-forward pants and shoes are only fashion-forward if they are, in

fact, cut and designed in the style of the moment. At this time of the year, it's too hard to determine what skirt lengths, pant shapes, and boot styles will be most popular next year. When you are buying gloves, particularly late in the season when pickings are slim, err on the side of a bit tight rather than a bit large, as these items always stretch with wear.

I tend to stock up on tops in the "in" colors that are being shown that year at the beginning of a season. If you can find knit shells in basic colors (such as black, cream, beige, or red) during end-of-winter clearance sales, by all means grab them, especially in lightweight wools and seasonless silks. Picking up colors such as lilac, apple green, and sky blue can help lighten up all your dark suits for spring. I tend only to buy shirts and blouses when I need them to complement a certain outfit, no matter how inexpensive they are on the clearance rack. I find if I buy too many without a plan, they just sit in my closet.

It has been my experience that the items you won't have much luck finding during clearance sales include winter boots, scarves, hats, and ski jackets. By late February, these pieces are well picked over, so you're probably better off holding these purchases until the following year.

Spring

Where the Boys Are

Stocking up on T-shirts early in the warm-weather season is a good strategy if you want to get a good selection.

If you are in need of white Ts to get you through the spring and summer heat but don't want to break the bank, check out the boys' departments at local retailers and pay anywhere from 20 to 50 percent less, according to the Women's Consumer Network (WCN).

WCN reports that a woman's size 6 is comparable to a boy's size 14, a size 8 to a boy's 16, a size 10 to a boy's 18, and a size 12 to a boy's 20. If being cool and comfortable is of the utmost importance to you, make sure your Ts are

100 percent cotton, as opposed to those with a percentage of polyester, Lycra, or spandex. Natural fabrics breathe better when the temperature starts to soar.

Sunglass Style

Although your first priority in choosing sunglasses should be to protect your eyes, a pair of shades can do so much more. Worn on top of the head, sunglasses can double as a headband. Left to dangle from a stylish holder, they become a utilitarian necklace.

How do you find sunglasses to help you look your personal best? Match the frame to your particular facial features for the most flattering look.

- **Round face.** Choose frames with straight or angular lines that are slightly wider than your face.

- **Triangular face.** Choose frames with straighter top lines and lower side lines.

- **Oval face.** Choose any frame shape as long as it is in proportion to your face.

- **Oblong face.** Choose oval frames with horizontal top lines.

- **Square face.** Choose oval or round frames that are at least as wide as your face.

Before buying any sunglasses, check for proper fit by slipping the glasses on, then looking down. They should stay firmly in place. To keep that snug fit over the long term, be sure to remove them with both hands, otherwise you'll risk stretching the temples and hinges.

To care for your sunglasses, clean the lenses with a soft cloth or eyeglass cleaning tissue. Store them in a case when not in use to ensure they'll remain scratch-free and wearable for many years to come. These same tips

apply to regular eyeglasses as well, so study them before your next visit to the optician!

Summer

Stress-Free Bathing Suit Shopping

In Part Two you learned which bathing suits look best on which bodies. But even when you know what you're looking for, the process of bathing suit shopping is still a daunting task. Here are some guidelines to make it a little easier:

- **Plan a shopping trip solely to select a swimsuit.** If you find one quickly, move on to another department. If after an hour you're having no luck, call it a day before you get overwhelmed and make buying mistakes.

- **Once you select a suit, make sure you have a matching cover-up or short set.** These summer basics help you feel pulled together at all times and are ideal in a variety of summer casual situations.

- **If you'd rather shop for your suit through a catalog, a good rule of thumb is to select the suit of your choice in at least three sizes.** Keep the one that fits best, and send the other two back right away.

- **Be sure to ask about the return policy before making your final selections.** Most stores have strict rules about bathing suit returns.

Summer Sale Success

In most areas of the country, the summer season is the shortest season of the year, so you don't necessarily need a lot of strictly summer clothes in your wardrobe. A few trips to the store to expand your summer work wardrobe, to stock up on beachwear, and/or to add a few new dressy casual outfits to help

celebrate the season might be all you need to get you through a few months of warm weather.

I always save one of my summer shopping trips for August to take advantage of the summer clearance sales. End-of-summer sales are a great place to stock up on basics such as sandals, shorts, and colorful Ts in classic styles that will let you enjoy a few more days of warm weather late in the season while giving you a head start on building next year's summer wardrobe. If you are planning a fall or winter vacation to a warm climate, keep an eye out for summer-weight wardrobe staples on the clearance rack that are also easy to pack.

Here are the items I look for at the end of the summer and why:

- **City sandals:** These dark, heavy-soled sandals can carry you through early fall. Those you couldn't justify purchasing at the beginning of the season because they were too costly are often significantly marked down at the end of summer to make way for boots and heavier shoes. Very casual sandals can wear out from lots of beach and picnic terrain, so consider replacing these at the end of summer too.

- **Dark shades of linen and tencel:** Although it's best to put lighter shades of these fabrics away after Labor Day, colors such as black, chocolate brown, and hunter green are fine to wear through September. If your summer-to-fall transitional wardrobe is in need of some attention, this is the time of year to expand it with darker yet light-weight fashions.

- **Silk twin sets:** These can be costly when they are not on sale. I wear many short-sleeve and sleeveless styles year-round for layering. These shorter-sleeve sets are first stocked at stores in early spring, and because they are so popular, they seldom get marked down with any regularity. I scour the sales racks for them this time of year, and I am thrilled when I find one significantly discounted whether for myself or a client.

- **Sundresses:** As with bathing suits, search end-of-season sales for pretty sundresses to match your favorite footwear. If you find a dark linen sleeveless sundress you can wear it in the early weeks of fall with a T-shirt underneath. Many of my older clients like this technique as it helps them to camouflage their arms.

- **Word of caution:** I always avoid buying trendy printed items at the end of the summer sales. There is usually one signature print introduced at the beginning of each warm-weather season such as butterflies, polka dots, or retro prints that dominate store shelves. These prints typically don't repeat the following year, so I pass over them, no matter how cheap they are on the sale rack.

Fall

Back-to-School Shopping for Moms

Teen fashion has become more and more controversial over the last decade. If you find yourself questioning whether or not what you see advertised as teen fashion is appropriate, you're not alone. The topic comes up over and over again in our corporate and public seminars from parents and educators struggling to define how far is too far when it comes to provocative and overly casual school attire.

If you wonder how teens can afford all these clothes, the answer might surprise you. At the expense of their studies and extra-curricular activities, some are reported to be working two and three jobs to support their shopping habits. Others have parents who hand over credit cards every time they visit the mall. Teens today not only socialize more and more at malls, but they live in an information age that enables advertisers to market to them in new and sophisticated ways.

Here are my back-to-school shopping tips, reflecting the unique challenges of instilling good shopping and fashion sense into the minds of new-

economy teens. Whether you have kids or not, you might be interested in these insights. They are consistent with the "organized approach to dress" philosophy you've been exploring throughout this book.

- **Make an appointment with your teens at home to review all the clothing currently in their wardrobes and talk about what's appropriate to wear to school.** It might sound crazy to have to "schedule an appointment" with your kids to do this, but with lifestyles being so busy and teenagers and parents often going in opposite directions, actually setting a time to talk about school clothes before you or they hit the mall to shop can save you a lot of emotional and financial stress later.

- **During this discussion, recognize that their need to be in style is valid.** Letting them have many different looks in their closet is honoring their need for self-expression and personal growth. Helping them figure out when it's appropriate to wear each category of dress in their closet is good parenting. Explain your reasons for wanting them to be dressed in a way you deem appropriate when they go to school. Words such as *respect, boundaries*, and *safety* generally resonate with teens, even if they don't verbalize this understanding to you directly. Using a lot of humor in this exercise is typically a good strategy!

- **Have them clean out the outgrown and seldom-worn clothes before you give them money or they spend their own money for new clothes.** Either have them put away clothing for a younger sibling or have them donate it to charity. Helping them adopt a streamlined and sensible approach to dress (i.e., less is more; charity as a way of making items no longer useful into something valuable) is a useful skill that can be easily transferred into other areas of their life in the future.

- **Encourage them to organize their closet in a way that saves them time in the morning while helping them get out the door feeling**

good about themselves. Like adults, when kids start their day organized, their whole day has a better chance of being successful. Typically, their day starts in their closet.

- **Finally, browse through a few back-to-school catalogs with your teen and talk to them about the issue of "what one wants" and "what one can afford."** A calm financial conversation at home is one way to avoid an emotional blowout at the store. Avoid buying everything before school starts. Once your teens see what everyone else is wearing, they might have different ideas about what they like and dislike.

Holiday

Holiday Shopping Made Easy

The crowds are racing for the malls. It's wall-to-wall people. How will you get a parking spot, let alone finish all your holiday shopping? Relax! Follow these suggestions for making holiday shopping a lot less stressful.

- **Shop early.** The best strategy is to shop year-round. This way you're not scrambling at the last minute to find the perfect present for each person on your holiday list.

- **Keep a holiday shopping file on family and friends.** This will become your resource for vital statistics on gift recipients, including sizes, likes, and dislikes. It is also a logical place to keep sales slips for returns. Avoid the post-holiday credit card blues by referring to this file often to make sure you stay within a realistic budget.

- **Avoid crowds by shopping during off hours.** If possible, take a day off from work and plan to shop in the morning when the stores first open. You are more likely to find a wide selection and courteous ser-

vice at this early hour. You should also take advantage of extended holiday shopping hours at many stores and shopping malls. Check ads in your local newspaper or call ahead to anchor stores—sometimes they will open earlier and close later than the mall itself.

- **Take advantage of services offered by malls.** These services include baby-sitting, valet parking, stroller rental, and gift-wrapping. Visit the information booth with list in hand, and ask staff to direct you to the appropriate stores and services.

- **Buy larger gifts last.** You won't want to be carrying heavy items around with you all day.

- **Don't forget charity.** At holiday time, there is ample opportunity in the malls and elsewhere to donate to a good cause.

Parting Thoughts

To me, the best part of being a wardrobe consultant has nothing to do with clothes. Rather, it's the human side of the business—meeting warm, funny, successful, and caring women who graciously welcome you into their homes, share many parts of their personal and professional lives with you, and trust you to help them dress for some of the most important and memorable days of their lives. There is something about the closet, fashion, and shopping experience that bonds women for life. I am blessed to have collected so many friends, mentors, and business associates through my entrepreneurial journey. I am also grateful to have had this opportunity to have met you.

I hope you have experienced a personal connection to the systems, strategies, stories, and tips expressed in this book. I'd love to hear how this book has helped you master the art of dressing well. Please share your success stories as well as any of your favorite closet organization, image enhancement, and/or shopping tips with me at marylou@dressingwell.com. Your feedback is invaluable to me.

If you would like to stay in touch on a regular basis, I encourage you to visit our website and sign up for my *Dressing Well* "Tip of the Week,"

which is delivered free of charge by e-mail. If you liked this book, then you will love these tips. They are full of even more seasonal and year-round fashion tips that are practical and easy to implement.

If you should ever find yourself in need of a private wardrobe consultation, I welcome the opportunity to be of assistance to you. My company works with women from all over the United States and Canada. Some travel to Boston to work with us; others arrange for us to visit with them at their homes. Please visit www.dressingwell.com to learn more about our individual as well as corporate services.

I've never been good at saying good-bye. I do hope to hear from you!

All the best,

Mary Lou Andre

President and Founder, Organization By Design, Inc.

Editor, www.dressingwell.com

P.O. Box 920885

Needham, MA 02492

Phone: 800-578-3770

Fax: 781-449-9465

E-mail: marylou@dressingwell.com

MEET OUR EXPERTS

This book was enriched by the following experts who generously provided us with additional tips and strategies for choosing and using your wardrobe. We encourage you to contact them if you are interested in learning more about their products and services:

Christa Hagearty
President
Dependable Cleaners
320 Quincy Avenue
Quincy, MA 02169
www.dependablecleaners.com

David Josef
President
David Josef, Inc.
59 Wareham Street
Boston, MA 02118
www.davidjosef.com

Diane Isaacson
Fabric Expert
Fabric Place
136 Howard Street
Framingham, MA 01702
www.thefabricplace.com

Brooke Kanal
Fashion Stylist
One Blackberry Lane
Framingham, MA 01701
brookekanal@rcn.com

Debbi Karpowicz Kickham
Contributing Editor/*Bridal Guide*
 Magazine
119 Fisher Street
Westwood, MA 02090
debbikarpowicz@hotmail.com

Evana Maggiore
President
Evana Maggiore International
60 Myopia Road
Winchester, MA 01890
www.fashionfengshui.com

Penny Shuman
Principal
PS Design
2 Summer Street, Suite 4
Natick, MA 01760
pennyshuman@aol.com

Diana Simon
President
Bra Smyth Retail
100 N. Winchester Boulevard

Suite 380
Santa Clara, CA 95050
www.brasmyth.com

Jodi R.R. Smith
President
Mannersmith Etiquette Consulting
P.O. Box 1344
Marblehead, MA 01945
www.mannersmith.com

Barbara Thornton
President
DesignerShoes.com
125 Newbury Street
Boston, MA 02116
www.designershoes.com

Dianne H. Webster
Certified Financial Planner
Integrated Financial Strategies
P.O. Box 546
Amesbury, MA 01913
www.ifslegacy.com

This book wouldn't be complete without a resource guide. In today's modern society, closet organization, fashion, and shopping help are typically only a click away on your computer. Yet sifting through the volumes of websites available in each of these categories can be overwhelming.

In designing a user-friendly resource guide, we honored our "less is more" philosophy and limited the amount of categories and resources in this guide to help keep you focused. If there's a topic that you don't find included in this guide, I suggest going to your favorite search engine to do your own search. We go to google.com most often to search for specific information on behalf of our private clients.

If you know of any unique websites that feature hard-to-find closet organization, fashion, and shopping resources, we'd love to know about them. Send us an e-mail at info@dressingwell.com. We'll be updating this information on our website on an ongoing basis. Happy surfing!

Wardrobe Organization

Ballard Designs *www.ballard.com*

If you are in the market for whimsical fashion-themed prints and accessories to help decorate your dressing areas, check out their fun wares.

California Closets *www.calcloset.com*

One of several national companies offering custom storage solutions. They are on the high end, but the service and product speaks for itself. The Closet Factory is another reputable company in this category. Do a search for "Closet Design Companies" on your favorite search engine for a comprehensive list of what is available in your area.

The Container Store *www.thecontainerstore.com*

They claim to be the most organized site on the Web and we agree. They have hard-to-find and unique items at good prices.

Expo Design Center *www.expo.com*

The place to go if you are a do-it-yourself type organizer.

Hold Everything *www.holdeverything.com*

Great source for closet accessories such as baskets, shoe racks, and out of season storage solutions.

Lillian Vernon *www.lillianvernon.com*

Lillian was in the business of organizing long before it was fashionable. Her cost-effective and fresh product mix each season is the reason for her success.

National Association of Professional Organizers *www.napo.net*

If you need hands-on organizing help, their database of professionals who will come to your home and work with you is invaluable.

Placewares *www.placewares.com*

Organizing products with a sophisticated and contemporary flair. Great ideas for people with very small spaces.

Handy Fashion Sites

Association of Image Consultants International *www.AICI.org*
Log on to find an image consultant in your neck of the woods.

The Clothing Doctor *www.clothingdoctor.com*
The ultimate guide to caring for clothes.

Consumer Review *www.mouthshut.com*
Gives consumers a chance to review brands of clothes, shoes, and accessories.

Daily Candy *www.dailycandy.com*
Subscribe to their free daily e-mail service, and you'll soon be the insider telling everyone what's hot and what's not.

Fashion Tape *www.hollywoodfashiontape.com*
Clear, double-stick tape for hiding bra straps, securing revealing necklines, fixing hems and more.

Frenchlink Tours *www.frenchlinks.com*
Personal advising and custom itineraries for independent travelers to Paris. The webmistress is the author of *Best Buys to French Chic: An Insider's Savvy Shopping Guide to Paris.*

Good Feet *www.goodfeet.com*
Custom-made insoles that can be inserted into shoes for more comfort.

Grand Style *www.grandstyle.com*
Great meeting place for women size 14 plus. It links to every plus-size retailer and fashion designer imaginable.

It's Deductible *www.dressingwell.com*
Visit our website to order this handy guide that helps you properly itemize all your charitable donations.

Manhattan Wardrobe Supplies *www.wardrobesupplies.com*
One-stop wardrobe supply shop for designers, stylists, and the general public.

Silkies *www.silkies.com*
Stock up on hosiery at reasonable prices.

Talene Reilly *www.talenereilly.com*
Handy totes that solve every professional woman's business versus fashion dilemma.

Winter Silks *www.wintersilks.com*
Great source for silk long johns. We love them for layering without bulk in the winter.

Smart Packing Sites

International Travel *www.journeywoman.com*
Great site for figuring out what to wear in various cities throughout the world.

Magellans *www.magellans.com*
Since 1989, travelers around the world have relied upon these superior products and world-class service to make their travel more comfortable, safe, and rewarding.

Travelsmith *www.travelsmith.com*
Features clothes that travel and pack well. Lots of styles made of wrinkle-resistant microfibers.

Weekenders *www.weekendersusa.com*
Pack light with these versatile mix-and-match pieces that are machine washable and don't require ironing. These clothes are only available at home presentations or by phone. Check out their website for more information.

Tried and True Shopping Destinations

Ann Taylor *www.anntaylor.com*
If you are a petite or missy size, stock up on handy tops and blouses for work here.

Bluefly *www.bluefly.com*

This website brings the outlet store concept directly into your home. It features great deals on end-of-season, excess, and closeout products from name-brand designers and resellers. Because of the unpredictable nature of the acquisitions, inventory is always changing and size ranges may not be complete.

Chico's *www.chicos.com*

Easy to fit and wear casual clothes.

Coach *www.coach.com*

Sturdy, reliable totes and leather accessories that always set a business tone.

Eileen Fisher *www.eileenfisher.com*

Easy to wear, easy to pack.

J. Jill *www.jjill.com*

Great selection of casual clothes for various sizes.

Kate Spade *www.katespade.com*

Contemporary totes for all sorts of lifestyles.

Lands End *www.landsend.com*

A godsend for our taller and shorter clients. You can have the length of the pant cuffed to your exact requirements.

Liz Claiborne *www.lizclaiborne.com*

Affordable career and casual clothes for petite, missy, and plus sizes. Great style advice, too.

Nordstrom *www.nordstrom.com*

Best shoe selection on the Web. They wrote the book on customer service.

Sierra Trading Post *www.sierratradingpost.com*

Representing quality manufacturers Ralph Lauren, Cole Haan, and Calida of Switzerland at 35–70% off retail.

Talbots *www.talbots.com*

Classic women's clothes in missy, petite, and women's sizes. Basically the same merchandise found at the store in a well-organized format that is easy to navigate.

Victoria's Secret *www.victoriassecret.com*

Good source for bras for average size women. We particularly like their racer-back styles.

Feel Good Sites

Dress for Success *www.dressforsuccess.com*

This is a nonprofit organization that provides interview suits to low-income women seeking employment. Their website lists the names, addresses, and telephone numbers of specific "sister" and "cousin" organizations across the country (and in many other countries!) and how you can make a donation at a location near you.

Morgan Memorial *www.goodwillmass.org*

Their Clothing Collaborative enables job training graduates to learn the basics of how to dress for work. They are also given vouchers to the Goodwill Stores for obtaining work appropriate attire for their interviews and for their first year of employment.

Shop Well with You *www.shopwellwithyou.org*

This is a nonprofit, one-on-one personal clothes shopping service for women battling cancer. Visit their website for more information.

Consumer Reporting Agencies

(to track your credit history and safeguard your credit cards)

Equifax *www.equifax.com*
1-800-525-6285

Experian (formerly TRW) *www.experian.com*
1-888-397-3742

Trans Union *www.transunion.com*
1-800-680-7289

Social Security Administration (fraud line) *www.ssa.gov/org*
1-800-269-0271

Appendix A: Personal Action Plan

Consultation Date: _____

Prepared For: _____

Season: _____

Organization By Design™
Wardrobe Management & Fashion Consulting

Areas of concentration:
(#1–5 in order of importance)

_____ Traditional Business Attire
_____ Business Casual/Classic Casual
_____ Dressed Up Casual
_____ All-Out Casual
_____ Special Occasion/Black Tie

Closet Checklist:

☐ Skirted Suits _____
☐ Pant Suits _____
☐ Dresses _____
☐ Jackets _____
☐ Tops _____
☐ Skirts _____
☐ Pants _____
☐ Sweaters _____
☐ Vests _____
☐ Eveningwear _____
☐ Belts _____
☐ Shoes/Boots _____
☐ Pocketbooks _____
☐ Scarves _____
☐ Jewelry _____
☐ Coats _____
☐ Briefcase _____
☐ Gloves/Hats _____
☐ Hose/Tights/Socks _____
☐ Undergarments _____

Sizes/Preferences:

_____ Petite _____ Tall
_____ Missy _____ Woman's

Suit _____
Pant _____
Skirt _____
Jacket _____
Dress _____
Blouse _____
Top _____
Shoe _____

Earrings: ☐ Pierced
 ☐ Clip
 ☐ Either

The Organized Wardrobe

PRODUCTS TO KEEP ME ORGANIZED

MISCELLANEOUS IDEAS

Maximizing What You Have

HAVE

NEED TO COMPLETE OUTFIT

Shopping Strategy

NEEDS

SHOPPING DESTINATIONS

Stores:

Designer/Brands:

PERFECT WHAT YOU HAVE

Alterations:

Shoe Repair:

Miscellaneous:

COLORS TO CONSIDER

Appendix B: Wardrobe Grid & Summary

#	SUIT	DRESS	JACKET	SKIRT	PANT	BLOUSE	SHOES	HOSE	ACCESSORIES	NOTES

Professional Image Seminars • Personal Wardrobe Consultations • *Dressing Well*™ Publications & Products

Organization By Design, Inc.
P.O. Box 920885 • Needham, Massachusetts 02492-0009
Voice (781) 444-0140 • Fax (781) 449-9463 • e-mail info@dressingwell.com
www.dressingwell.com

Appendix C: Master Shopping List

Consultation Date: _____

Prepared For: _____

Season: _____

**Organization
By Design**™
Wardrobe Management & Fashion Consulting

Women's Closet Checklist:

☐ Skirted Suits _____

☐ Pant Suits _____

☐ Dresses _____

☐ Jackets _____

☐ Tops _____

☐ Skirts _____

☐ Pants _____

☐ Sweaters _____

☐ Vests _____

☐ Eveningwear _____

☐ Belts _____

☐ Shoes/Boots _____

☐ Pocketbooks/Bags _____

☐ Scarves _____

☐ Jewelry _____

☐ Coats _____

☐ Briefcase _____

☐ Gloves/Hats _____

☐ Hose/Tights _____

☐ Undergarments _____

SHOPPING PRIORITIES

1. _____
2. _____
3. _____
4. _____
5. _____

GENERAL SHOPPING LIST	ESTIMATED COST	ACTUAL COST

INDEX

Page numbers in **bold** indicate tables.

ABOUT THE AUTHOR

Mary Lou Andre is a nationally recognized wardrobe consultant, speaker and, author. She is founder and president of Organization By Design, Inc., a Needham, Massachusetts-based wardrobe management and fashion consulting firm that helps people understand the power of being appropriately dressed in a variety of situations.

Through her extensive corporate, retail, and private client services, Mary Lou has helped thousands of individuals identify and pull together a wardrobe that complements their professional and casual lifestyles. She is also the editor of Dressing Well On-Line, Organization By Design's trademarked global connection that averages 30,000 visitors per month.

Mary Lou is recognized by the media as a fashion and retail expert and has given in-depth interviews on *ABC World News Now* and *CBS This Morning*. Her firm has also been profiled nationally on CNN, and her professional image insights are regularly featured in national magazines such as *Marie Claire*, *Executive Female*, *Family Circle*, *Woman's Day*, *Working Mother*, *Parenting*, and *Entrepreneur International*.

A graduate of the University of Massachusetts at Amherst with a degree in journalism and a concentration in fashion marketing, Mary Lou officially opened Organization By Design in April of 1992 after several years in public relations.

Private clients of her firm include executives, doctors, lawyers, bankers, media

personalities, politicians, fellow entrepreneurs, as well as stay-at-home moms, and young women just starting their careers. In the corporate arena, Mary Lou has provided consulting and services for companies such as Bose, Estée Lauder, Fidelity, Harvard Business School Executive Education, Hewlett Packard, John Hancock, Lillian Vernon, Nordstrom, and Sara Lee.

Mary Lou is the 1999 recipient of the prestigious Avon Spirit of Enterprise Award that recognizes women under the age of thirty-five throughout the United States that have demonstrated outstanding achievements as young entrepreneurs. The award also pays tribute to her involvement with national and regional charities such as The Massachusetts Breast Cancer Coalition, the YWCA, The Urban League, and the National Multiple Sclerosis Society.

Mary Lou and her husband TJ Andre reside in Needham, Massachusetts with their twin boys John Joseph and Timothy.